THE LITERARY WORKS OF JACK B. YEATS

Princess Grace Irish Library: 5

THE LITERARY WORKS
OF
JACK B. YEATS

John W. Purser

Princess Grace Irish Library: 5

BARNES & NOBLE BOOKS
Savage, Maryland

First published in the United States of America in 1991 by
Barnes & Noble Books, 8705 Bollman Place, Savage, MD 20763

Library of Congress Cataloging-in-Publication Data

Purser, John W.
 The literary works of Jack B. Yeats / John W. Purser.
 p. cm. — (Princes Grace Irish Library ; 5)
 Includes bibliographical references and index.
 ISBN 0–389–20929–5
 1. Yeats, Jack Butler, 1871–1956—Criticism and interpretation.
 2. Ireland in literature. I. Title. II. Series: Princes Grace Irish
 Library series ; 5.
 PR6047.E3278 1990
 828'.91209—dc20 90–610 CIP

Originated and first published in Great Britain
by Colin Smythe Ltd., Gerrards Cross, Buckinghamshire

Produced in Great Britain
Printed and bound by Billing & Sons Ltd., Worcester

Contents

Illustrations

Plates section between pages 48 and 49.

Abbreviations

Even when not stated above, all the plays also appear in *The Collected Plays of Jack B. Yeats*, ed. Robin Skelton, London: Secker & Warburg, 1971

WRITINGS ON JACK B. YEATS

Caldwell Martha Bell Caldwell. 'Jack B. Yeats. Painter of Life in
 the West of Ireland'. PhD Thesis. Indiana 1970.

Mays James Mays. 'Jack B.Yeats: Some Comments on His
 Books'. in *Irish University Review* 2 i. Dublin. 1972.

McGuinness Nora McGuinness. 'The Creative Universe of Jack
 B.Yeats'. PhD. Thesis. University of California. 1984.

Murphy William M. Murphy. 'Prodigal Father'. Ithaca.
 Cornell University Press 1978.

Purser John Purser. 'The Literary Works of Jack B. Yeats'.
 PhD. Thesis. University of Glasgow. 1989.

Pyle Hilary Pyle. *Jack B. Yeats: A Biography*. London. RKP
 1970.

Rose Marilyn Gaddis Rose. *Jack B. Yeats: Painter and Poet*.
 European University Papers XVIII Volume 3. Berne.
 1972.

Skelton Robin Skelton. *The Collected Plays of Jack B. Yeats*.
 London. Secker & Warburg 1971.

Skelton 2 Robin Skelton. 'Themes and Attitudes in the Later
 Drama of Jack B. Yeats'. *Yeats Studies* No.2, pp
 100-120. Dublin. Irish University Press. Bealtaine
 1972.

The following people are also referred to by abbreviations in the text
and notes: John Butler Yeats and William Butler Yeats by their initials,
George W. Russell by his pseudonym A.E., Thomas Bodkin, Joseph
Hone, Thomas MacGreevy, John Quinn and James Starkey by their
surnames.

The page references given in the text relate to Robin Skelton's edition
of the plays, and to the first editions of the novels, except in the case of *Ah
Well, And To You Also*, and *The Charmed Life*, when they refer to the later
editions.

Introduction

It is my considered opinion that he was a man full of deception.[1]

Victor Waddington, who wrote the above, was Jack Yeats's dealer for many years. He was therefore well placed to understand Yeats's relationship with the buying public, and his 'considered opinion' has to be taken seriously. Being 'full of deception' does not mean that he was positively deceiving people (Waddingtom made that clear), but it certainly implies the more negative quality of deceptiveness, just as distances are deceptive in a mist. The trouble is that Yeats's literary works have thoroughly deceived his commentators and the question arises as to whether the mist is of his own creating, or simply the result of our not having wiped our spectacles.

Jack Yeats did not write for literary critics any more than he painted for the art critics. He frequently failed to satisfy the latter, painting no portraits, no nudes, no still lives, no studied landscapes, his subject matter almost exclusively Irish and his style idiosyncratic. But he is regarded by many as Ireland's greatest painter and by a significant few as one of the masters of the twentieth century.

Why have his writings failed so to impress? The answers are simple. Much of Jack Yeats's literary output is virtually unobtainable, even from libraries, and that includes all his third person novels. Nora McGuinness is the only person to have devoted a whole thesis to his writings. He is in the shadow of himself as a painter. He is in the shadow of his brother as a writer. But, crucially, he is very much cleverer than has been supposed and, as with his work as a painter, he is unconventional and innovative. He has not so much been wilfully deceptive as astonishingly misunderstood.

Yeats was educated among people in the West of Ireland without the social and literary preconceptions of the universities. They had become wily, and clever in their use of symbolism in order to deceive the authorities. They knew what was meant by 'the dear silk of the kine', 'the green linnet', 'the bonny bunch of roses' and 'the garden so green'. To such people an ace of clubs was obviously a shamrock and 'the harp without a crown' required no explanation. They would have had a good guess at

the bearing *The Green Wave* might have upon *In Sand* and, knowing what a Bowsie was, might well have understood why he was companioned by a man called No Matter in a novel called *The Charmed Life*.

With this background in mind, and with the aid of evidence which has not previously been referred to, including a new chronology, new interpretations are given for many of his works and an overall pattern in the novels is revealed. The religious imagery of *The Careless Flower* and *The Amaranthers* is developed, and the significance of the theme of inheritance in *The Amaranthers* is brought out for the first time, allowing the two halves of the novel to be seen much more clearly as part of an integrated whole. *The Charmed Life* is shown to have an underlying Faustian and Christian significance, related to the progress of Ireland as a nation and *Ah Well* is interpreted as a quite remarkable fable of a kind of Eden in reverse. The hitherto undiscovered Prologue to *The Deathly Terrace* is considered; some revisions and additions are made to McGuinness' observations with respect to the trilogy: *Harlequin's Positions* is interpreted as a riposte to Shaw and an assertion of Ireland's need and ability to maintain her independence in the face of the approaching war; and *La La Noo* and *The Green Wave* and *In Sand* are seen in part as approving extensions of that theme.

There is far more to Jack Yeats than has met the eye and it is hoped that a move will be made to make his writings available in properly edited publications (*pace* Skelton's admirable pioneering work with the plays), so that they can take their place in the forefront of Irish letters, where they indubitably belong. In the company of Synge (who shared a journey and a vision of Ireland with Yeats);[2] Joyce (who recognised a shared methodology with Jack Yeats);[3] W.B.Yeats (who knew that few would recognise his brother's genius as a writer while ackowledging it himself);[4] and Samuel Beckett (who learnt much from the older man and wrote in profound admiration of *The Amaranthers*);[5] Jack Yeats would then be able to stand proud, and the prophecy of his father would come true:–

Some day I shall be remembered as the father of a great poet, and the poet is Jack. (Murphy p.209)

Acknowledgements

In such an undertaking one's debts to others are extensive. My family was used as a sounding-board and suffered the follies that are not presented here as well as the ones that, no doubt, are. My erstwhile tutor, Professor Butter, suffered a like fate and was both patient and helpful. Persons upon whom I had no call found time to write to me, ferry me, entertain me and inform me. That they did so so generously and freely reflects both on their personal kindness and on the homage and affection which the mention of Jack Yeats invariably evoked. Nothing but kind words was ever uttered with respect to his name. My chief acknowledgement is therefore to Jack Yeats himself whom I have studied happily for several years, continuing throughout to enjoy his company as expressed through his work and his letters.

The debt which I owe to Anne Yeats and Michael Yeats is acknowledged in the list of manuscript sources, and this list includes the names of most of the institutions whose librarians have been unfailingly helpful. Special mention must, however, be made of the University of Glasgow. The magnificent library there was quite exceptionally efficient and its staff wonderfully helpful: and the Department of English Literature was, of course, my first stimulus and my mainstay. The Scottish Education Department funded my research.

The book itself is dedicated to my wife, Barbara, without whom it would never have been completed.

All others to whom I owe a debt of gratitude are listed below. It would take many pages to acknowledge them properly, but they know, and I know wherein their kindness lay.

Ivan Allen; Samuel Beckett; Professor Peter Butter; Maurice Craig; Richard Cronin; Dr H. Eyre-Maunsell; Dr E. Fitzpatrick; Anthony Graham; Mrs Hilda Graham; Patrick Graham; Professor Robert Hogan; Miss Bay Jellett; Professor Norman Jeffares; Mrs Olda Kokoshka; Louis Le Brocquy; the late Sean McBride; William McQuitty; Mr and Mrs J. Meddlycott; Mrs Morgan; Mrs R. Phillips; Serge Phillipson; John Pilling; Barbara Purser; Mr and

Mrs J. W. R. Purser; Sean Purser; Sarah Purser; Vasco Purser; Hilary Pyle; Helen Hooker-Roeloffs; Professor Robin Skelton; Dr Clement Smith; Colin Smythe; Professor William Stewart; Mrs F. Vickermann; Tim Vignoles; Victor Waddington; James White; Terence de Vere White; Anne Yeats; Michael Yeats.

1

Life and Style

Jack Yeats's chief hobby was to be 'An eccentric incognito'.[1] We may take that response to Cyril Clemens' questionnaire with a pinch of salt. Any man who paints and exhibits as prolifically as he did, and who writes seven novels and nine plays, cannot remain wholly incognito. But the pinch of salt can only be a small one for it is a remarkable fact about Jack Yeats that there is very little biographical material to draw upon, notwithstanding the intense study to which the Yeats family has been subjected. He was generally secretive and left no diaries: he tore out any pages with biographical information from his wife's diary:[2] he left us virtually without any comment on his own family: his correspondence is scattered, and the evidence of his writings and paintings cannot be used for the purposes of justifying assertions about his life which are then used to justify assertions about his writings and paintings. He rarely commented upon these and nobody ever saw him paint except for his wife, and then only when he painted a portrait of her, the only formal portrait in oils that he ever produced. Nor did she even know when he was writing a book or a play: she came to the first night, or he put a published copy in her lap (Purser p.185).

In such circumstances much credit should go to Hilary Pyle for her seminal biography. It remains the standard work on Yeats's life and I have no need to go over the ground which it covers so well. However, Pyle's book is now twenty years old and a considerable amount of correspondence has become available since it was written: also, the only major study of Yeats's literary works (McGuinness) adds no new evidence, and there is a need to correct one or two false impressions with respect to his life, and to provide an accurate chronology of his main literary works. Some of the corrections have major consequences for a proper understanding of his output, and all of the evidence presented (much of it not previously referred to) has an increasing relevance as the relationship of Yeats's work to contemporary politics becomes clearer.

1

Jack Yeats was born on 29 August 1871 at 23 Fitzroy Road, London. In 1879 he went to Sligo to live with his grandparents where he stayed until 1887 with one known interruption to visit London in 1880.[3] The impression has been given that he was bottom of the class at school and had little formal education (Pyle pp.14 and 15), but he wrote to Lollie from Merville in 1883 that he was first in the exam[4] and he writes on another occasion to Lily that he hopes to come second in the exams.[5] According to A.E. 'when he went in for the Intermediate Examinations he passed in everything except drawing!'[6] and in the same article he refers to 'the capacious Noah's ark of his mind'. York Powell, a history professor at Oxford, said that Jack Yeats was the best educated man he had ever met[7] and told J.B.Y. that Jack 'had a mind like Shakespeare's'. Jack himself sorrowfully quotes his sister Lily as saying that he had 'no brain, only a nerve centre'[8] but he provides his own subtle image for his approach to learning some fifty years later in a letter to Joseph Hone: 'I lept into the arena of learning with the feathers on my heels entwining the spurs.'[9] It takes a moment to appreciate the image. To get round the ring one needs a horse, and spurs to goad it with. But Jack Yeats's spurs are entwined by feathers – a natural growth allowing him to be mercurial enough to jump through the hoops, horse or no horse. He would never have used spurs on a horse. The spelling 'lept' is probably deliberate as it reproduces his childish errors and enthusiasm, as well as reflecting the Irish pronunciation of leap as lep. Jack's spelling, though not his punctuation, was marginally better than W.B.'s.

Schooling over, in 1887 at the age of sixteen, Jack left the home of his grandparents, though he went back summer after summer. But he was ready to start at art school and in that year he rejoined his parents when they moved to London. This was his first real move away from his grandparents and from Ireland, and it was also at this time that his mother was incapacitated by two damaging strokes. However, suggestions that Jack Yeats suffered from an 'absent father' syndrome and paid a 'high psychic price' for betraying his mother's ideals (McGuinness pp.11 and 17) do not bear scrutiny (Purser p.5 *et seq*), and J.B.Y., Pyle and Murphy all give a picture of a happy child and self-possessed young man, full of humour, who went his own way without any signs of psychological distress. His art school studies completed, he set about earning his living as an illustrator and, at the age of twenty-two, made a very happy marriage to an

English girl – a fellow art student. Her name was Mary
Cottenham White – known as 'Cottie' – and she seems to have
been as utterly devoted to Jack as he was to her.

The years in Devon following Yeats's marriage are amply dealt
with by Pyle. This was the period of his closest friendship with
Masefield, but though it was a cosy world with thatched cottage,
kitchen garden, model boats on the river and miniature plays for
local children, all commentators stress his growing Irish
nationalism. There is a clear political significance in *A Broadsheet*
and *A Broadside* – series which he published around this time, in
which an attempt is made to lead his own Anglo-Irish class to an
understanding of the need for an independent Ireland that takes
heed of the poor. No doubt his friendship with Synge, and their
work together for *The Manchester Guardian* in the poverty-stricken
far west of Ireland had its influence; and it is quite likely that
Synge's untimely death in 1909 prompted Jack Yeats to make the
move to Ireland in 1910 that he had long desired. He and Cottie
settled several miles south of Dublin in the small coastal town of
Greystones but moved into the capital the year after the Easter
Rising.

It has been assumed that the Easter 1916 Rising was the cause
of a nervous collapse in Jack Yeats (Pyle p.119, Murphy p.455,
McGuinness p.54). Yeats was indeed ill at this time, but too much
has been read into it and it is important to correct this impression.
In fact his illness had started as early as November 1915[10] and in
June 1916 he wrote to Starkey that he was 'much better and
getting better all the time now'.[11] There is no question but that he
would have wanted the Rising to succeed (and in many ways it
did succeed) and that later he was against the pro-Treaty forces
and adhered unswervingly to a left-wing republican ideal (see
below), but there is nothing to indicate that the Rising caused his
illness when the evidence of his correspondence is that he was ill
before it and getting better after it. J.B.Y. and others have
assumed he was depressed, and Pyle draws attention to a change
of character in his sketch-books: but she balances this by her view
that his style scarcely altered (Pyle p.120). If it was depression,
one could speculate reasonably on other grounds. For instance,
at about this time any prospect of Cottie becoming pregnant
would be near its end (cf Murphy p. 383). Loneliness could have
been a cause; and we know that he felt isolated in Greystones
(Pyle p.120). Also, the 1914-18 War depressed sales of paintings
and may have left Yeats more dependent on Cottie's personal

income. At the age of forty-four Yeats might have suffered a
'mid-life crisis'. Or he might simply have been the victim of a
durable virus. In all of this there is nothing to justify McGuinness'
view of Easter 1916 as the source of an ongoing disillusion with
the future of his republican ideals. In fact in 1917 and 1918 he is
criticising the fantasy Ireland of the emigrés and appears to be
very happy where he is:

the London of the exiled Gaels, who move in a strange Ireland of their
own imagination. The queer thing about this imaginary Ireland is that it
is so like the country. It is the anatomical figure in which one or two of the
muscles and several of the larger bones are missing.[12]

But I have come to think, in my patriotic pride, that my country has all
sorts of places, except perhaps the place of palms and humming birds.[13]

It is my view that Jack Yeats not only never gave up his ideal,
but never lost faith with the capacity of the Irish to achieve it.
Disillusioned with some politicians he certainly was, but with the
Irish people he held faith, well aware that it would not be smooth
running:

. . . Ireland consists of all sorts of people. In fact it is a nation ready to
start at any time – though I know that if we had Home Rule tomorrow,
for many years there would be many queer things done, as there would
be among any people who had no hand in governing themselves since
modern ways of governing became necessary.[14]

Perhaps the dramatised view of Yeats's reaction to the events
of this period given by these three leading commentators is fed
by a mis-reading of his most famous 'political' painting –
'Bachelor's Walk: In Memory' (Plate 1). This is how Yeats
himself spoke of the painting:–

It reflects an incident I witnessed just before the Easter week outbreak.
Some of our fellows had been shot along the quay here. A commom
flower woman, passing with a basket of carnations, dropped one or two
of them as a memory-offering on the spot where one fell. They were her
stock-in-trade, and I thought it a noble action.[15]

Pyle declares this flower to be a rose, and uses this as the basis of
an assertion of the rose as an Irish nationalist symbol.[16] But if the
rose can possibly be appropriated by any nation, then it has been
appropriated by England, and in any case the artist's and the
painting's own statements are quite clear that the flowers are
carnations. Murphy says 'His sense of horror at the barbarity of
the Bachelor's Walk massacre was communicated starkly in his

painting entitled simply, 'Bachelor's Walk: In Memory' '
(Murphy p.455). The incident was indeed horrifying, but the
painting shows none of that: it concerns itself, as Yeats says, with
a noble gesture. Sunshine after rain, and a boy with a visionary
look on his face (neither of which suggest horror) form the bulk of
the remaining subject matter. What is clear from the painting (the
woman carries a basket of carnations), and from Yeats's comment
on it, is the economic significance of the gesture.

Yeats was a nationalist but also a left-winger, and in one of his
plays – Harlequin's Positions – he asserts Ireland's ability to reject
economic and military pressures from wealthier nations, the
rejection being achieved largely through the agency of her
humblest citizens, of whom the 'common flower woman' is a
noble example.

He was a great believer in Ireland and its destiny and its peasant class: a
somewhat unusual point of view for a man of his breeding and
generation; for the Yeats[es] were Irish Protestant landlords.[17]

The picture of a disillusioned Yeats, realising his ideal through
fantasy: 'By turning inward, by seeking forms to express his
vision, he transcended the failure of the Ireland he had hoped to
create', (McGuinness p.36) may have some truth in it, but it
would be wrong to assert it as the whole substance of his
reactions. The trilogy Apparitions gives a kind of history of the
native Irish ability to achieve independence, though clearly
pointing to the injustice of Partition in terms of an inheritance and
a will. We have a combination of documentary and internal
evidence to show that Harlequin's Positions is a direct riposte to
Shaw's John Bull's Other Island (which insists on Irish dependence
on British finance), and Yeats had the example immediately
before him of the Irish people's ability to win an economic war
with the British in the hungry thirties, as well as win back the
Treaty Ports. In The Amaranthers there is a divisive will, but in the
second half an Irish street-trader adapts to his inheritance and
finally successfully confronts capitalism. La La Noo takes up from
Harlequin's Positions, asserting the significance of Ireland's
neutrality in the Second World War; and In Sand with The Green
Wave offers a vision of the old values of Ireland spreading across
the world in a message of economic and political healing. They
were written during the Second World War.

These interpretations are dealt with in detail in subsequent
chapters, but the background of Irish achievements should not be

overlooked. Ireland succeeded in breaking away from the Commonwealth and joining the League of Nations; she won back her ports from British naval occupation; she negotiated the final pay-off of British landowners; she got rid of the Oath of Allegiance: she asserted her economic independence in a trade war with Britain and a budget and constitution aimed at self-sufficiency; and she sustained her neutrality against many odds and Shaw's predictions. Against these achievements may be set the various points raised by McGuinness. These include economic stagnation in the thirties, though this was a world problem as well as an Irish one; continuing partition of Ireland tied to the alienation (some would say the betrayal) of the IRA by De Valera; the censorship act; and the abandonment of a peasant ideal in favour of industrialisation – a thing which the Republic of Ireland had scarcely experienced but which was essentially announced by the commissioning of the Shannon hydro-electric scheme, referred to in *Harlequin's Positions*. We do not have to make an equation out of these facts and then place Yeats on one side of it. The Irish nation was and is developing, so if there ever was an equation, it could not remain a static fact of life for Yeats: and he was too complex and subtle a man to be systematised. One can cheerfully assert that he was a left-winger on the basis of Lady Gregory's reports in the early twenties[18] and his collection of anti-Fascist news-sheets and articles in the thirties[19], but his comments to Hone in 1925[20] (written by him rather than reported of him) are less than orthodox:

. . . I do not know quite what you, in the meantime, think of as a democrat: anyway I am sure I am not it so do not waste your cruelty on me. I think I would rather like being a tyrant if I need not be a whole time tyrant. I would like to shut down my tyrant desk, lock up my tyrant office, write 'away away oh' on the slate and not come back till I felt like it.
 But if to intend to have what you want is to be a democrat then there go I. I am yours very sincerely

 Jack B. Yeats

This far from left-wing sentiment is underlined by something approaching his brother's elitism in a letter to MacGreevy in 1932:

Good people, with hearts to lift up other hearts, say that the book societies of America bring lighting [?] and advice to the empty and needy, who otherwise would not know what to read. Ah! stop it then. It would suit heroes like you and me to have the empty and needy

remaining so, and so, and so entertaining us with their openings of their mouths and putting their feet in them. Surely it is better that two crooked billets should be amused than that nine hundred and ninety nine million hay seeds should be so instructed as to arrest their feet at the moment of putting them in their old gobs.[21]

However, we do have some clear statements by Yeats of an underlying faith in Ireland subsequent to the establishment of the Free State. For instance, in 1925 he writes to Hone:

Ireland will be all right a generation from now. Opinions are wayworn now . . . a generation from now . . . Ireland will pull out clear of everything to give herself scope and she will walk by all the rest as if they were going backwards.[22]

and follows this in 1926 with:

Ireland will never be a cabbage patch for England or a perpetual ceilidh as you suggest. The climate is unsuitable for cabbages and the ceilidh lovers dug themselves in and then the crust caved in on them and other lovers will soon be dancing on their graves.[23]

At the heart of his hopes for the country was the influence of its natural inheritance – its landscape and its people untainted by capitalism:

The jaded civilisation and the slave civilisation delight in the pull toward science and away from nature . . . no man can have two countries; and this applies with greater force to the artist than anyone else, for the true painter must be part of the life he paints . . . And there is a country more ready than any other to lift painting into its rightful place, and that is Ireland, this land of ours. Because here we have not too many false traditions about painting to get rid of, and so we have an open mind, and the foolish civilisation of the cities and the love of money for the sake of money has not yet stolen us away.[24]

He never lost that vision: even when his painting was unfashionable and Dublin seemed too blasé for words, he believed his work would be appreciated eventually, in a way that his father's was not (and could not have been) because he trusted the land itself to produce the right kind of people:

As it is here if the day was to be ever approximately suitable and my figure fit to be seen and I was to remove all my garments and walk through the street I wouldn't raise a flutter. Citizens would just point towards me and say 'a most unassuming fellow'. And in the great world they pretend to get a thrilling out of a painting of coloured Euclid floodlit, more shaking than they get out of a daisy plucked from the bog in the

ungloved hand of a pure Irish boy. My father got a parboiled deal. But his
son lives on and I hearten myself with my old song
> Jacko Macacko
> The son of old Whacko
> Jacko Macacko
> Has come home to roost.[25]

This line of thinking continues into the Second World War with
specific relation to the Kindersley case. This was a notorious
custody squabble in which Lady Oranmore and Browne
appealed unsuccessfully against her son being sent to Eton at the
request of the father (the Hon Philip Kindersley) who was a
prisoner-of-war at the time. All sorts of unworthy sentiments
with respect to Ireland's neutrality, the likelihood of bombs
dropping on Co. Wicklow versus the playing fields of Eton, and
the father's enforced absence were given rein. Jack Yeats's
reaction is important for it gives us a clue to his attitude to the
whole issue of neutrality which, as far as this boy was concerned,
he clearly saw as no bad thing:

. . . Mr. Barton is doing a good work in making it clear that they must be
caught young. He will succeed and in a few years time counsel will be
made to say 'Surely, today, in no civilised country, is it possible, for an
instant, to contemplate, the plucking, of a boy, from the clear four
dimentional air of a Dublin mountain, where his schoolfellow is the great
grand nephew of a Nat Hone: and placing him in the murky two
dimentional fog of a Thames Valley, where he is in the shocking danger
of having to breath the same air as the grandson of a Philip Alexis
Laszlo'.[26] [Yeats's spelling and punctuation]

Though he had none, children were dear to him and, according
to my father who met him often at Sarah Purser's 'days of wrath'
(as her 'at homes' were known in our family), Jack and children
were always at ease with one another. But he was naturally
shocked when Erskine Childers' son announced that 'The
Republic goes on' just after his father's death. Yeats had gone
round to commiserate with Mrs Childers and, as Pyle says, he
was disturbed by 'the child's use of the slogan at such a time'
(Pyle p.119). This has been used to justify the conclusion that
Yeats was disillusioned with 'popular nationalism' (McGuinness
pp.54 and 165) but it is not sufficient on its own and no other
evidence is offered to support it. The only definitive evidence
we have with respect to this issue comes from Lady Gregory in
1923[18] and makes no mention of disillusion, though she reports
him as saying that he would not fight for a Republic 'and thinks

the Government have done and worked well, but that the initial fault was accepting the Treaty'. Many years later Niall Montgomery told Hilary Pyle that Jack 'was a Republican of a strange kind, because while he started off by hating Cosgrave, he ended up disliking Dev even more – 'that fellow from 42nd street'.'[27] But this was not such a strange kind of Republican, considering that Dev split the IRA when he came to power, nor is it clear when and for how long Jack became disenchanted with De Valera, whose political career at the head of the state was one of the longest this century for any nation, extending well beyond the end of Jack Yeats's writing career.

Yeats's personal papers, however, reveal a continuing interest in political ballads and other writings, particularly in 1936, 1937 and 1938 from which years he kept copies of *The Worker* – an anti-Franco left-wing news-sheet – and cuttings from *Saoirse Eireann* and *The Irish Democrat*. These are not the sort of writings a man would collect and save if he were out of sympathy with them and Yeats appears to have kept no cuttings representing the other side of the various issues. But the criticisms are concerned with continuing Partition, Lombard Murphy's and Pat Belton's exploitation of transport and other workers, and Murphy's Fascist blue-shirts who supported Franco. The only direct criticism of De Valera in these papers concerns itself with Partition, and there is a balancing item from 1944 advocating a vote for Dev on the basis of his record on the Annuities dispute and the Treaty Ports. Dev's record on these issues and the popularity of his policy of neutrality (against constant pressure from Britain and the U.S.A.) won him the election.

When Cyril Clemens asked Yeats in 1938 what was his favourite country outside his own, he replied 'The country which shows most respect to my own.'[28] This is not the reply of a disillusioned man living in a world of fantasy. Such a man would not expect respect for his own country for he would have little enough of it himself.

The picture that emerges from all the above evidence is of a well-educated, well-balanced and intelligent man who, if he was depressed to the point of illness in 1915, was getting over it in 1916. There is no evidence of any extended or serious illness for the rest of his active life. It is the picture of a left-wing nationalist aware of growing Fascism in the thirties and unwilling to yield anything on the issue of Partition. When asked by the publisher of *Sligo* 'what colour would you like for the cover?' 'Any colour

but orange' was the sharp reply.[29] Orange was the colour of
Unionism. There is no indication that he disapproved of Ireland's
neutrality in the Second World War, though it is likely that De
Valera's imprisonment of Republicans and failure to initiate
anything resembling left-wing policies in the late thirties angered
him.

As for Yeats's private life, he kept it private. His writings are
full of reminiscence, but neither his wife nor his family ever
appear in them, and Jack Yeats himself is never active in them –
he merely observes. However, it is possible that Hartigan in *The*
Silencer has some affectionate associations with his father, and
James in *The Amaranthers* may be seen as setting to rights some of
the losses of Uncle Fred Pollexfen. There may also be an oblique
reference to him in the character of Ted in *Rattle*. In order to
provide a background for these suggestions it is necessary to look
a little at Uncle Fred's position in the family.

Fred Pollexfen was excluded from his father's will, and Fred's
brother George left half his share in trust for Frederick's children
while greatly angering old J.B. Yeats by leaving him nothing. The
reasons for this treatment of Fred Pollexfen are given by
Murphy[30] and are based on evidence supplied almost entirely by
the Yeats family who were closely involved. Basically the
accusations are that Fred gambled, was extravagant, and lost
money on the Stock Exchange; and that he was spoilt and unpleas-
ant. Jack Yeats allowed himself to act as defendant in a put-up
court case in order to forestall Fred Pollexfen,[31] and two of Fred's
daughters lived in J.B. Yeats's household for some years.

The Fred Pollexfen side of this story has never been told, nor is
it ever likely to be, but there was more to the situation than has
met the eye (see Purser pp.12-13) and the fact that Jack Yeats was
prepared to be defendant in the friendly suit may even indicate
that he was one person in the Yeats family who could see the
other side of things, while being essentially loyal to his own
family.

Jack certainly shared with his Uncle Fred an interest in the
origins of the Pollexfens, as he acknowledges in this letter to W.B.
written in 1938:

As in a dream – I remembered that Uncle Fred Pollexfen said that the
original Pollexfens were flying tin men from Phoenicia.
He was satisfied. I don't know how. But I, at once, began a search up in
the bight of the Mediterranean for any name that would suggest
Pollexfen, and in a moment I had it – Helen must be our grand, grand,

grand, grand aunt for we must be descended from her brother Pollux so that giving us Leda and the Swan for grand, grand, grand, grand parents that ought to be good enough for any man. (See Pyle pp.3-4)

We do know that Jack Yeats did not side with his father over the matter of Uncle George's will, which he thought was perfectly fair, and asked Hone not to include references to it in his collection of old J.B.Y's letters.[32] There are several prominent wills in Jack Yeats's writings, in *Rattle*, *The Amaranthers* and *In Sand*; and the question of inheritance is fundamental to *Harlequin's Positions*. The significance of these in relation to Fred Pollexfen will be pursued in the chapters on the trilogy and *The Amaranthers*. The Castor and Pollux reference will be touched on in the chapter on *The Charmed Life*.

But for the most part Jack Yeats was free from any kind of family worry. His father had emigrated to and died in the States. Jack and his brother kept their distance, and Jack had severed his professional connections with the Cuala Press where his sisters were employed; and, of course, he and Cottie had no children – the one family worry they might have wished upon themselves. Apart from trips to London he travelled little outside Ireland after he settled there. His life was always his own, his studio sacrosanct, his work never shown until completed, not even to his wife.

In 1947 Cottie Yeats died. So close was their relationship that during her last illness, though they had been given no cause for immediate alarm, Jack Yeats quietly told the doctor that he and Cottie had been saying good-bye to each other.[33] She died the next day. Yeats had written his last by 1944; but he continued to produce some of his greatest paintings until his own death in 1957 at the age of eighty-five. He died revered as a painter, loved as a man, and tolerated as a writer.

Yeats was only tolerated as a writer because that side of his work was not taken very seriously. The consequence has been misunderstanding and condescension.

No novel was ever more individual than this. Mr. Yeats's angle of vision is his own; even his style, which is excellent if a little hypnotic, reminds one of nobody else's. Felicitous phrases like a 'freckle of small islands' are of common occurrence and the author's sly, ironical humour never fails him: 'The papers smell of paraffin, which made James think that civilisation was not far away.' An imagination, however, can be too arbitrary, a sense of humour too personal, and the events in this story, when they do not surprise us by their unexpectedness, irritate us with

their lack of logic. Considering how much talent has gone into its composition, *The Amaranthers* is not at all an easy book to read.[34]

That review by L.P.Hartley in my experience speaks for many. But it is a tragedy that this should be so. The imagination in these works is not arbitrary, the events do not lack logic. There is no obfuscation, no pretension and, in the majority of his writings, no waywardness; but in order to explain the misunderstanding, this book is largely given over to matters of interpretation. To some extent this has been necessitated by the deceptive nature of Yeats's style. It seems casual and conversational in tone and it often has that indefinable sense of humour to it that was present in his speaking voice. There is no doubt that his syntax and punctuation are very free, though only occasionally slack, and some readers lose their way in it.

Much of the apparent carelessness in Jack Yeats results from mis-prints and an absence of editorial discipline. *The Amaranthers* suffers badly from both. But this is partly due to the Yeats family habit of regarding full stops and commas as interchangeable commodities. W.B.Yeats might have been speaking for his brother as well as himself in this letter to Robert Bridges:

I do not understand stops. I write my work so completely for the ear that I feel helpless when I have to measure pauses by stops and commas.[35]

Jack Yeats also wrote for the ear, and his punctuative indulgence extends to mixing up capitals and lower case for initial letters. Here is an example of the resultant confusion which should have been edited out:

They had a good two-man song that if they once got into the middle by the pole and raised it. They'd stop any circus act. (CL pp.39-40)

Obviously the full stop should be a comma and there should be no capital for 'They'd'. For some readers there may be an added problem if they are more used to hearing of poles being raised than songs. Much more confusing is when a typographical error sneaks into a sentence that already, and quite deliberately, has no main verb:

As soon as the band's feet trod the white sand they turned . . and belted, one final tiger onto the laughing air. Then, marching easy, along the strand edge, where it mingled with a velveting of short pale-green grass, starred with small flowers. On top of the low bank on the north of

the track. Then inside the bank again while it trailed along the bluffs from ten feet, to fifty at the highest. (Am p.3)

The full stop after 'flowers' is a mistake. But the resulting sentence from 'Then marching easy . . . the north of the track', and the sentence which follows, are both intended to trail just as the band does: a main verb would spoil the effect.

This style of writing has plenty of precedents and is less tortuous than the Proustian system which only drops full stops onto the sward by mistake, whereas Jack Yeats drops them with the erratic generosity of sheep dung. As for the omission of main verbs, compared with William Faulkner, Yeats is a model of clarity. But it is a difficult style at first, particularly for those who do not read with the flow of conversation in their minds and who have no experience of Irish speech mannerisms. The oral tradition was still strong in Ireland in Yeats's day, and we know he spent much of his life watching and listening to raconteurs at fairs, by the docks, or selling oysters. To those who find this hard, I can only assert that familiarity soon brings with it a sense of the flow of the style, and also the reward of many beautifully phrased passages and striking images. Jack Yeats watches and listens to words with the same affectionate detachment as he does people:

It would be amusing to be using words for the last time. Careless or careful, letting them float away like paper money of an inflated coinage. While any man makes a picture in his mild memory to match with a word, 'Coinage' makes him see round metal discs, and inflating them gives him the laugh. (AW pp.3-4)

The forced alliteration here is a deliberate inflation of the coinage.

The parallel between words and coinage is an old and fascinating one. The railway Speculator in *The Amaranthers* with his three thousand 'silver pancakes' (a cant phrase for coinage as frequently tossed as pancakes themselves) is defeated by the rhetoric of a hired pen:

In this matter of the railway he was the true mercenary and having won by the banging of his sentences, he gave reasons:
'The wildness of the Island-men hid a dangerous, secret, and irresponsible malignity.'
'The quicksands – deep enough to swallow the railways system of the world and the Bourses who tied themselves to the railways.'
'The strange power of the Island-men of transferring evanescence.'
In lands where tombs were a passionate delight few men were so

hardy as to face the chance of leaving nothing. The hired pen won for the pelican, the turtle and the Islanders. (Am p.28)

The pelican and the turtle are used symbolically for charity and love. It is the power of the word that keeps them there, roosting on the speculator's abandoned arch. The rhetoric is effective and subtle: the assonance in 'The wildness of the Island-men' makes the association of the two: the string of adjectives culminating in the verbal noun 'malignity' has a grammatical and emotional logic that an ordinary noun would have broken. It is also underpinned by subtle assonance: 'hid . . . irresponsible . . . malignity.' Yeats uses these skills for many purposes, as when the rhetorical word order gives a swing to the sound pattern that aids comprehension in an otherwise complex sentence:

I would to God this minute I could, and so I could if all your wills will help me, take away from half the words I remember their bitter ungenerous meanings and give them their sweet memories only. (ATYA p.174)

The first part of the sentence is given shape by the balanced assonance of 'would' and 'could' and connected to the parenthesis by repeating 'could', and by the alliteration on 'w'. The second half of the sentence flows freely without any parenthetic phrase, because the mood changes from considering the effort of change to the reality, the delayed and emphatic 'only' also being effective.

Yeats frequently complained about the decay of language. It is a common dilemma for writers, reacting to a wayworn rhetoric. They care about the devaluation because they still respect the coinage. Wordsworth and Coleridge did not empty their own or anyone else's pockets: nor for that matter did Joyce and Beckett: they just gave the coins a good shake and let the air dry the sweat and the wind blow the fluff off them. We may be thankful that when Jack Yeats wrote

Silence is golden and speech is silvern and the rest is papern I suppose. (Sl p.43)

that he had paper to note down an epithet which so wittily denies its own meaning. He also wrote:

Give us the fight: we don't want it all too much one way: some of us may want prose to beat poetry. But that is only if the Poetry is conceited. Give us a bright, generous eye, a clean-skinned body, and spirit to enjoy the battle, and we will do as much as we are allowed by the management to

cheer that beauty to victory over low browed thick-necked prose with a
smirk.

The smirk is all the trouble, even if you can deliver the goods after the
smirk you are not liked. Show respect. When Moses smote the rock he
smirked. Beware. (Sl pp.22-23)

The public is indeed hard to please. Here is the same theme as
that which, we shall see, underlies the plays: the fight 'of the tent
people against the rest'. And so you must move on, changing the
pitch, shifting the stance to keep the children of Israel from
wearying of you in the desert.

Conversational tone notwithstanding, Yeats is a master of
economy. Take this conclusion to the story of the Man who went
to Spain when he discovers that the beautiful girl teaching him
Spanish is mad:

But I wasn't able to cry. My mouth was bitterness of sadness. (CL p.99)

The transition from the flesh to the emotion, mouth to sadness, is
simply and effectively made by 'bitterness' which is both a taste
sensation and an emotional state. The use of nouns instead of
adjectives gives the three nouns much the same status and
produces a metaphor that becomes a reality. He can be similarly
effective in economical description, using alliteration, and
'mouths' and 'wriggly' to give a hint of personification:

Some small rivers meander to the sea. It is low tide, so we have their
multitude of mouths, wriggly about the strands. (CL p.108)

A tired phrase is given new life by a simple change –
'ne'er-do-betters' (AW p.48), and he can provoke speculation and
comment with the sharpness of the true satirist:

I remember a small town where no one ever spoke the truth but all
thought it. (AW p.12)

he goes on:

It was a seaport town, like all the best towns. But there was a lake very
near it. The cold brown bosom of the fresh water, and the blue steel
verdigris green corsage of the salt water, and between the two the town.
(AW p.12)

That last sentence is full of subtleties, and humour. The town has
been tucked between a cold bosom and an unfeeling bodice,
squeezed into a neat iambic rhythm and alliteration – 'between
the two the town.' The lake has a compact alliteration, whereas
the sea spreads its assonance for its greater area; but they share a

spondaic rhythm that emphasises by contrast the ordered little town which, by-the-by, is E-shaped so it has three feet, like the iambic rhythm that matches it.

Yeats's metaphors can bear a lot of pursuit:

His thoughts lie about a dry dock, repairing, while his speech is afloat. (CL p.190)

and his use of simile can be as visually explicit as befits a painter, as when describing a maid entering a room in a hotel where a woman is being bathed:

the little maid slips into the bedroom, sidling round the side of the door, as if she was a bookmarker, inserting herself in a book. (CL pp.158-9)

A door is indeed firm and hinged like a book-cover, and the bookmarker is put into service to find a place in a book, just as a maid is in service to the rooms in the hotel: but the idea that inside the room there is a story is also implicit in the image, and in the novel, inside the room, a woman is dying.

Yeats can also be absolutely direct:

People are full of love for one another, if only they can get a couple of winners each. (CL p.5)

and he can be kindly critical too, making a splendid verb out of a noun:

I tried to willow myself to suggest I didn't think it as bad as all that. (ATYA p.126)

He can capture a character very quickly by simply observing a gesture – in this instance of a secretary whose boss has just been shot – a combination of self-awareness and ungoverned instinct after shock. She rings her photographer boyfriend to give him the scoop:

Early that evening a page tiptoed into Miss McNeill's office and gave her a large envelope . . . She knew what she was going to see when she unfolded the paper. So she opened her dress and put her hand over her heart. She wanted to feel if it was beating, which was absurd of her, for the blood was tingling in her head, a fife and drum band. (Am p.63)

A similarly vivid gesture is given to James's guide 'Oh-Oh', whose language James does not understand. It is their moment of parting and at one point Oh-Oh had imagined murdering James,

but relented, so this occasion is full of significance for him and he
has to show it:

Then, after pointing down the track as the way that James should take,
he dragged James' body to his, forced his neck over on his right shoulder
and gave the horny left side of James' neck a gentle little bite with his
small front teeth. Then without a sound from his lips, he sprang into the
undergrowth and let it close to behind him. A trap sprung, a trap reset!
(Am p.207)

The detail – 'horny', 'small front teeth' – makes vivid the
extraordinary gesture. And Yeats can also evoke deeper feelings
with economy. This little extract from *Sailing Sailing Swiftly* is
about the only time he gives any idea of Annette's sense of loss
after being widowed only a few weeks after her marriage, but it is
sufficient:

– suddenly she remembered it was Thady who had made all this for her.
She was alone in the carriage, as she was on all that journey, and she
thumped with her white fist the cushion beside her, and cried out loud,
'But he is here beside me,' and she stretched herself along the seat and
wept softly for one half-hour and then remembered and sat up and sang:

> Through my sighing all the weary day, and weeping all the night,
> And I sailing, sailing swiftly –
> 'to,' she sang, not 'from' the County of Mayo, and she cried very little
> more. (SSS pp.50-51)

It will be noticed in these quotations that Jack Yeats uses a very
wide variety of sentence structure, varying from a couple of
words to sentences several lines long; sometimes firmly focussed
on a verb, sometimes meandering and deliberately convoluted or
trailing. The same is true of his handling of paragraphs and even
whole pages. In *And To You Also* there are nearly four pages which
are nothing but a list of topics for an unwritten Chapter, but the
latter end of the novel is pure dialogue. A similar variety is to be
found in the plays. I have given examples in the relevant chapters.
What can be tiring, until one is used to the style, is the richness
of it. Yeats's language is full of images and objects, crowded with
significant detail. It is one of the most densely physical of
vocabularies at the same time as being full of ideas. Of abstraction
there is practically none, and one could claim that in this respect
his style is part of a philosophy. It savours the moment, insists on
circumstantial detail and weaves rich chains of association. One
can understand why some readers are initially overwhelmed by it
and have failed to see the woods for the trees, but I do not believe

that Yeats is at fault. A complex and rich work is not going to be fully appreciated at a first reading. In any case, there is no point asking of these novels and plays that they meet expectations which it is part of their value not to fulfil; and there is also little point in criticising a writer because he is not understood when, as shall emerge, his meaning pervades both the form and the incident of his major works. Before leading into that discussion, however, it is necessary to establish the chronology of his writings so that, in the case of the novels at least, the remarkable extent of his formal planning may be appreciated.

Note on the Chronology

Previous critical assessment of Jack Yeats as a writer has unquestioningly accepted the date of publication as the date of composition of his works. For the most part this has not led to any serious error, but in the case of *The Careless Flower* it has misled several commentators, including two of the most significant – James Mays and Nora McGuinness – into treating it as his last and culminating novel when it is indubitably one of his earliest. I shall argue that this error has obscured a progression in the novels which was probably a conscious one. Even Hilary Pyle, knowing that substantial sections of *The Careless Flower* had been published in 1940, calls it his 'final novel' (Pyle p.155) and treats it accordingly.

Likewise *In Sand* was known by Pyle and Rose to have been written during the war, but nothing has been made of this fact, and subsequent commentators have contented themselves with repeating the 1949 date of first production, which would make it his last literary work. Nora McGuinness bases part of her interpretation of the play on the assumption that it was written between 1947 and 1949 (McGuinness p.410); but this error is not crucial to what she has to say, though it accounts for what she has not said.

An explanation of the chronology is followed by a list of known and probable dates. I shall begin with the plays, omitting the Miniature Theatre plays which are adequately dated from Yeats's manuscripts by Skelton on each title page.

Plays

Jack Yeats's first play for the 'larger theatre' was *The Deathly Terrace*. We know this because he refers to it in a letter written in

1944 – a letter which also gives some background to the play and to *In Sand*.

> . . . I am very glad to know that the Hospital were not the vandals who destroyed the Shelter. If there comes a dawn, that gets a break, a shelter may be what all vandals will long for most of all. I have a new play 'In Sand' which I send you with notes for characters and scenes. I also send you my first play 'The Deathly Terrace' which I don't think you saw. Robert Loraine (the airman actor) had the play with him in New York in 1932 with the idea of getting some one there to produce it. By some chance perhaps Saroyan may have read it, and so got the idea of a character, who tells the adventures of his life which seem to have nothing to do with the moments of the play, for he had such a character, with grand talk in his play where the scene is laid in The San Francisco Saloon . . . P.S. Sheila of The Deathly Terrace should be of any type (with each type it's a different play) except Marie Lloyd in her mountainous declining years.[36]

Since the subject matter of *The Deathly Terrace* concerns the advent of the talkies it cannot be earlier than 1929; but it was probably conceived round about that time as the previously unnoticed Prologue was written on his 61 Marlborough Road notepaper and in 1929 the Yeatses moved to Fitzwilliam Square. Even allowing for the probability that he was using up the notepaper after the move, it seems likely that he would have managed to do this well before 1932, when Loraine had it.

The trilogy of *Apparitions*, *The Old Sea Road*, and *Rattle* must 2, 3, 4 have followed close on *The Deathly Terrace*'s heels, not only because of the publication date of 1933, but because he wrote to J.C. Miles in June 1933 as follows:–

Here are some plays of mine. You will be saying 'this is a very talkative fella'. But it is only by a turn of the wheel that the plays come out so soon after Sailing Sailing Swiftly.[37]

Since *Sailing Sailing Swiftly* was reviewed in *The Observer* on 7 May 1933, and since the letter implies that the plays were written at some distance in time from the novel and probably after it, we may assume for them a date of composition of round about 1932. Although these three plays were definitely written as a trilogy and 'should be tied together with music'[38] Yeats nonetheless offered *The Old Sea Road* and *The Deathly Terrace* as a double bill to Ria Mooney in 1949, describing *The Old Sea Road* as 'tragic' and *The Deathly Terrace* as 'extravagant and fanciful'. He sent her *The* 5 *Silencer* at the same time and added:

All have elaborate scenery and mechanical devices, which would be expensive, and which, when I wrote these plays I thought important. Now I know, with the fine players and producers available, they are mostly fussy and of no importance.[39]

According to Robin Skelton *The Silencer* was Jack Yeats's 'next play' (Skelton p.6) and he refers to the 'later prose works, *Sligo*(1930) in particular' implying a very early date of composition: but he gives no supporting evidence for this and there does not appear to be any among his papers. In certain respects it has similarities to *The Deathly Terrace*, as Skelton himself points out (Skelton 2 p.111) but, in the absence of any external or internal evidence to date it positively, it will have to remain an enigma. Arguments on the basis of its style are unlikely to prove anything. Skelton seems to think highly of it (Skelton p.7), whereas McGuinness is less impressed (McGuinness p.391). Dramatically speaking its most obvious dangers lie in the length of the speeches, but this applies just as clearly to his last play *In Sand* as it does to his first, *The Deathly Terrace*. The earliest reference to *The Silencer* is in a note stating that it was sent to Miss Vosper on 6 October 1948, along with *The Deathly Terrace*.

Harlequin's Positions was first produced in 1939 but is referred to in a letter to the Abbey of 19 September 1938 as 'a play of war's alarums'.[40] Since war's alarums were being sounded as early as 1936 in *The Worker* (see above), the date of composition could be any time between 1936 and 1938. *Harlequin's Positions* was probably followed by *La La Noo*. Produced at the Abbey in May 1942, *La La Noo* contains clear references to the war then current, so we can narrow the date of composition to 1940 or 41.

In Sand was first produced at the Peacock in 1949; however, a note in Yeats's own hand states that it was 'written August 1943'[41] and the letter to Mrs Le Brocquy of July 1944 (quoted above) refers to it as 'a new play'. The Prologue to *In Sand* – *The Green Wave* – must have been written before 1948, when he refers to it in a letter to Ria Mooney, saying 'It seems to me now to have more to do with the play than I thought.'[42] The word 'now' suggests that the Prologue had been in existence for some time and, while it does not prove that it was written at the same time as *In Sand*, it certainly suggests it. An author is unlikely to write a prologue to an already existing play without having a fairly clear notion of its relevance. But a prologue to a play not as yet fully

formed in the author's mind might well rely on a more intuitive relationship. Rose gives the date as 1942 (Rose p.26) but gives no source for this suggestion.

Before considering the chronology of the novels, it is worth mentioning that when Jack Yeats states that *In Sand* was 'written August 1943' he probably means just that. The state of all his manuscripts suggests fluent composition with little revision. If there were earlier drafts they have not survived. What has survived is remarkably close to the printed versions, punctuation excepted, and his style is nothing if not fluent. Writing to Mrs Le Brocquy, he shows that he is prepared to make changes where necessary but clearly states that he finds revision difficult:

I am very glad indeed that you like 'In Sand'. I agree with everything you say about 'curtains' and perhaps the difficulty could be got over with blackouts and a voice giving the passage of time: and I agree the last two scenes are too short apart. A thoughtful producer will find me give very little trouble over arrangements of scenes or cuts. But I find the greatest difficulty in adding new lines to dialogue, which is all written in one steady mood. I send another copy of the play . . . with alterations and some additions . . . I have got over the difficulty over the change into evening dress.[43]

In Sand was heavily cut for the BBC in 1956 and Yeats wrote down the number of words in some of his plays with the proviso 'uncut'. However, some details were important:

there was some uncertainty about the special recording of 'I know my love by his way of walking'. Time was short and I wanted to be certain of it: for I believed the playing of this tune to be essential.[44]

One might be tempted to conclude that his writings were 'dashed off' – but they contain such a high degree of integrated and planned thought that such a conclusion cannot be considered seriously. Nora McGuinness in particular has shown that his writings were very carefully thought out, and this work endorses and extends that view – a view little regarded hitherto. What seems likely is that Yeats had developed his memory to such a degree that he could do the groundwork without the aid of paper. Much the same applies to his painting. His wife, Cottie, was the only person who ever saw him painting (and that only when he painted her portrait), and she described him as working with great intensity and rapidity.[45] In his early years he filled

many sketch books; but for the best part of his painting career he relied on his memory alone.

Novels

) *Sligo* was the first of Yeats's novels, for it was referred to by him as 'the book where I first began to jettison my memories' (ATYA p.93). It was published in 1930 and the reviews date from June of that year, but the date of composition is not known.

2. *Sailing Sailing Swiftly* has been referred to above and, given the time it takes to prepare a book for publication, can hardly have been written later than the autumn of 1932.

3. *The Careless Flower* almost certainly comes next, as the manuscript has '2 copies, binding at side 10/10/33' clearly written on the title page. The hand could be Yeats's own, in a fit of legibility and with a different pen, or could be the typist's. In either event the date is unequivocal and clearly part of the instruction. It is extremely unlikely that it is an error for 10/10/43 as substantial parts of the novel were published in *The Bell* and *The New Alliance* and *The Dublin Magazine*, in 1940. In a letter to James Starkey of 24 May 1940, Yeats offered him 'an extract from an as yet unpublished book The Careless Flower'[46] with the clear implication that it was already complete. MacGreevy, in the 1947 BBC interview (Purser p.177)) says 'it is not, I believe, the latest of his books'; and by way of reinforcement there is a reference in a letter to Sarah Purser in 1942[47] to a remembered incident which crops up in the novel (CF p.125). This date of 1933 makes much more sense than the assumed date of 1947 because what it means

4. is that after his next novel, *The Amaranthers*, (which forms a natural progression from *The Careless Flower*) he wrote no more third-person narratives. I believe this to be deliberate. It also means that *And To You Also* is his last novel, and this too makes much better sense.

The Amaranthers was published in 1936 and being reviewed in early April, so it cannot have been written later than 1935. If the successful quest in *The Amaranthers* is the natural successor to the quest thwarted at the last minute in *The Careless Flower*, then we have it pinned down to between late 1933 and late 1935.

5. *The Charmed Life* (published in 1938 and being reviewed as early as 6 February) has a probable reference to the build up to the Spanish Civil War (1936) on page 93 with the phrase 'what may have happened in Spain of the last few years'. This makes 1937

the likely year of composition. On the other hand, there appear to be no internal clues for the dating of *Ah Well*. Parts of it first appeared in *The Bell* in January and February of 1941 and it was published and reviewed in the autumn of 1942. The extracts in *The Bell* are virtually identical with the final publication, so we may assume that the book was complete, or near completion by the end of 1940. Because he declared *Sligo* to be his first book we know that *Ah Well* cannot precede it, but since we have no earliest date of composition for *Sligo* that does not help much. The setting of an E-shaped town may relate to the E-shaped town in *The Charmed Life*, but which came first would be a nice matter for debate.

Given that sequence of publication is untrustworthy, perhaps the best argument for placing *Ah Well* after *The Charmed Life* is that in such a position it would form part of a natural and comprehensive progression in narrative and narrative technique, which is dealt with in Chapter 8.

That *And To You Also* (published in 1944 and being reviewed in late October) is the last of his novels is made virtually certain by the fact that some of the characters in it are drawn from previous novels – The Baron from *Sailing Sailing Swiftly*, Bowsie from *The Charmed Life* – and by references to events in *The Charmed Life* (ATYA pp.98 and 107). The book also starts with the reference to *Sligo* as his first book. That reference makes particular sense if he knew that he was writing his last. The manner of the conclusion tells us that he was indeed signing off with a valediction, if not a benediction for his readers:

> and so farewell, farewell, farewell, farewell,
> Farewell to you also.

TITLE (Novels in italics)	Written	Published
Sligo	before 1930	1930
The Deathly Terrace	between 1929 & 1931	1971
Sailing Sailing Swiftly	before 1932	1933
Apparitions		
The Old Sea Road	1932?	1933
Rattle		
The Careless Flower	1933	1947
The Silencer	after 1931	1971
The Amaranthers	between 1933 & 1935	1936
The Charmed Life	1937?	1938
Harlequin's Positions	between 1936 & 1938	1971
Ah Well	before 1941	1942
La La Noo	between 1940 & 1941	1942
The Green Wave	1943?	1964
In Sand	1943	1964
And To You Also	between 1937 & 1944	1944

Note

The 'Written' column is deliberately careful, but unqualified
dates are certainties.

2

The Theatrical Context

It is the fight I suppose of the tent people against the rest. (Sl.p.46)

Jack Yeats handled the theatre unlike anyone before or since, so it is not difficult to accuse his dramas of being untheatrical, simply because they appear to be without theatrical precedent or issue. Robin Skelton, from whose edition of the plays all references are taken, has written of them:

Belonging to no school of thought, not even being easily allied to the Irish writers' drama of its day . . (Skelton p.19)

and has gone as far as to say (and I agree with him):

The drama of Jack B. Yeats. . . is both inimitable and likely to become, once it is given the attention it deserves, seminal. (Skelton p.11)

But there is a context in which some of the stranger aspects of his dramatic style do have a precedent – a context wider and older than the strictly theatrical tradition, but one to which the theatre returns, every now and again, as though to remind itself why it is there. It is the long tradition of popular entertainment associated with travelling circuses, country fairs and sporting events, involving the whole world of commerce from gambling to selling shoelaces. It is the world where the trader and performer will gather no money if the crowd thinks it knows what is going to happen, or how it is done, or is allowed to remember that it does not need shoelaces or could get as good for less at the nearest shop. Does not the salesman have his 'pitch', his place of performance? And deceit, and even aggression are part of his trade. His pitch is also his manner of address, and the word 'pitch' in that context is as often as not associated with deceit. The whole business of buying and selling over the ages has been so deceitful that even the word 'sell', on becoming a noun, means a form of deceit.

For Jack Yeats the theatre existed cheek-by-jowl with the salesman's pitch (Plate 2) and something of the quality of that

25

relationship is conveyed by the following extraordinary direction on the dust-jacket of *Apparitions*:

But all the time, from the rising of the curtain, not before, so as to avoid queering the pitch of the queue-amusers, a fife and drum band marching up and down in the roadway, far enough away to reduce the fifes – for the fifes comment, the drums never.

I do not suppose that Yeats seriously expected this instruction to be carried out: but it is there to make us aware of the relationship between town and theatrical gown (which is in a sense the subject matter of the first play of the trilogy) – a relationship perhaps sensed more keenly by Jack Yeats because he was brought up in a world where the theatre companies toured; here tonight and gone tomorrow, just like the bookies. A town must be on the defensive against such:

The Bookmaker's chief saw it at once, he howled like a stricken factory chimney falling, and all the lesser bookmakers joined him. It was of course 'the double double' or the 'double cross.' That jockey was not intended to make the weight. The Ring was absolutely under water, but they had to raise their hands to pay. They went home bag empty in their grimy old motors with the covers drawn as close together as they could be drawn, and inside flattened faces gazing at concave faces. They had given a whole day to the preliminaries of the skinning of one small town, and the town had won. (Sl.p.116)

Likewise, the town wins in *Apparitions*. On such occasions the public of the town are often at least as quick-witted as the performer; so pretence, illusion and deception are his natural weapons against them. In the theatre these are part of the convention that we all accept, but only, as Johnson put it, 'credited with all the credit due to a drama'; and if that convention is broken by the actors we are not too sure how to react:

After stabbing with it several times, he threw it from him and pulled out a real dagger and introduced reality into the play. The audience were in two minds whether to hiss, or clap, so they booed . . . (Sl.p.55)

This passage is part of a mildly satirical account of the development of a society: but though the Roman gladiators are behind us, we all watch the television news and pay money to see many horrors which we know we cannot influence – and there is no doubt that some of these horrors are mounted specifically for the media. The proscenium arch is in our rooms, yet we would regard it as the utmost disgrace against public decency if a theatre

were to be used (as television has been) as the place for a violent blackmailer to make his demands and the victim's mother her appeals. Jack Yeats was very much aware of the equivocal nature of entertainment: as Alfred puts it in *Harlequin's Positions*:

War has its charm. It feeds something that all men and women long for – excitement. Indeed I have thought that if the range of guns could have been limited by the League of Nations . . . the tourist cruising companies could have continued to cater for their customers. ' Travel round the world and see the wars from a swivel chair.' (HP pp.286-7)

And so we do.

It is not a far cry from the fascinations of war to the games we play, sometimes for a living:

The charge is a penny for three throws. The barrel man defends himself with the sticks in his hand, and if hard pressed drops down into the barrel. (*Life in the West of Ireland*) (Plate 3)

Just after the Second World War Yeats painted 'Humanity's Alibi' (Plate 4). In the 1911 painting the barrel man seems to thrive on the sport; but the expression on the man's face in the later one is of helpless misery. He is so overwhelmed by the odds that he has succumbed to a living nightmare in which he either cannot make himself retreat into the barrel, or it has become of a sudden too small for him. Yeats once wrote of 'the mercy that is in the hearts of all the human race for the naked human' (ATYA p.112) but, although his shirt is torn open and he is bare to the hips, there is no sign of it here. The title could not be more bitterly accusatory. Our alibi – that we were playing a game at the fair, just the usual sport, no war – is so thin that it is no alibi at all. The theatre of war was showing the play we payed to see.

If one accepts the connection that Yeats is making between our pleasures and our vices it becomes easier to understand the strange manner in which he upsets the theatrical conventions, sometimes by presenting us with extremities of human behaviour, such as the murder of Hartigan and his ghost's peroration, or the deaths of Michael and Ambrose as part of a last joke which fails. In *The Deathly Terrace* derisive music was to be played as the audience were leaving the theatre, and the title play of *Apparitions* ends with a direct snub to the audience for taking pleasure in the suffering of others. This attitude relaxes in the later plays – as though his Harlequin's positions were reversed: not ending in Defiance and Determination, but in Admiration.

The spoof seances in *Apparitions* and *Harlequin's Positions* are replaced by an almost ritualistic complicity in *La La Noo* and *In Sand*, both between the actors themselves and between them and the audience.

It might be thought that an initial aggression towards one's audience was the consequence of the kind of insecurity that is born of ignorance. But Jack Yeats at sixty years of age must have been one of the most experienced observers of the theatre of his time: not only because of his intimate knowledge of all forms of popular entertainment, but also through his miniature theatre and his association with Synge, W.B., and the whole Abbey Theatre experience. Yeats was a regular theatre-goer, as evidenced by his considerable collection of playbills. Anne Yeats assured me that he would probably have attended all of them. He even catalogued them and, so frequent was his theatre-going, that, by the time he was sixty and writing his first plays for the larger theatre, it is reasonable to say of any play that he could possibly have seen that he probably did see it.

But Yeats's fascination with so many forms of confrontation between performer and public must have given him a broader perspective than most theatre-goers. In many of his plays one can trace the influence of the salesman, the boxing ring, the circus, the melodrama (and its cousin the cinema, which largely motivates *The Deathly Terrace*), and not forgetting that most ambitious of performances in which some of his nearest indulged – the seance.

Invigorating to most of the above was the Irish readiness to dramatise, which has been the basis of many plays from Lady Gregory's *Spreading the News* to Synge's *The Playboy of the Western World* or to the fantastical dramas of George Fitzmaurice. The manifesto of the Irish National Theatre hoped 'to find in Ireland an uncorrupted and imaginative audience trained to listen by its passion for oratory',[1] and Synge's Preface to *The Playboy* has this famous passage referring to the Irish:

in countries where the imagination of the people and the language they use, is rich and living, it is possible for a writer to be rich and copious in his words.[2]

Some critics have sought to play down the significance of that relationship; but while Synge's and Yeats's theatrical rhetoric is no more documentary than Shakespeare's, all three undoubtedly had roots, and the two Irishmen found their rhetorical roots in

their own country. One can tire of a thing, but it does not make it untrue. Flann O'Brien tired of the Old Irish love of nature which was the subject of his thesis, and he was a regular mocker of Irish literary rhetoric. Jack Yeats had this to say about him:

I daresay Myles na gCopaleen found little but ugliness, but I believe I could find in that country, with a chain of little lakes moving through it and a far line of pale blue hills leading down to the flaggy shore of Clare, plenty to call beautiful.[3]

Jack Yeats was brought up among such people as the Irish National Theatre sought, and I believe much of his work is, at heart, addressed to them. He noted their phrases and anecdotes in his sketch-books (see Caldwell pp.31 and 41), and made frequent use of their colourful expressions and their speculative way of talking. Characters such as Hartigan adopt rhetoric virtually as a way of life. There is an element of the salesman in this love of oratory; a hope that the ideas currently passing through the orator's mind will find a buyer. The salesman is not merely at the door of Yeats's theatre; he is inside in the persons of Nardock, Ambrose and Hartigan, each one of whom has his equivalent of the salesman's pitch:

NARDOCK . . . I have been a wandering, gambling orator, (DT p.106)

MICHAEL [To Ambrose] You flatter yourself, you've just come on the wrong pitch and now you're all hit up about it. What you want is a good sleep and a think it over. (OSR pp.154-5)

HARTIGAN . . . You are saying to yourself that I'm one of these dud inspirational philosophers given away with a penny paper and you think I am holding you against your will, and you have no will. You are listening to me because you have nothing to say yourself . . . (Si p.232)

Charlie Charles, the barber who has listened too long to his customers, reverses the situation: and Old Snowey uses dictaphone, properties, and wayworn rhetoric to persuade The Seekers that he is in touch with the dead, though he cannot see the real ghost of Hartigan still selling his philosophy from a pitch the other side of the grave. There is much that is playful and comical in these situations; but such sport can have, like boxing, lethal consequences.

That Yeats regarded the aggression of the boxing ring as a form of dramatic as well as sporting entertainment is clearly indicated by *The Glove Contest*.[4] In this early article he is as much concerned with the presentation as he is with the fight, taking particular

interest in a near-comic fight between an older boxer and a young Italian. In *The Old Sea Road*, however, the sport is truly dangerous. Michael, who is shortly to die, strips off in a bog hole for a dip, a sort of preparatory ritual for his strange tussle with Ambrose. We are invited to think of them as naked boxers:

AMBROSE . . . Now I'm naked and fit to fight for my life with my two
 hands. Naked I came and naked I go. Now aren't I a son of old Adam
 like yourself? (OSR p.157)

The fight which follows is not physical, but it ends in murder. Boxing likewise makes entertainment out of life and death and we are all in it:

The Noble Art of Self Defence, so well named, never forget it, with the
stripes on our far too fat backs where we fell ourselves on the ropes, we
still are exponents, if even we were never worth our mother's trouble in
rearing us, of the Noble Art of Self Defence. (ATYA pp.111-2)

'The Old Days', painted in 1942, (Plate 5) has an impromptu boxing match between two horse-bus ostlers as its theme: but it is not just a scrap over a woman, for 'in the background – the backcloth as it were – was a cemetery'.[5] On the left the boxer is fair-haired, the horses are hitched to the pole under a light and they are on the lighter side of the painting. On the other side the boxer is swarthy, dark-haired, his bus is hearse-coloured and the horses are not hitched. The suggestion is of a struggle between life and death, light and dark, motion and stasis. The suggestion is reinforced by Yeats's use of the same cemetery and light for an illustration in *Sailing Sailing Swiftly* (Plate 6) where Uncle Ned attends the funeral of a man with his own name:

. . . the part of the cemetery he was overlooking was the part where they
were just finishing the interment of what, he felt still, was half himself.
(SSS p.133)

Like the boxing arena, the circus tent can also be a place for sorting out the world's boasters and undermining the knowingness of humanity sitting round the ring – hence the image of the arena of learning quoted in Chapter 1:

Better bury all the gramophone records, smooth the earth over them
with our noses, and start again with the first man who can think of a
wheelbarrow. But let the Beginning be in a circular confined place, a
circus tent . . . the old single-pole whirl-a-gig round and round, over the
garters and through the balloons. (Sl pp.33-4)

Though there is no bloodshed and no rope barrier, there is still much aggression. Anyone who has been to Duffy's circus in an Irish country town, and seen the strength and readiness of the farmers in the audience in taking on the Strong Man, has also to admire the readiness of the Strong Man. His ability to entertain depends entirely on his skill in maintaining a sense of fair combat without being pulverised himself. Yeats kept a cutting (unidentified) of a contribution of his own on a similar kind of daring. Since it has not been noticed before I reproduce it in its entirety:

It was on a race course in the South of Wicklow that I saw 'The Rock Breakers.' The tall man in the clown's dress had cords attached to his wrists and again round his body, to suggest, I suppose, that he was in bondage to the man with the sledge hammer. The hammer man never spoke, but the tall man, who had a low, sad voice, used to take the rock in his hands and hold it to his breast and say, 'That man will break this great rock on my breast.' Then the pennies would begin pattering on the ground. When there was half-a-crown on the ground the stone was to be broken, but always before that sum had fallen on the sod another race was started and the crowd had rushed away. As soon as the race was won the collecting of the half-crown began all over again. I never saw the rock broken, though it can be done. J.B.Y.

Challenge and aggression do not necessarily mean a distancing of the audience; they can have a curious attraction: and in tapping this long tradition in entertainment Jack Yeats was building up a new approach to the theatre, with actors and audience much closer to each other, whether in combat in the earlier plays or complicity in the later ones – which were written with the tiny Peacock theatre in mind. For Yeats it was a closeness he knew from long ago and was trying to revive:

I remember when plays, that are played now as quaint before gigglers in the expensive seats, were played as if the players were the brothers and the sisters, or at least the country or town cousins of the people in the auditorium. I think the quaint toss is the poorest and the most insulting toss ever thrown down before the human life. (AW p 10)

In *Sligo*, published in 1930, he had the idea of theatre in the round long before it became fashionable; and the title play of *Apparitions* (published in 1933) was written with the intention of having the audience surrounding the actors. This applies only to the first play of the trilogy, not to all three. Yeats left (and published in the 1933 edition) clear instructions for and drawings

of the sets for all three, and the latter two must use a proscenium arch to be workable. There is a separate instruction for the staging of the first play in an arena (Skelton p.122), from which it is clear that he did not expect an impossible shift of venue for the second and third plays. On this point, he has been criticised in *Apparitions* for expecting an actor's hair to 'turn slowly white'[6]. The instruction should read 'has turned snowy white' (Skelton p.131) and ample time is given in the preceding blackout for the actors to powder their hair from powder under the table round which they sit; or to be powdered by the perambulating ghost, or to don wigs.

The connection between the idea of theatre-in-the-round and the circus is made explicit in the following passage:–

When is the drama in a Circus ring going to take hold of the drama that can be seen all round and at which the audience seem to have a part. It should naturally develop from the revived apron stage . . . The circular drama might mean an ordinary drama with a small cast . . . (SI p.60)

Robin Skelton goes so far as to say that Yeats was 'derisive about the Picture Frame Stage.'[7] But *La La Noo* and *Harlequin's Positions* would be almost impossible without a proscenium. Everything he painted was put into a frame and he even suggests that we see the world as though through a proscenium arch:

In the middle of the oval proscenium of each eye she would flitter with style. (CL p.2)

A degree of affection for the proscenium is essential for miniature 'cardboard' drama since the figures have to be slid on stage from a concealed position. The proscenium arch also allowed for the creation of the illusion of distance:

The best scenes are I think the deep ones with many side wings, and the backcloth far back . . . (Skelton p.17)

This applies as well to the plays for the larger theatre, in which the creation of an illusion of depth is equally important and is backed up by frequent reference to areas of action outside the stage area. A boat is watched from a distance into the back-stage landing place in *The Deathly Terrace*; in *La La Noo* the climax of the action is the crashing of a lorry off-stage, watched by those on-stage; in *The Old Sea Road* people come and go between two country towns off-stage left and right and we see and hear the sea throughout the play as well as a lark above us. In *Rattle* there is a

quay back-stage at which boats draw up, and a view through the
trees of a distant city; and in *Harlequin's Positions*, besides the
visible departure of a train, there is a scene with two river pilots
looking out to sea, and the action is governed by rumours of
distant events. Into this illusion of space step the actors as into the
illusion of a painting:

I generally begin a picture in the distance and come away forward, and
let the people walk in.[8]

Part of this interest in perspective and illusion may well have
been stimulated, as was his painting, by the indented coastline of
the West of Ireland, where the distant islands and the clarity of
the light draw the eye out to the Atlantic, but part of it was no
doubt a hangover from the extremes of nineteenth-century
theatrical illusion:–

My first play was The Shaughraun, and Boucicault's light-toed peasants
were more supernatural than Shakespeare's sugar-filled holiday tasks.[9]

The streak of Irish nationalism in Boucicault appealed to Yeats.
He honoured the playwright along with another
nineteenth-century Irish hero, Bianconi, in one of his most
famous paintings – 'In Memory of Boucicault and Bianconi'.
Much of the extravagance of melodrama, of which Boucicault was
the leading light, seems to have rubbed off on Yeats. For instance,
the many deaths by murder and suicide (Ambrose, Michael,
Hartigan, Ted) or near suicides (Nardock, The Governor); the
more elaborate of the stage effects – Boucicault was a master at
these – such as the train and boats already mentioned, and the
ritual of the bearers with the palanquin in *Rattle*; and the frequent
use of music and song – all these are reminiscent of melodrama.
The Deathly Terrace opens with Sheila singing a Tommy Moore
ballad, and Andy sings 'Rolling Home': the trilogy is connected
by music, each piece with its particular significance: in *The Silencer*
the fake seance opens with 'Lead Kindly Light' and in *In Sand*
there is a band (mostly off-stage to spare cost) who play 'I Know
My Love By His Way Of Walking'.

The 'total theatre' element of the melodrama appealed to Yeats
in much the same way as did the circus, and he found a use for it
in a symbolic context. Through the elaborate settings we are
invited to feel the current of life flowing in and around the drama.
Nardock speaks of 'this Dramatic Terrace' (DT p.108), making us
aware both of the dramatics of Sheila, approaching from the

distance, and of the relationship of the Terrace to ourselves in the audience. *The Old Sea Road* is not only a country road, but a setting for man on his journey through life. Two die on it. The wharf in *Rattle* is the stepping-off place for the strange world of Pakawana in which acceptance and forgiveness are symbolised by the cloak and collar of the order of the Golden Wave: 'Good wishes like tides between us.' (Ra p.191) The presence of the sea in many of the plays serves to carry our thoughts into the widest of contexts and its role in *In Sand* is fundamental.

Jack Yeats's background in melodrama was not an uncritical one:

[Synge] went with me to see an ordinary melodrama at the Queen's Theatre, Dublin and he delighted to see how the members of the company could by the vehemence of their movements and the resources of their voices hold your attention on a play where everything was commonplace.[10]

And in picking on Boucicault he was picking on a playwright who broke through the melodramatic mould with heroes who were anything but conventional. In *The Streets Of London* a scoundrel becomes the hero and joins the police. The Shaughraun attends his own funeral (compare with Uncle Ned) and he and Myles in *Arrah-na-Pogue* have all the plausible talk, opportunism and readiness to hazard their lives, of characters such as Yeats's Nardock, Hartigan, Stranger, Ambrose and Michael – with this difference: that the motivations for self-sacrifice in Boucicault become in Yeats part of a much more complex approach to life and death, just as the elaborate settings take on a much wider significance than that of theatrical illusion.

Robin Skelton has suggested that George Fitzmaurice's fantasy plays may have been an influence (Skelton p.11), but I think this very unlikely. The only Fitzmaurice fantasy play Yeats could have seen before he had written his own plays was *The Magic Glasses* in 1913, and the 1914 edition of five of Fitzmaurice's plays does not appear to have been in his library. Even if he did know these plays, the extravagance and colour of Fitzmaurice's Kerry dialogue is quite unlike anything in Jack Yeats, as is the overt symbolism. If there is a link it is that of their oddity and the ignoring of their works by The Abbey. Much the same could be said about Synge's dialogue compared with Yeats's, and as for subject matter, he had no need to learn from Synge what he already knew from his own previous and much longer experience

of the West of Ireland. Nor was he apparently much enamoured
of his brother's theatrical mannerisms if the following is anything
to go by:

Oh, don't say 'Masks': Oh Masks, such a lot of talk about Masks being
just about the last thing but three. (Sl p.132)

When he used a mask in *Apparitions* it was a studied tease.
However, I do believe that his brother influenced him in a
negative way, in that I cannot imagine that *Apparitions* and *The
Silencer* were written without an awareness that people would be
set to thinking about *The Words Upon the Window-pane*. This
relationship, and the influence of Shaw's *John Bull's Other Island*
on *Harlequin's Positions*, will be dealt with in their appropriate
places. It may be that other influences on Jack Yeats's drama will
be unearthed, but my own view is that he is essentially *sui generis*.
Skelton says much the same, and it has been said by reputable art
critics with respect to his paintings: but current critical fashion
does not care for the notion of naturally occurring genius and
may one day be able to make an advance on demonstrating that
he did not invent the English language overnight.

Something one can be sure of is the versatility of his dramatic
output. There are Miniature Dramas (on which Skelton and
McGuinness cannot be bettered): there is a play (*The Deathly
Terrace*) originally intended to be accompanied by a
sound-and-light display: there is one of the first plays written for
theatre in the round (*Apparitions*): there is a trilogy connected
thematically by music and allegory (*Apparitions–The Old Sea
Road–Rattle*) : there is a play (*Harlequin's Positions*) in five acts, each
act related to the stylised posture of a Harlequin: there are plays
which strictly observe the unities (*La La Noo* and *Apparitions*),
plays which break some of the unities, and two which break all,
including unity of character (*Rattle* and *In Sand*). Most of the plays
are dominated by men, but one is dominated by seven women (*La
La Noo*) and its short speeches and crisp dialogue contrast
strongly with the lengthy monologues of *The Deathly Terrace* and
In Sand. There are comedies (*The Deathly Terrace, Apparitions*, and
The Silencer – a supernatural comedy): and tragedy (*The Old Sea
Road*) and something between the two in *La La Noo* – by Yeats's
own reckoning.[11] There are Romances: a romantic tragedy in
Rattle and a romantic comedy in *In Sand*. There is *Harlequin's
Positions* which is none of these things: Yeats called it 'a play of
war's alarums'.[12]

This combination of originality and versatility puts Yeats at a tangent to literary tradition, and where he touches it one is not quite sure whether it is with a kiss or a smack. But as to the theatre itself there is no doubt how deep-rooted were his interest and affection:

But still I remember. I remember a play I saw once, not so many years ago, but it was an old play then and of times long gone away. The actors were nearly all too young to remember the days when the play was in its prime, and there was no one alive to remember the days the play was set in. And yet the greater number of the audience had such respect for the old days that they encased the players and their play in a bright sugar cave like an Easter egg, and inside that cave the old days were breathing warm because the audience liked to have it so, now was that love?

That was love old Dusty Brown. (AW p.11)

3

Creating a Theatrical Rhetoric:
The Deathly Terrace and *The Silencer*

When Jack Yeats first wrote for the live actor, as opposed to the
cardboard cut-out, it is not surprising that his subject matter
should have been the relationship of actor and audience. He
seems to have had a dim view of it to begin with. He, and the
times, had outgrown the old theatrical certainties. Music hall was
giving way to the cinema, where the balance between live actors
and live audience had an abstract quantity on one side – just as
cinema has yielded to television the other side of the balance, the
response from which is now measured in viewing percentages.

The Deathly Terrace was written just after the arrival of the
'talkies' and it is about the making of a 'talkie' by an actress who
has left the stage for the cinema. Yeats left a book of abstract
pen-and-crayon sketches representing a colour and music
display to accompany the play. It was numbered to match a
manuscript sadly not to be found among his papers. This book
has the new Fitzwilliam Square address on it, so it was written
down after late 1929, and on its back cover can be dimly, but
indubitably made out, the following direction in Yeats's own
hand:

Derisive music to be played as people are actually leaving the theatre.

Yeats gives no clue as to how these sketches were to be
realised, but they are of interest because they prove that he had
an overall conception of the pace of the drama. One needs that
proof. The third and final act is over twice the length of the first
two put together; some of the speeches in it are almost two pages
long; and of the nine named characters, only three appear in it. I
also discovered among his papers a hitherto over-looked scenario
for a mimed and spoken Prologue to the play which I reproduce
here with Yeats's layout, spelling, erasure and punctuation:

Prologue. Terrace Death
in printing office Western Town USA Earlies

37

Printers Devil hit on head with fulling box of type
having been left in charge of office (with orders to
brush floor). by Editor and, done up swell, friend
Printers Devil dazed rises up and sits up
Curtain falls rises again
Boy finished work of prints sleeps Enter Editor
and Friend (tipsy) (who should be good dancer)
Dancing friend washes boys face and golden hair
Editor reads long galley boy has set up.
begins simple words gets more ornate and ends
with involved and very long words
Dancer does a little step dance for each part.First quick with a lot
of the treble. The loud and flat foot
last slow and sleepy like a part of a sand dance.
Dancer washes black from Printers Devils'
face and golden hair as he comes to
Editor without letting boy see and with something
of a fond glance and scratching his head
puts roll of galley behind fire.

The Prologue scenario, whether abandoned or not, points to
the importance of rhetoric as a theme in the play; and parallels
between the characters are fairly clear. The Editor, a manipulator
of news and events, corresponds to Nardock who also
manipulates events with his fake suicides. The Friend is like
Andy in that they both dance to the tune of events, the Friend to
the expanding rhetoric of the Printers Devil, Andy, with his life
dancing to the tune of luck and the rhetorics of Sheila and
Nardock, graduating from the one to the other. The
golden-haired boy (the Printers Devil), like Sheila with the yellow
rose in her hair, is trying out a new rhetoric; his in print, hers on
screen. But whereas the boy's linguistic convolutions are
affectionately wiped from his face and tucked behind the fire,
Sheila is only to be silenced by the setting sun.

The progress of theatrical rhetoric is built into the play in
several ways. Just as the Printers Devil learns to use longer
words, so do the speeches lengthen – particularly Andy's. At first
he affects Sheila's stagey style – 'Quite a while, lovely soul' (DT
p.96) but he soon takes to undercutting her:

SHEILA . . . and seen nobly acted by a natural nobility like you and I and
 all of us, isn't that so Andy?
ANDY Oh very so so. This is a Trade Show not an intellectual treat. (DT
 p.100)

Finally, in the company of Nardock, he launches into the story of his life – a life directed as nearly as possible by chance – and then, following Nardock's speech about the death of speech, sings 'Rolling Home'. They are about to turn their backs on their audience (for whom Nardock recommends edible sweetie papers, so they make less noise eating in the theatre)(DT p.116), leaving them to feed off Sheila as she approaches the 'Dramatic Terrace' (DT p.108) of 'Shark's Belly Hall' (DT p.105). They trick the approaching Sheila into believing that they have died for love of her, and she is left holding the stage for a final fatuous farewell to the theatre.

The talkies represented a real threat to the live theatre. The proposed selling of a business for a cinema is the basis of the plot of *Rattle* and the actual sale of a shop for a cinema is fundamental to *Harlequin's Positions*. This threat must have saddened an ardent theatre-goer like Jack Yeats – and it affects Sheila who makes her 'last fond farewell to the gods, the pits, the dress circles, and the stalls' (DT p.118). Her defection to the cinema, working with two inexperienced cameramen and a producer, Andy, who has no experience, is ridiculous. She wears a yellow dress and twiddles a yellow rose. The colour is not accidental: Yeats changed it in the manuscript from the conventional red rose because yellow is the colour of betrayal, cowardice and sickness. It is also a debased version of gold (the gold of the boy's hair who has betrayed nothing). The association of yellow and sickness springs to Nardock's mind as Sheila approaches, and he and Andy, who is now his devotee, draw attention to it.

NARDOCK . . . And if you are sick, a sinking sun, a falling curtain, and a guttering candle can't be too quick about it, that is if you're really sick – look Andy, how's the yellow huntress making out on her voyage?
ANDY We know who she is, this huntress. She's Sheila. She got her old 'Slicer' dress on and she's coming here. (DT p.116)

The dress she wore for her film, *The Slicer*, is yellow, and Sheila is about to delay the curtain against the back-drop of the setting sun. Is she, the 'daughter of the legitimate' (DT p.118) and therefore an emblem for the theatre, really sick, and why is she described as a 'huntress'? It seems to me that she is a huntress in that she wishes to consume the likes of Andy and Nardock to feed her own ambitions and that she is indeed sick, if what she regurgitates in her final speech is anything to go by. In the end she is left high and dry in more ways than one. She forgets her

lines and, at a crucial moment of self-adoration, has to step on the painter of her boat to stop it from drifting away. It escapes her anyway and she capitulates:

SHEILA Ah so, flop, ends the tropic day. That gets me.

It is a marvellous curtain line with its ridiculous but expressive assonance (flop-tropic), and it demonstrates powerfully Sheila's inability to rise to the occasion.

Sheila has been unable to maintain her fidelity to the theatre, but then it was not wholly dependent on herself. Because of this, it is hard not to feel sympathy for her as well as derision, and we are probably meant to transfer at least the derision to our own changing tastes, seeing her type is our new goddess. 'Derisive music to be played as people are actually leaving the theatre' now makes sense. The point of the timing is that we *are* leaving the theatre, in more senses than one. The elaborate ruses of Nardock and Andy to fake suicide and escape undetected are also relevant to this theme in that they are silent visual illusions, like the movies before the talkies. Nardock and Andy escape with their rhetoric from the new art form in which there will never be time or patience for such talk as theirs.

But what of Nardock's speeches, which occupy most of the play? They may not be cliché-ridden like Sheila's, but they are every bit as eccentric and rhetorical. How seriously is this man to be taken, whose hobby appears to be Jack Yeats's – that of an eccentric incognito – and who has assumed his name 'for the purposes of confusion'? (DT p.106) His name is indeed a confusion. It is an anagram of Conrad (plus a 'k') and as such it messes up the man whom Yeats described as having 'too much respect for the authority of convention and not enough for truth'.[1] It also relates to the word 'Nordick' coined by Jack Yeats at the time this play was being written, a word which

comes from two words buttoned together the words are 'Nasty' and 'Ordinary'.[2]

Nardock is certainly not ordinary – but he could be the 'doc(k)' who cures such things. This may seem far-fetched, but there are reasons for putting it forward. Apart from Nardock's name being 'Assumed for the purposes of confusion' (DT p.106) we have Del Garvey's name as 'the result of two torn entries' (DT p.111) and Andy who was 'born in Shoreditch but I never saw either the shore nor the ditch' (DT p.109); and the name of Nardock's house

was at one time 'Lord Jim'. Clearly, playing with names and Conrad was in Yeats's mind.

If Nardock is the antidote to the nasty and ordinary people of the world, with their 'respect for the authority of convention', presumably we take him seriously and, like Andy, adopt him as our mentor. But it is not so simple. The current name of the 'Lord Jim' house is 'Shark's Belly Hall' and the Terrace is surrounded by sharks. Since it is also referred to as 'this Dramatic Terrace' by Nardock (DT p.108), there is a strong suggestion that we, the audience, are the sharks. The feeding of the loaves as pretend legs is then a derisive gesture in the same way that we are thrown speeches from the Terrace, or as the potential audience for the film is fed 'old steady stuff' because 'they'll simply love it' (DT p.101).

If Lord Jim was a former inhabitant of Shark's Belly Hall, then he was eaten up by the viciousness of life around him. Nardock survives because he recognises that 'everybody isn't my fellow man and don't you forget it' (DT p.104) and by making money out of a mineral which 'justifies its existence by lending itself to all forms of adulteration' (DT p.105). Nardock does not use the produce himself, not wishing to thin down his own diet. The imagery of eating pervades the whole last act. Nardock and Andy eat, drink and smoke through most of it – tossing their leavings to the sharks, and Nardock is arrogantly and selfishly trying to outdo the public:

. . . Originally I read all books. But today I read only jackets. By exchanging jackets and obliterating titles I have added to the difficulties which add to the powerful digestiveness of the Human Race. (DT p.108)

In his own way Nardock is as bad as Sheila, who hopes to make money out of a patchy film and watches her own rhetoric flop; for his mineral makes money out of public gullibility, and he too is haunted by the audience that might catch up on him and the rhetoric that fails. That is why he uses fake suicide, changes book titles, and asks:

Has every word, like every dog, a day, Andy? (DT p.113)

Skelton sees Nardock in a much more positive light (Skelton pp.5-6) and there is truth in that view of him. Nardock's rhetoric can be entertaining and some of it is searching. And now and again he is allowed to come up with lively observations and turns of phrase – London as 'a muffled sob' and 'Premeditation is the

thief of Luck'. But my own instinct is that if this play were ever performed (I know of no performance) it is the comic and satiric element in it that would have to be stressed, and this not least with respect to Nardock whose lengthy speeches, understood at their face value, are too much of a good thing; and understood for what lies between the lines, they are too insulting to the audience. The planned colour-and-music accompaniment might have done something for this problem, but in the end I do not believe that Jack Yeats knew what he wanted from the play – hence the confusing assertion that:

Sheila of the Deathly Terrace should be of any type (with each type it is a different play).[3]

One could charitably claim that this shows Jack Yeats to be a writer who allows his work to stimulate a wide variety of responses, and who has liberated his drama from the tyranny of the author. If the play were ever tested in the theatre that claim might be substantiated. Without such evidence, it reads as though he did not know whether he wanted an audience for his play or whether he believed he could produce a rhetoric that could do more than feed the sharks. But there is no denying that he has tossed a well-fleshed bone into our mouths, however crossly we may gnaw upon it.

The theme of rhetoric is continued in *The Silencer* and is embodied in the character of Hartigan, and it is for this reason that I have placed them in the same chapter. We know that Yeats sent these two plays to Miss Vosper in 1948, and this may indicate that he too thought of them as a pair. We cannot lean too much on this, however, as he had also considered breaking up the trilogy and pairing *The Deathly Terrace* and *The Old Sea Road* (see Note on the Chronology). In the absence of production of any of these plays, Yeats may simply have been trying to find any combination that would appeal to a producer. There is an obvious link between *The Silencer* and *Apparitions*, both plays involving the appearance of a ghost and both with something near to spoof conclusions.

The relationship between Jack Yeats's and W.B.'s attitudes to spiritual manifestations is made precise in *Apparitions* (see Chapter 3). But the seance in *Apparitions*, in which the ghost turns out to be a fake, becomes a squalid fraud on the part of the medium in *The Silencer*. Moreover, the ghost in *The Silencer* is real, but visible only to its murderer. It is not known if W.B. ever read

The Silencer – it has never been produced – but Jack cannot have written it without realising that it embodied some sort of dig against his brother's spiritualist activities. Some of the tricks used by Old Snowey in his seances are taken by Jack Yeats from a book he had in his library called *The Mystery Unveiled* by a Dr Ormonde.

The fraudulent voices of the medium bear on the rhetorical theme in the play, as does its subtitle *Farewell Speech*: but Hartigan's rhetoric, which leads up to his final speech, and how it affects and is affected by commerce, is what is central to the action. Hartigan is the new Nardock and Old Snowey a sort of debased performer but far worse than Sheila; but the whole conception is more balanced in interest and layout, even though Hartigan is the only character to feature at both ends of the play. The three acts in *The Silencer* are of similar length, and Hartigan's speeches are more evenly distributed than Nardock's. They are also heard in the context of more than one character and Hartigan is manipulated by others as much as they by him. By comparison, Nardock has dialogue only with Andy and sees himself, and is seen, as being virtually at the hub of events.

The plot is simple. Hartigan, a garrulous Irishman among Englishmen, is employed in various functions on account of his gift of speech. In each of these employments his gift works against him – even when 'employed' for criminal purposes. One of the criminals blames him for the failure of the crime and shoots him. In a fit of remorse he tries to contact Hartigan's ghost at a spiritualists' meeting. The spiritualists are fakes, but Hartigan's ghost appears and so annoys his murderer that he tries to shoot the ghost. The shots bring in two policemen and the landlord, but the policemen are party-goers in fancy dress and the murderer makes off, leaving behind him the ghost of Hartigan, now silenced but still flitting about.

Hartigan is a failure in terms of worldly affairs, compared with Nardock who has learnt to exploit his mineral resources: in fact, as far as the ship of commerce is concerned, Hartigan is a Jonah. His own denial of it – 'Every horse is a winner until I find it – not that I'm what they used to call a perisher' (Si p.228) – is to no avail. Every venture upon which he is taken aboard founders. But, like Jonah, when Hartigan is finally swallowed up by death, he re-emerges on the shores of a new world, triumphant and capering with delight. I cannot help feeling that Jack Yeats was making here a gentle and affectionate tribute to his own father.

John Butler Yeats was a great talker and a disastrous business man – and he was known as a Jonah:

Sometimes my father would come too, and the sailors when they saw him coming would say 'there is John Yeats and we shall have a storm', for he was considered unlucky.[4]

It is a sailor who is first to cheat Hartigan, and Hartigan himself has been at sea and constantly uses the sea and sea stories in his many splendid diversions. Perhaps the best example of this imagery, and of the quality of Hartigan's rhetoric, is the magnificent image Jack Yeats gives to him as he tries to occupy the mind of a plain-clothes policeman too careful to be transported by fancy:

A face is built to meet the waves as they come. The nose is like the bow of the ship; the eyes the hawse holes; the ears the cat heads – cats' ears where the anchors hang a-dangling; and the mouth is the cream of it all, the waves that break with smiles. If you look over a ship's bow before dawn you see the white curve breaking bright – the brightest in all the world. (Si p.228)

There is, in the context, great courage in that image, for Hartigan knows his gift is being used by a bunch of small-time crooks; and we know that for once, faced with the immovable mind of the law, Hartigan's gift is wasted. Imaginatively and technically it is a brilliant piece of writing in which the old images of Petrarch are brought alive by gifted observation. To many of us, faces are flat things; but to a man who carves or paints faces they are indeed shaped like the prow of a ship; and as for the brightness of the bow-wave before dawn, I can only recommend the reader who has not noticed it to take a sea trip. But this is not just a well-visualised way to inspire us to outface the world in all weathers, as Hartigan does: it is virtuoso writing. For instance, the last sentence is perfectly shaped to match the image of a wave. Like a wave it crests and spreads with a gathering of accented syllables and alliteration at the point where the eye and ear focus (for want of a better verb):

If you look over a ship's bow before dawn you see the white curve breaking bright – the brightest in all the world.

There are many such passages in Yeats and it is not the place of this chapter to consider them properly; so this must be sufficient to serve as an example of Yeats's qualities as a prose stylist – and

of the importance those qualities have to our appreciation of Hartigan's rhetoric.

But Hartigan's gift of the gab is troublesome to him, for it has a will of its own. As soon as anyone, including Hartigan himself, tries to put it to some materially profitable use, disaster strikes: finally death. The flow of words in his final speech, and in his speeches as the Ghost, seems to enslave his listeners:

You have never existed in your own right. You exist now in mine. As the waves of the wind ripple the flag from its flag-pole, so you move and exist. As one ripple disappears on the flag's flying tail, another is beginning at the rope making its journey from the hoist to the fly. By my lips you live; by their stillness you pass away or back again into your solidity of a poised dust mote. You could wish yourself alive but you will never do it. (Si pp.232-3)

Almost immediately after this, Hartigan is shot dead. After such arrogant assertions, the dramatic situation is not without irony – even humour. Old J.B.Y. could hold an audience like that and life cut him down a good few times. The ability to hold an audience and the compulsion to do so belong almost in the world of the Ancient Mariner – another Jonah. But Yeats takes this need a stage further, not relating it to guilt, but to memory in general. The ghost needs to work through his memory until:

. . . one day by forgetting here and there we will arrive at one thought . . . But not yet is that one thought set for me. I cannot in the twinkling of a star be forgetting the grey beards of the sea. (Si p.244)

If Nardock thought language was on its last legs, Hartigan shows it still has life by a simple cross-referencing of images: not the twinkling of an eye, but of a star – his new environment: setting the image of a lively eternity against the aged eternity of the world – the grey-bearded sea. The idea of arriving at one thought by a process of forgetting seems to have had something to offer Beckett, especially in the conclusion of *The Unnamable*:

you must say words, as long as there are any, until they find me, until they say me strange pain strange sin .

But for Yeats and Hartigan there is neither pain nor sin in this necessity:

. . . where we leave down one gangway, we come aboard skipping up the next. Ever ashore, ever a-floating; before the wind and in the wind's

eyes, in the trough and on the crest, forgetting where the foaming stars
come down and the twinkling waters rush up. (Si p.245)

This is, rather, a world of delight in which heaven and earth
become confused at last; and we may be grateful that this
philosophy gave rise to Jack Yeats's becoming an author:

In it [Sligo] I explained that my reason for writing was to jettison my
ideas. And that is, I believe, the true reason for all the books I have
written.[5]

Understood in the context of such as Hartigan, one sees clearly
that Yeats's writing was not a casual discarding of mental
rubbish, but a philosophical necessity. This is a philosophy
which Yeats *enacts* in his writings – as Michael says in *The Old Sea
Road*:

Well, gaze on this (*placing his hand spread out on his own breast*).A
philosophy. The thing not the student of it. (OSR p.150)

A person with a lot of ideas 'throws out' ideas. In other words,
he wrote as he painted, because he had to, because he could not
keep it in and find room for new life. On this point I am strongly
in agreement with McGuinness in believing that Yeats took his
writing seriously and cared about it. Any old or young fool can
write a diary to clear their brain, but the production of seven
novels and more plays, sent off to publishers and producers,
cannot be considered a mere diversion from his true vocation as a
painter, as some critics have suggested.

This being said, there is a strong element of comedy in *The
Silencer*, and it is applied to Hartigan with unsparing realism. At
the height of his fantastical speeches he, or the dictaphone
through which he speaks as a ghost, is shot by an exasperated
criminal of few words, all crass. Hartigan is ignored as much as he
is listened to; and the final note of the play is one of spoof – the
fancy dress policemen taken for real ones, then owning up; the
ghost dancing in the background being the only certainty in a
world of cheats and deceivers. Even Hartigan's name is punned
on via Chatagain suggesting Heartagain (Si pp.228,244,245). If
Jack had the memory of his father in mind, he could hardly have
chosen a better name: and though J.B.Y. was never shot for his
eloquence, there was still much to be redressed, as the letter
already quoted from in Chapter 1 indicates:

My father got a parboiled deal.
But his son lives on and I hearten myself with my old song

> Jacko Macacko
> The son of old Whacko
> Jacko Macacko
> Has come home to roost.[6]

Jack Yeats is being fair, as well as ready to sharpen up a metaphor when he writes 'parboiled' for 'raw'. Hartigan got a parboiled deal too, and McGuinness seems to have instinctively guessed at a connection when she writes of Hartigan as an embodiment of the artist 'adrift in society' (McGuinness p.387). But she also suggests that he is the 'target of the former revolutionaries' in a Free State Ireland which has no role for him and in which The Silencer, Hill, 'represents the gunman, the noble outsider of revolutionary days, who has become excessive' (McGuinness p.388). She notes and ignores the fact that the play is set in England and overlooks the fact that Hill is given an English accent, using "im' for 'him' and 'wot' for 'what' (Si pp.230-1). The same can be demonstrated for Sam; and Hill's claims to represent 'Truth and Justice' allied with his violence do not require the category of 'revolutionary' to accommodate them – in the context of his accent they would better suit a Black and Tan – but one simply cannot re-locate a play in order to justify a theory, unless there is reason to believe that one country is being used to stand for another. If there was ever to be a country in the world that Yeats would not use to stand for Ireland, that country was England.

But there is a political element in the play, notwithstanding the above. The imaginative, garrulous Irishman cannot fit into the London business world at any level, even a criminal one; and his only compatriot does not sell things, he sells advice (Si p.211). What is suggested here is that Hartigan, representing Ireland, has a spiritual element to him, admired, used, envied by the English, but never emulated. We see the English quarrel over business (Si p.214) and cheated in their attempts to contact the spirit world by a fraud.

Hartigan *becomes* a spirit, relieved to be free of his body, and the only person who can see him (Hill) is tormented by his existence, although Hartigan's ghost is not interested in him. Hill attempts to shoot the ghost, but his gun will only fire when he points it at the dictaphone. Hartigan's spirit is invulnerable where his flesh was not. There may be an echo here of the Irish hero Dubhlaing O'Hartagain, who wore a cloak of invisibility at the battle of Clontarf but was killed when he removed it to show Morogh

O'Brien that he was indeed there and fighting against the Danish invaders, but I would not wish to make anything more of this than to suggest that Hartigan may possibly represent Irish values that we should believe are always there, even when they are invisible and inaudible.

It is easy, writing about a rich script and strangely intriguing scenario such as *The Silencer*'s, to become too serious. The sight of a ghost flitting about and using a dictaphone is bound to be funny, however profound his oratory. The scene with the spiritualists should be supremely funny, and the unmasking of the genteel bar-room talk of the businessmen at the very start of the play should be funny also. Only a stage production will tell us whether the blend of comedy and Hartigan's philosophy comes off – and it may well be that, fascinating as Hartigan's speeches are to read, their extravagant fancies will be more comical than anything else when performed.

In certain respects the play deliberately gets more ridiculous as it proceeds, drifting ever deeper into illusion and deceit as Hartigan moves from losing a client to being robbed, to becoming involved in a robbery, to being killed, to becoming a ghost – finally speechless: and as commerce gives way to crime, which yields to and then exposes fraud and is brought to book and released by two fake policemen. Such a procedure is risky, and in the process of establishing a theatrical rhetoric for himself, Yeats may not have found a satisfactory balance between the progress of the action and the content of the speeches. Not until his last play was Jack Yeats again to risk such long speeches as he had done in *The Deathly Terrace* and *The Silencer*: and in that final play the ultimate rhetorical gesture was to be the writing of a single sentence in the sand between the tides.

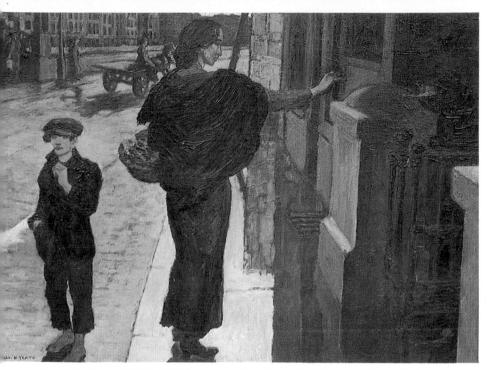

1 *Above* 'Bachelors' Walk', 1910 (*see* pages 4-5). Stolen from Dunsany Castle in January 1990 and, with four other pictures taken from the walls at the same time, the subject of a ransom demand which Lady Dunsany has no intention of paying. They had been left in her will to Ireland.

2 *Below* Cartoon in *Punch* by 'William Bird', one of Jack Yeats's pseudonyms (*see* page 25).

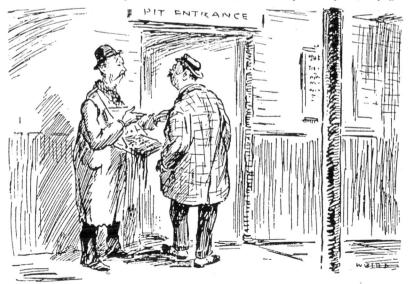

"EXCUSE ME, SIR. IF YOU LOOK AT YOUR PROGRAMME WHEN YOU GET INSIDE, YOU WILL SEE THAT THE LADIES' DRESSES ARE SUPPLIED BY MADAME POM-POM, THE PARASOL BY PAULINE, THE GENTLEMEN'S CLOTHES BY PHILLIPS AND BAILEY, THE WALKING-STICKS BY TWISTER, AND THE MONOCLE WORN BY SIR CUTHBERT COMES FROM OPPE AND TICK. BUT THEY DO NOT TELL YOU THAT THE COLLAR-STUD, WHICH IS LOST IN THE SECOND ACT, WAS SUPPLIED BY YOUR HUMBLE SERVANT. WHAT ABOUT A COUPLE YOURSELF? I'M SELLING THEM AT TWO A PENNY."

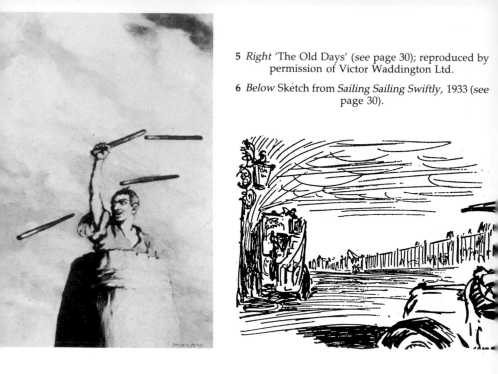

5 *Right* 'The Old Days' (*see* page 30); reproduced by permission of Victor Waddington Ltd.

6 *Below* Sketch from *Sailing Sailing Swiftly*, 1933 (*see* page 30).

3 *Above left* 'The Barrel Man' from *Life in the West of Ireland* (*see* pages 27 and 92).

4 *Below* 'Humanity's Alibi' Courtesy of the Bristol City Art Gallery (*see* page 27).

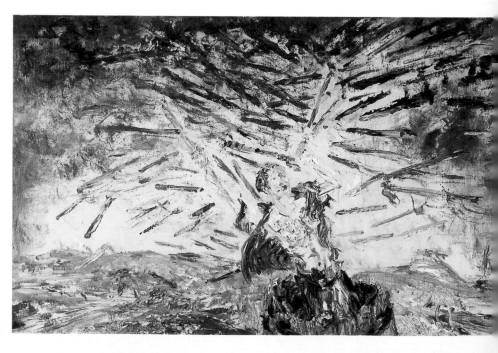

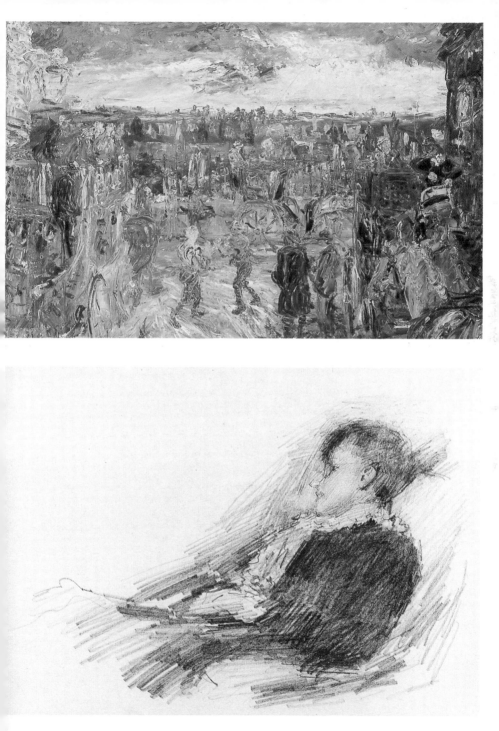

7 A pencil sketch of Sarah Purser, by John Butler Yeats, author's collection.

8 Illustration from Padraic Colum's *Outriders* (*see* page 157).

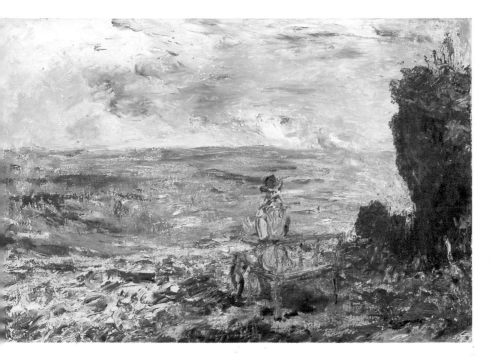

9 *Above* 'The Novelist' (*see* page 119); author's collection.

10 *Below* 'Death for Only One' (*see* page 169); courtesy Connor O'Malley.

11 'The Death of Diarmuid' (*see* page 150); courtesy the Tate Gallery.

12 'A Westerly Wind' (*see* page 158); courtesy Howard Robinson.

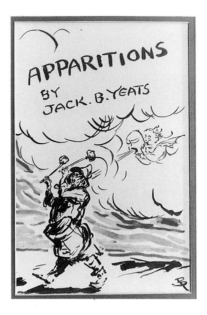

13 Jacket illustrations by Jack B. Yeats for *Apparitions* and *Sailing Sailing Swiftly*, courtesy Oriel Gallery, Dublin.

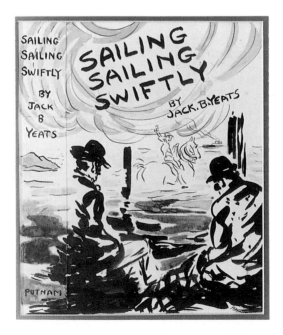

4

The Trilogy

The contrast between the garrulousness of *The Deathly Terrace* and *The Silencer* and the compact matter of the trilogy is remarkable. But though these three plays that were to be 'tied together with music'[1] deservedly found a publisher, they met with little understanding from the critics, most of whom confessed to being as charmed as they were confused. Not one of them made any attempt to understand why the three plays were linked, and among post-war commentators only Nora McGuinness has understood the basic connecting factor, though I do not accept all her interpretations. Here is what Jack Yeats wrote for the dust-cover of the 1933 publication:

These three plays should be tied together with music. Between *Apparitions* and *The Old Sea Road* – 'Believe me if all those endearing young charms', from the strings only. And between *The Old Sea Road* and *Rattle*, the whole orchestra in 'Let Erin Remember'.

But all the time, from the rising of the curtain, not before, so as to avoid queering the pitch of the queue-amusers, a fife and drum band marching up and down in the roadway, far enough away to reduce the fifes – for the fifes comment, the drums never.[1]

The fifes and drums were to play 'Johnny I Hardly Knew You' – one of the most bitterly humorous of the anti-recruiting ballads. The implication is that the fifes and drums were to play during all three plays, though the tune really only applies clearly to the first of them and the wording may be unintentionally ambiguous. Besides these three tunes (the words of which would be readily recalled by audiences of Jack Yeats's day), the whole of 'My Dark Rosaleen' is sung in *The Old Sea Road*. Of these four only 'Believe Me If All Those Endearing Young Charms' is not an overtly Irish Nationalist song; and to a people used to personifying their nation as a woman with whom one should keep faith, that lyric is as natural a candidate for political significance as the Mangan, though Moore's initial inspiration was deeply personal. Nora McGuinness, aware of the tunes' significance, states:

The true revenant in the entire volume of *Apparitions* is Irish history, and the plays are actually social problem plays.

And she has this to say of the title play, *Apparitions*:

In *Apparitions*, Yeats shows us contemporary Irish society unable to deal with its own past. The seven representative men chosen to confront the apparition fail: the artist has set up an apparition to show them their own paralysis and lack of community. The society collectively rejects the artist's vision of truth. Yeats wanted the plays staged in an arena . . . to show the audience that its indifference was part of the problem. (McGuinness pp.385-6)

I have already shown that only the first play was intended for an arena, and to say that the seven men are 'representative' of Irish society or of a small Irish town is absurd. For a start there is nothing in the play to suggest that Pullickborough is in Ireland. None of the characters' names is in any way Irish or identifiably Anglo-Irish, and the name of the village could be English or Irish. Even if the village were in Ireland, the names and occupations of the seven picked men show them to be well-travelled, self-styled heroes, not representative locals. They are stock characters with the smell of decaying empire, farcically presented, full of platitudes and fatuous self-importance. Everton kills animals for sport and is buying friendship in the village (Ap p.123); Albemarl has retired from the 'torrid sun and other – other inconveniences' (Ap p.125) to the 'honest' village of Pullickborough (suggesting he was involved in dishonesty); Scott is a mercenary with more sentimentality than courage (Ap p.127); Parlbury (speech-burier) is a socialist modelled on Shaw, who knows nothing of real poverty and misunderstands its needs (Ap p.132); and Little Livid is an ex-music-hall artist who parodies himself with 'Leer, girls, leer,' (the original being 'Cheer, boys, cheer'). Finally, the cowboy, Phil Poleaxe, is proud of his few words, but turns out to have no action either. Not one single character in the play ever uses an Irish turn of phrase, but the village barber is unquestionably English. For instance, 'Six you want, I says and six you shall have. Our Squire, I says, Mr Weston' (Ap p.123) is English. An Irishman of his station would have said 'says I'. Similarly, 'You know, my name ain't Charles at all' (Ap p.131) is unlikely to have been spoken by an Irishman – who would say 'isn't' or 'is not'. Parlbury is almost certainly English too, for he 'learnt to love cricket playing on the village green' (Ap p.132) which is not an Irish, but is a quintessentially English, pursuit.

What this means is that the theory that this is 'contemporary Irish society unable to deal with its own past' is untenable. This is reinforced by the fact that 'Johnny I Hardly Knew You', though an Irish anti-recruiting song, is not exclusive to Ireland. The English and Americans have their versions too. It also means that McGuinness's assertion that 'society collectively rejects the artist's vision of truth' is untenable because society (in the form of the villagers) is not collectively represented by anybody except the barber and the hotel waiter who have engineered the whole farce between them. The villagers then turn out to enjoy the spectacle of the incomers' humiliation.

When the hotel's ghost, which these incomers are recruited to exorcise, appears, they have not the courage to carry out their intended assault upon it. Instead, each man's hair turns white at the sight of it, except for Charlie Charles, who has unashamedly hidden himself under the table. Like the worm, he now turns on his recruits (they are his customers too) and mocks them viciously in a lengthy diatribe and by staining each one's now white hair red. He has persuaded them that he is staining them black and they are such a cowardly, stupid and self-satisfied lot that not one of them imagines that he has been duped along with the others until a mirror is passed round.

The play now reaches a climax of remarkable ironic density. Jimmy, the hotel waiter, ushers out the absurd procession of clapped-out heroes: the old crew from an out-dated social order and fighting out-dated battles, and Charlie Charles has to be woken, apparently bored with his own revenge, though he and the villagers have the laugh. His name associates him with the village, not only because it was given to him by his predecessor, but because Charlies were village watchmen in both England and Ireland in the days before policemen. Mostly it was their business to be made fools of by the villagers (hence 'you're a right Charlie') but old J.B. Yeats recalls them sometimes outsmarting the locals.[2]

Well, we may laugh with the locals at the silliness and irrelevance of those who no longer command respect, and that is an easy laugh: Charlie Charles, 'the worm' (Ap p.133) has turned. But with them all gone, Jimmy appears wearing the ghost costume and turns out to be another sort of worm that turns, but this one turns on the audience and reader. Yeats (speaking, I suspect, through Jimmy) disguises his contempt for our pleasure and amusement at the discomfiture of the seven by having Jimmy's speech broken up by hesitations as he dictates it. For

Jimmy is an author – a manipulator of characters – dictating to the adoring hotel clerk who acts as his secretary. Has this whole play been a figment of his imagination? If so we have been thoroughly duped ourselves. But strip his dictation of its revisions and hesitations and the contempt shows that we have been duped in another way, enticed into revealing our own nastiness:

> JIMMY In my last chapter I beguiled the reader, and I trust I did beguile him, for the worm-like sufferings of another are a joy untold to the observer from the Olympian heights of safety in the front row of the best seats, which surround the arena where the victim's heart throbs. In short, in my last I described the indignities I had to put up with from bull-necked, ignorant, inaesthetic clods. (Ap p.139)

Apparitions was meant to be performed in an arena. We have been sitting round (a bit like the sharks in *The Deathly Terrace*) enjoying the worm-like sufferings of others; and I don't suppose hand picking is necessary to ensure a sufficiency of bull-necks and ignorance. Jimmy then puts an 'idiot card' on the table announcing THE END. He replaces his ghost mask, but at the back of his head. He is now two-faced. What about ourselves, which way are we meant to look? Did we guess that the ghost was a fake? Did we even guess that Charlie's laudatory introductions for each of his seven recruits were all deliberate lies? If the villagers came on stage would they be laughing at us too?

Clearly the social contrast between Charlie, Jimmy and the villagers on the one hand, and the seven recruits on the other is fundamental. Social status, world travel, high adventure, political earnestness – these guarantee neither wit, courage, nor intelligence. A barber can winkle out all his customers' weaknesses; a hotel waiter can have a secretary and write a novel, as secure in his own superiority as those whom he serves are secure in his inferiority; those who used to recruit villagers to fight in foreign wars have been recruited themselves and, the war over, the villagers can truly say to each of them, red-haired and scarcely recognisable, 'Johnny I Hardly Knew You'.

We could of course ignore Charlie and Jimmy – and Jack Yeats if it comes to that: but the fun of the thing is sufficiently well and economically done to keep us entertained, particularly if we look upon ghosts and seances with any suspicion. And as we are made aware of ourselves as an audience we are made to realise that our entertainers are not merely our servants, but are making a living by their wits: and behind those wits there is usually an

author – an author who, perhaps, commands the play as the medium commands the seance. Jack Yeats knew of such people and of such a play.

Among such people was his own brother, and the play was *The Words Upon the Window-Pane*. It was produced at the Abbey on 17 November 1930. Jack Yeats saw it and it was at this time or shortly after that he wrote *Apparitions*. That his brother's participation in seances was common knowledge cannot have been lost on him; and he would have been a prize idiot if it did not occur to him that many in his audience would mark the contrast between the brothers' dramatic attitudes to seances. *Apparitions* does not include a seance in a strict sense or in the way that his play *The Silencer* does; but waiting around to exorcise a ghost is near enough to invite the parallel. He must either have intended the contrast to be noted, or at least have been prepared to accept the consequences, intended or no.

The Words Upon the Window-Pane parades before us the tortured soul of Dean Swift. A company of seven spiritualists is upset by a disturbing element which, like the seven in *Apparitions*, they wish to exorcise. A research student identifies this element as Swift's ghost. What this discovery adds to our understanding of Swift is the very unpleasant idea that after death he survives, preoccupied only with the troublesome rather than the creative side of his nature, manifesting himself in the image of his last physical ruin. The play courts ridicule, but if it is taken seriously, as it is clearly meant to be, then the audience is entertained by a purgatorial image of suffering that borders on the gratuitous, as the spiritualists and the audience are made privy to Swift's weaknesses.

Apparitions changes all that. The ghost author has his revenge. He is alive: he is the instrument that, more gently, exposes the weaknesses of the spiritualists and the audience. The girl who adores this author is not permitted to take from him the mask, though she struggles for it; nor is she willing to accept the typewriter to walk out with, though she brought it in. This little pantomime is bound to suggest a struggle between the author's need for privacy and the need of some to break in upon that privacy – shown here by the Clerk's attempt to recover the mask, by her open gestures of affection which are not returned, and by her refusal of the typewriter – symbol of the professional nature of her relationship to Jimmy. The parallel between this pantomime and the relationship between Swift and Stella is

obvious if we once have these two brothers' plays in mind. But the audience is rebuked only by Jack Yeats for taking pleasure in the sufferings of others. The thought cannot be avoided that, by making such a rebuke, Jack rebuked his brother too. Perhaps that is why this witty and well-made play was never taken up by the Abbey over which W.B. presided. He must have known about it. It was published as part of the trilogy in 1933 and widely reviewed, though I have not discovered any reviewer to have made the connection. But if Jack would have been a prize idiot not to realise that, willy-nilly, there was a relationship, Willy would have been a prize idiot not to notice it too.

Although I have headed the previous chapter 'Creating A Theatrical Rhetoric' *Apparitions* is also a part of that creation. Besides the manner in which the audience is involved, there is throughout a use of wayworn rhetoric to point out the weaknesses of the seven men: 'What I want to say won't take long. I'm a man of few words . . .'; 'What I have to say will not take long. Every man in this hall to-night knows my views on every subject – they are Duty, and Deeds, and Determination'; 'I am a man of few words and what I say is, we're here for a purpose – let us fulfil that purpose'; (Ap p.130) and so on. Charlie Charles addresses the seven with a similar speechifier's rhetoric until the joke is revealed and he abuses the lot of them in more colloquial style. Johnny too is trying out a rhetoric, carefully rephrasing as he goes along. Words, in fact, are a mockery of one kind or another from start to finish of this play in which the visual element is at least as vital; but the interest is more evenly divided among the characters, the speeches are more economical, and the action is focussed, whereas in *The Deathly Terrace* the distribution of dialogue is very uneven and the action is blurred by the repetitious 'suicides'.

The rebuke to the audience at the end of *Apparitions* is disguised – eased into our minds. Perhaps, by the time we have recognised it for what it is, the strings will have begun the Overture for *The Old Sea Road* – 'Believe Me If All Those Endearing Young Charms' – and its soothing nostalgia will smooth our ruffled feathers. The scene has shifted from an English village to a road between two Irish villages – Cahirmahone and Jacksport. Cahirmahone literally means 'backside town', but idiomatically means out-of-the-way, obscure town – as in the back room of a house. Jacksport is by name and reputation a livelier place. Cahirmahone has an Irish name, Jacksport an English name.

Three relative strangers come, or nearly come, to these towns. The first to arrive is Ambrose Oldbury the practical joker. He tries to deceive the people of Cahirmahone into believing that the Grand National is cancelled because of a burst brewery and that Jacksport has been blown up in an earthquake. His jokes have a very limited success. Next is a Ballad Singer and last comes Michael of the Song. Michael attempts to sing a song in Jacksport 'about nothing but your old waggin' world' (OSR p.150) and is rejected in the second verse because 'the unfortunate people thought it was personal' (OSR p.150). We meet only the inhabitants of Cahirmahone and environs – roadmenders, postman, teacher, pupil, policeman, peasant farmer, peasant woman, publican – and a student who prefers Jacksport, which is otherwise unrepresented, though the school is in that direction. Michael and Ambrose meet and have a psychological struggle with each other which ends in Ambrose murdering Michael at the same time as committing suicide himself – to all of which Michael responds with: 'Would it be any offence if I said a prayer for you?' (OSR p.158)

Nora McGuinness sees Ambrose as a declassé Anglo-Irishman – 'the Ascendancy rake' (McGuinness p.386) and Michael as representing 'the plight of the native dispossessed artist, come down in ability and social position from his Gaelic forebears' (McGuinness p.367). These suggestions fit well enough with their names and appearances and with the failure of Ambrose in the backwater Irish town, Cahirmahone, and the failure of Michael in the more lively Jacksport with its English name and implied cultural debt to that country: but are they enough to explain murder and suicide? Might there not be something, no doubt implicit in the two cultures of the emergent nation, that explains such a tragic conclusion and which gives greater credence to the idea of an inevitable struggle between these two when both are, to a degree, already defeated?

In fact this play extends the cultural clash into a clash between flesh and spirit, one in which the people of Cahirmahone are not uniformly indifferent (McGuinness p.386), but in which there remains still enough of the old values for them to appreciate the Ballad Singer's assessment of Michael as a 'great creature' (OSR p.162), and which explains why no one has a good word for Ambrose. If this interpretation can be backed up, then the use of 'Believe Me If All Those Endearing Young Charms' as an Overture is given much more significance. Since Moore is these

days reduced to the role of Victorian sentimentalist and since the use of the tune is important, the lyric requires explanation.

Moore's lyric (which could probably have been sung by memory by a generous percentage of a 1930s audience, either side of the Irish Sea) was written to reassure his wife when she was disfigured by smallpox. Moore had been a great ladies' man and this perfect lyric (for it matches its melody with great sensitivity) is not 'a desperate attempt to maintain a belief in an ideal', as McGuinness avers (McGuinness p.374). The first stanza is a realistic acceptance (hence 'dear ruin') of the certain ruin of the flesh. It does not sever soul and body, for the wish of the heart entwines itself round the ruin. The second stanza is a touching and confident assertion of the 'fervour and faith of a soul'. The soul is likened to the sunflower worshipping the sun, so the soul is given embodiment and the person it worships is no longer a ruined building but a sun rising and setting. The point of this image is not only to raise Moore's wife to conventional astral status, but to move away from the idea of a decaying building with dependant ivy (which will one day bring each other down) to the idea of a process that will be repeated with sunrise and sunset and the flower opening, turning and closing. The poem moves from the specific to the general – to a grander process in which all humanity shares.

The Old Sea Road starts in the early morning, over an hour before it is time to go to school, and only the two roadmenders appear. The second scene is an hour later and humanity is on the road and the sky is brighter. Act Two is in the evening, ending with a lurid sunset and the deaths of Ambrose and Michael, and the final Act takes place the following morning, at the same hour of day as Act One, Scene Two. Yeats makes pointed reference to the sun and the light in the stage directions, and the time span of the play enacts the imagery of the last line of the Moore, but realising the implied continuance of the process.

The relationship of the song to the play is not, however, such that we should be searching for a Mr and Mrs Moore in the latter. What is at issue is whether the ideals of the song are still in evidence in Ireland and, if so, have any likelihood of survival. It is for this latter reason that the theme of education is important in the play. The pupil's uncle relates his own education to hers; the schoolmistress and the pupil appear; the student is lectured by Michael of the Song. It was a topical subject as the young Free State had only recently been setting up an education system and

curriculum: that is why Nolan speaks of Ireland as 'the Home of Saints and Chisslers' (OSR p.146) – substituting children for 'Scholars'.

The central combat between body and soul, or flesh and spirit, around which the action revolves is between Michael of the Song and Ambrose Oldbury. Their names speak of their natures. Ambrose Oldbury means, in essence, Eternal Death. Ambrose for Eternity, but the Ambrosia he shares with Michael is poison. Poison is referred to as 'the weapon of the Saxon' in the 'Lament For The Death of Eogan Ruad ua Neil' published by Jack Yeats long ago in A Broadside[3], and this, along with his English name and his blue college blazer and badge, clearly identifies Ambrose Oldbury with anti-Irish forces, which did indeed spell death. His surname – Oldbury – obviously relates to Old Burier, hence Death. The question is not whether he can kill Michael, for he does, inevitably. What matters is the state of Michael's mind when Death comes.

Michael of the Song's name is also obviously significant. The archangel Michael guards the gates of Paradise following the eviction of Adam and Eve and is the traditional conqueror of the Serpent – the Devil in fleshly form. The tag to his name 'of the Song' allies him to the tradition of Irish song (including, no doubt, the Irish Melodies of Moore) to which Yeats was so deeply attached:

Those executions were against all that the songs of Ireland had taught all these years, all the ideas that had been looked up to.[4]

Here again the question is not whether he kills Ambrose, for the flesh dies of its own (hence Ambrose's suicide); but whether he can expose the flesh for what it is:

Without irreverence, I say the professionals are the spirit clothed in flesh. The amateurs are of course the flesh clothed in what looks like the spirit.[5]

Jack Yeats wrote the above in 1931 (just about when this play was being written), in the context of approval of Bishop Berkeley – a man for mind over matter, if ever there was.

The professionals are the ones I like. What was non-European Irish in Berkeley was what was professional. All the map from China to Holyhead, Sandycove and parts of Killiney is Amateur.[5]

One can deduce from this that Ambrose is an amateur and Michael brings his unwelcome influence to a halt. That Ambrose

represents fleshly pursuits is indicated by his possession of money and by his smoking. Michael has no money and no food and, though he politely accepts cigarettes, he always extinguishes them. Ambrose tries to disguise the fact that he is the flesh clothed in what looks like the spirit by burning a wad of money. Michael is not fooled and Ambrose is forced to burn the genuine thing. Michael is not impressed even so. He regards it as plain foolish and points out that the gesture should have been unnecessary (OSR p.157). The spirit of course needs the clothing of the flesh and Michael needs food and air. But he is not a slave to hunger and desire. We know he is hungry – he asks the student for food – but he refuses to go down to Cahirmahone when the student offers to treat him. The significance of all this is related to Ambrose thus:

MICHAEL But there's plenty of people doing things they don't get anything out of, drawing the breath of Life for a starter.
AMBROSE Well, as you say for a starter, we've got to do that for a starter. Some people aren't content with that, they have to inhale cigarette smoke. I do myself.
MICHAEL I hate to see good smoke disappearing down into the dark caverns of the unknown. I've got a stomach, that if I filled it full of smoke would soon be asking me to send down something more solid.

Ambrose also smokes a pipe. So does Christopher:– 'I'll have the tobacco or I'll perish', he says to Molly, who replies:–'It's an awful thing the slaves men are to the pipe' (OSR p.147).

The flesh is by its nature tied to the four elements, earth, air, fire and water. Cigarettes represent an abuse of the elements of air and fire. Poison represents an abuse of the elements of earth and water. Michael uses water and earth – the bog pool and wisps of grass – to cleanse and dry himself in what seems almost like a ritual bath before battle, and the importance of a right relation to the elements underlies the action. All four are specified as part of the setting. The Road itself, with its roadmenders shifting stones, is the earth; the air is referred to and illustrated for us by the sound of the lark whose native element it is; the sun is the fire; besides the bog pool, the sea, whose sound we are to hear throughout, is water.

The sky, sea and land are brighter than the people (OSR p.142)

That opening stage direction makes the importance of the elemental setting deliberately clear.

The effect of all this on the people of Cahirmahone is the ultimate concern of the play. What hope for Ireland in the struggle between spiritual and material values? The answer is mixed. Michael rids the community of its joker – the flesh clothed in what looks like the spirit – but is himself lost to the community as the price of it. Of the two, he is the only one who is specifically mourned, being referred to directly by the Ballad Singer, the teacher and Molly. But the Ballad Singer, recognising him as one of the 'great creatures', makes a specific accusation also, blaming the Policeman and those like him for laying him low. It is noticeable that, when the Policeman appears in plain clothes, Michael recognises him as a plain-clothes cop and puts on his hat, presumably to avoid recognition himself. The Policeman appears at this point in the company of the Postman who says that he is showing this strange young man the way to Cahirmahone. The audience and all on stage but Michael know this to be a blatant lie. The Policeman came from Cahirmahone that morning. The Postman then gets Michael to reveal who he is and identifies him as the man who caused trouble in Jacksport. Given what has been said above about the relationship between the two towns, this makes Michael a nationalist. There is little doubt about this anyway, since he has persuaded the student to sing a nationalist song while he, Michael, is having his ritual bath.

What of the future, though? Ireland cannot survive solely on the right instincts of a Ballad Singer and an old peasant woman who, be it noted, takes up a position in Jack Yeats's drawing for the final tableau suggestive of Mary at the foot of the cross. The teacher is young and has influence. At least she ackowledges that Michael was a handsome man – a word with a more generous meaning than mere looks, especially as Michael is elderly. She also makes no mention of Ambrose. On the other hand she has hoped that Michael has not been telling the student 'anything that wasn't good for him' (OSR p.151). McGuinness takes this to mean that the teacher represents Irish censorship (McGuinness p.368). This is possible, but I think unlikely. In the context of the arrival of the Policeman in plain clothes, I think it more probable that she refers to nationalist republican sentiments. Cosgrave was still in power when this play was written, and had been mobilising secret police to protect his position as leader of the Free State.

The teacher is also portrayed as having right instincts. She draws her pupil's attention to the sound of the bees in the heather

(the elements of air and earth) and then to 'the old sea, listen how he sounds' (OSR p.146). Her pupil adds (in the subtle, almost sly manner in which Yeats sometimes uses imagery) the last remaining element – fire: 'He makes a noise like a child that'd be eating stirabout' (OSR p.146). This extraordinary image is very accurate, for a child sucking porridge is not unlike the slappings of the sea on rocks (it is a rocky coast we are told); and porridge is made by the application of fire to a combination of grain (earth) and water. The child's education is good, then. She is taught to notice the right things and she eats the natural native food and is capable of relating her experiences to nature around her, however oddly or instinctively. She and her teacher exit hand in hand. At the end of the play, the teacher and Nolan (the pupil's uncle) look up to listen to the lark. His niece is also being taught Euclid and finds that hard.

Jack Yeats did not like geometry – or mathematics, of which John is a student. He once referred disparagingly to abstract painting as 'coloured Euclid'[6] and replied, on being asked to describe 'the loveliest thing I have seen':

I couldn't possibly tell you. But I can tell you that it has nothing to do with arithmetic. It reflects only one light from far more than twenty facets.[7]

That is a more subtle remark than might appear. Twenty is the maximum number of facets to be found on a solid regular figure – the icosahedron – the outer figure in the Platonic attempt to contain the solar system. The light of the sun at the centre of all this was not to be refracted by such a limited conception.

The student is absent from the final scene. He is, perhaps, the chief question mark that Yeats wishes to place at the end of the play. At least he knows 'My Dark Rosaleen' by heart and sings it with passion. But he smokes, studies mathematics, and thinks the commercial instinct is a necessity (OSR p.150), evoking an angry rebuke from Michael. The student is poised between the two worlds. He is discovered by the road, he does not enter, and he offers to feed Michael in Cahirmahone. But he admits he has not visited it all summer and, despite Michael's explanation as to why he is so hard on Jacksport, it is in the direction of Jacksport that the student exits.

Finally, we have the figures of Nolan and Dolan: both elderly, smoking pipes, shovelling stones more or less like Sisyphus:

We spread them here, and in the fullness of time they roll down the hill until they reach the charming village of Cahirmahone, where they lie night and day to trip up the feet of the ancient warriors of the place. (OSR p.145)

Dolan has little to say and that is all negative, but Nolan appreciates the lark, is full of speculation, but is forced by hard-grinding economic circumstances to limit his education to what he can glean from the newspapers. He also declares he is wedded to the drink, but he can't get any. These two do not point to the future so much as illustrate the past. The one is deadened, the other frustrated but takes pleasure in his niece's educational progress. The battle between spirit and flesh is, for one of them, lost; for the other a nicely balanced, frustrating conundrum. The play ends with a new dawn and the sound of the lark. If it also ends with a conundrum as far as the future of Ireland is concerned, that is only natural. It only makes sense to write such a play if the issue is indeed in the balance. And it would not be right to regard it as an issue with good on one side, evil on the other. Spirit and flesh need each other. Michael and Ambrose are not the archangel Michael and the Devil incarnate; they are suggestive of these extremes. But they are both human and have leanings towards each other. Michael has 'troubled spirits' (OSR p.150) and possibly accepts the poison knowingly. Ambrose wants to prove himself free but Michael asks 'What's that?' (OSR p.157). Ambrose presumed, wrongly, that Michael was a free spirit. Ambrose has joined himself with material poverty, not realising that Michael may not so much have chosen poverty as learned to live with it. That is where Michael's spirit resides. He has not sold his soul for a mess of potage, but would have been glad enough of a piece of meat. Ambrose, trying to prove he has another trick left to crush such a spirit, can only do so by murder and suicide, and he ends up leaning against the body of Michael. Perhaps the most vital line in the play, and the most moving in the implied political context, is Michael's last utterance to Ambrose, uniting them both:

Would it be any offence if I said a prayer for you?

Ambrose shakes his head and dies, and the prayer is said.

Michael's forgiveness of Ambrose at the end of *The Old Sea Road* suggests that there is still hope of reconciliation between the haves and the have-nots; between English values and Republican values. That hope is only given certain expression in Michael's

death – perhaps his martyrdom. If a lasting truce between the combatants is to be attained, there will have to be some yielding from the other side. It is not enough for Ambrose to accept the prayer for his soul: he must in the end pray for the soul of *his* adversary. *Rattle* leads up to the enactment of that prayer. Tommy Moore once more provides the Overture – 'Let Erin Remember', but the action begins in England in the enemy empire.

We have been shown in the first play of the trilogy that the representatives of this empire – the silly seven round the table – are vulnerable. They are the 'haves' and they are shown up in front of the 'have-nots' on their own ground. In the second play, the combat is much more profound because Michael and what he represents are much more significant than the rather nasty revenges of the English villagers. In the last play the 'haves' learn to yield, if not everything, at least half of it. The final act, in which this occurs, is a fantasy, set in a fantasy land that has parallels with Ireland, but is not Ireland. It has to be a fantasy because it ends with forgiveness and the death rattle of Empires. In the early 1930s they still had a lot of rattling to do, and we are not wholly free of it yet. But the first two acts return to the satirising of the 'haves' that forms the bulk of *Apparitions*.

The parallels between *Apparitions* and *Rattle* are subtle but real. They are presumably deliberate, giving a balance to the trilogy, but extending its significance. In both plays a group of people have to deal with something they have inherited from the past. In *Apparitions* it is the hotel ghost; in *Rattle* it is the family wharfing business, and a substantial inheritance from the State of Pakawana . In both cases the elaborate plans of the persons responsible for dealing with the situation come to nothing. In *Apparitions* two 'servants' (the barber and the waiter) of these people get the better of them; in *Rattle* the two employees end up maintaining the status quo, at the suggestion of one of them, because the owners don't know what to do; and on going to inspect his property in Pakawana, Ted is shot and bequeathes half of it to Pakawana, the other half to his family. None of the reviewers of the 1933 publication made any connection between the plays and some of them thought the last act of *Rattle* did not fit in the play it belonged to.

In fact, even before the curtain has risen, Yeats has prepared us for this last act. *The Old Sea Road*, being set in rural Ireland, has already introduced us to what (in world theatre terms) is an exotic

environment, inhabited largely by people without wealth. Such is Pakawana, the location of the last act of *Rattle*: and the playing of 'Let Erin Remember' as an Overture should have alerted us to the idea that something to do with Ireland is about to take place. Since the first two acts are in England, the second one ending with the arrival of a delegation from Pakawana, it should not overstrain the abilities of a theatre audience – or even a literary critic – to guess that this last act might have something to do with the relationship between the two countries. Pakawana might just turn out to be a metaphor of sorts for Ireland. Until Nora McGuinness came along, however, it remained totally unnoticed. In simple terms of the plot, the connection is made by the fact that one of the 'haves' – Ted – inherits very substantial property in Pakawana. The Pakawanians invest him with the Order of the Golden Wave and take him to their country where he is killed in a sporadic civil war and forgives those responsible. What does the Overture tell us about this?

'Let Erin Remember' is another of Moore's Irish Melodies which were known by heart by thousands of people in the days this play was written, though those thousands will have been mostly Irish people. But even the Irish failed to notice that the 'collar of gold' that Malachi won from the proud invader might relate to the golden collar of the Pakawanian Order of the Golden Wave. The Moore poem recalls heroic days of old and, in particular, the heroism of Ulster and the vision that may be had of that lost culture under the waves of Lough Neagh. Lough Neagh is central to Ulster. The Moore poem begins thus:

> Let Erin remember the days of old,
> Ere her faithless sons betray'd her.

In the context of a divided Ireland, with the Unionists still holding on in Ulster, it seems obvious that Yeats was using this song to say something about the Irish inheritance. The whole basis of the Irish civil war was the question of partition and Republican status. In the earlier history of the struggle between Ireland and England the Ulster people were the most vigorous in defence of their country. But now Ulster and the pro-Treaty government had betrayed their inheritance. We know that Yeats was against the Treaty. We know that he kept ballads from the thirties still referring to the betrayal of the country embodied by partition. Is McGuinness right, then, to conclude?–

The struggle is still apparent some forty years after Jack Yeats published these plays advocating the relinquishment of the struggle for control of Ireland. (McGuinness p.385)

To establish whether McGuinness is right or not requires a careful look at the play. *Rattle* is set initially in England. The conversation in the restaurant tells us this, for Barlock is that night going to Smarthkin (an English-sounding name) which is a 'Garden City in the North East' (Ra p.180). Ireland had no garden cities. The towns of Upper and Lower Halton are referred to (Ra p.12). Again these are English names of a kind virtually unthinkable in Ireland. Beckerton, who essentially runs the business, uses Cockney rhyming slang: 'everything'll be all Isle of Wight' meaning all right (Ra p.185); and Canty, talking to Ted, refers to 'your Lord Tennyson'. We must assume that England is the country intended and that the people in it are English in the absence of any other pointers. This is important, because McGuinness basically regards the Gardeyne and Golback families as Anglo-Irish:

The Anglo-Irish guilt is the principal problem in *Rattle* . . . One of their number is shown paying with his life for colonial guilt. (McGuinness p.386)

The business of Gardeyne and Golback is a wharfing business. They therefore represent trade, and we are shown that that trade is still going on, by the arrival of two separate cargoes. The initial response of the family to their inheritance is to close the business down and sell out to a cinema owner. They are going to create a stagnation in trade. The late twenties and the thirties saw a world recession and it is reasonable to infer that Jack Yeats is laying the blame for this on the 'haves' who have neither the will nor the competence to handle the businesses they inherit, but only think of them as a means of making money and providing themselves with entertainment (they expect to have free passes to the cinema and a share in the profits). Their schemes fail and the employees are given a rise and left to carry on. In effect Yeats is giving us his answer to the recession. Stop profiteering and pay some attention to the workforce. This is entirely consistent with his known political proclivities. John Gardeyne, in particular, changes from being aggressive to the staff (see Ra p.170) and ends up proposing the rise in salaries and forswearing his ability to hear the death rattle in businesses (Ra p.183).

I have already pointed out that this was a world recession and

should not be seen as a specific comment on Irish affairs; but the world recession involved Ireland and it naturally involved the relations between nations, leading in part to the Second World War. A recession, in other words, was dangerous and Yeats introduces a very pointed symbol to show us that it is dangerous. William Gardeyne notices it, but fails to understand it:

There is something which is the exact opposite of the steady ebb and flow, flow and ebb, of the tide up and down this river . . . Why yesterday, ah, and there it is still! . . there was a piece of broken wood, off a packing case with some letters on it. P.E.A.C., I think – and then it was broken off. It may have been for peach or peaches . . . I saw it get caught in an eddy . . . There it stayed caught up. . . But there is some symbol there. Perhaps this vagrant wood is to show that the rhythm that cannot be mastered can be enjoyed until it laps you gently into a state of bliss with a number of other pieces of drift. (Ra pp.183-4)

The ebb and flow of the tide obviously implies the coming and going involved in trade – literally in the case of a wharfing business. A piece of wood caught in an eddy negates that process. William guesses loosely at that but concludes that it is good to be caught in an eddy 'with a number of other pieces of drift'. 'And how would you apply the symbol to us dear?' asks his sister Christie. He does not know. But the audience should know. He and his family have been gently mocked with their idle quarrels and their silly ideas. They are caught in an eddy like pieces of drift, indecisive, unbusinesslike, in static bliss. That's all very well for them, but what about the rest of the world, and what about the letters on the wood? Might not P.E.A.C. have ended with an E.? And if it did end with an H., does that not spell a word that means to betray? At this stage in the play the family are still thinking of doing away with the business and have made no room for the employees in their plan – one of whom consistently reminds us of his presence by thumping about upstairs. In other words, they are contemplating a betrayal of their employees, but in the end they do not. There is peace between the 'haves' and 'have nots'. A similar symbolic usage with respect to the distribution of wealth is to be found in Dickens' Harmon – will he cause Harm or create Harmony? Jack Yeats's Uncle Alfred was Secretary of the Dickens Society in Liverpool, where he managed the Middleton and Pollexfen firm's Sligo Steam Navigation Company office. There is room for much speculation in relating the family business to the family wharfing business of Gardeyne

and Golback but we must stick to the facts. How do we relate this apparent reconciliation to what goes on in Pakawana?

In the first play of this trilogy, the struggle between the flesh and the spirit has been farcical, the spirit being a fake ghost and the consideration of the spirit in such terms being satirised. In the second play it takes on its full tragic significance in the context of individual and national consciousness. In the third play might it not be given practical expression in the struggle between the rich and poor within and between nations? We have seen the answer Yeats gives within the nation of England; but what of Pakawana, whose wealth is bequeathed, after ten years in trust, to an Englishman?

In the Note on the Chronology, I have argued for a date of composition of these plays of around 1932. That is to say, when De Valera won the election and, to some, betrayed the IRA; and just ten years after the betrayal of De Valera by his own representatives, when they signed the Treaty with the betrayer-in-chief, Lloyd George.

> Let Erin remember the days of old,
> Ere her faithless sons betray'd her.

What happens then, in this fantasy-land of Pakawana? Ted is handed over a symbol of its wealth (the collar and cloak of the Order of the Golden Wave) and the papers that signify his legal right to that wealth; he is invited to the country to inspect it: and then he is shot. This shooting is presented to him as an accident and he forgives everyone – he goes so far as to say that there is nothing to forgive.

But the shooting is not an accident, it is a set-up. As the shooting comes close, his guide and interpreter, Dr. Canty, admits that they have arrived two days too soon, that their arrival was advertised by the smoke and sparks from the steamer being pushed to her limit, that the Capital has been kept ignorant of this, that there is a fight on in relation to a government post, and that though they would respect a flag of truce they don't like it. No sooner is Ted shot (by the first rattle of shots – presumably to make sure of him) than Canty hangs up his white shirt on a branch and the shooting stops. He gets Ted to make a will and then gives a signal, at which the leading revolutionary, Gossgogock, enters with the supposed protectors of Ted. Ted says he had forgiven Gossgogock long ago, motions for the collar to be taken off him, – 'Yes, take the old harness off you', says Canty – and dies.

Put simply, the state and the revolutionaries have colluded in the assassination of Ted in the kindliest manner possible, in order to get him to yield up the wealth of their nation. That this simple fact has not been noticed before is understandable, as the play has never been produced. It therefore requires careful visualising of the stage directions and memorising of costume details to notice that Canty's shirt is white and that all the previous gunfire has been single shots and that Canty actually signals the others to come on. Jack Yeats was an artist and visual things mattered to him, so it is a great pity that such explicit visual direction has occurred only on the page. In the theatre it would be as clear as day.

Unfortunately, when Ted yields up the wealth of Pakawana, he only yields half of it. The English get the other half. The Empire dies slowly, tired of troubles (the old harness), but wedded to the conventions of inheritance. McGuinness understands this other half of the inheritance to be Northern Ireland (see above) and I agree with her – especially in the light of the Moore poem. What I cannot understand is how she deduces Jack Yeats's approval of this division. What we have in this final scene is the vision of a nation with potential divisions acting in unity against a common financial oppressor who continues to divide the nation's wealth. To the Irish the division of Ireland was economic as well as political and religious – as the poem, by 'Top Hat', called *Paddy and John Bull*, indicates. This poem was among Yeats's collection of newspaper cuttings and ballads and is referred to in Chapter 5. It dates from 1938 but the point that it makes with respect to the economic significance of the North to Britain and Ireland was as true in 1932 as six years later.

The point in *Rattle* is that in international relations the poor can at least partially outmanoeuvre the rich and win back their inheritances. In the end, De Valera was to succeed in this with respect to the Irish Free State for which he finally achieved Republican status, but in 1932 there was no guarantee of it and Yeats may have been fearful of another betrayal. There is an interesting and relevant parallel between the position of Ireland and the position of India at this time, one which explains the odd condition of Ted's father's will, that the revenues of his estate go to Pakawana for ten years before being passed on to Ted. In 1919 the Government of India Act retained India as an integral part of the British Empire but made express provision for another full enquiry in not more than ten years' time into the possibility of a

more autonomous form of government. When those ten years were up, the Simon Commission came up with proposals unacceptable to the Indians and, in particular, representing the 'have-nots', unacceptable to Gandhi who visited Britain for discussions in 1931.

It seems more than likely that Yeats had India in mind as well as Ireland. Not only is there the coincidence of the ten year provision, but the palanquin on which Ted's corpse is carried off, and to which much reference is made beforehand, is an Indian object and an exclusively Indian word. There may even be a hint at the visit of Edward (Ted) Prince of Wales to India in 1921 – a visit marred by riots. The presentation of a gold collar studded with pearl and emeralds is typical of such state visits and symbolic also of the yielding up of a nation's treasures. There is quite probably an echo here of the scandal surrounding the theft of the 'Irish Crown Jewels' as the diamond star of the Grand Master of the Order of St. Patrick was known. Edward VII (another Ted) was much angered by its loss in 1907, though rumour even included him among the suspects. However, Ted refers to the Pakawanese language as 'a sort of Spanish I can't find in any dictionary', and the 'emerald gem of the western world' representing Ireland in the Moore poem is part of the insignia of Pakawana; so we may reasonably conclude that Yeats intended a comment on Empire in general, but was ready to use current situations and nudge us in their direction. One of these nudges is particularly direct when Dr. Canty says:

. . . there is a country, nameless, where with crowbars and hammers –
(*He hangs his head*) your Lord Tennyson said (*He recites in a deep sonorous voice*)
And all talk died, as in a grove all song
Beneath the shadow of some bird of prey.
(*He stands silent, and Ted hangs his head also. Then drinks again.*) But never in Pakawana.

That country was Ireland, and it is the forcible evictions of the land-grabbers in the nineteenth century that is recalled. The land-grabbers were as often Irish as English, so the quotation from Tennyson, referring to the betrayal of Arthur by Launcelot's adultery with Guinevere, points to betrayal within the country as well as outside it. There is dramatic irony in the quotation as Canty and Ted are in a grove and they sit silent, surrounded by gunshots which eventually kill Ted. He too is quite deliberately betrayed.

What separates this play from its several analogues is that Pakawana is already a republic and Ted forgives his assassins. The freedom that is being sought here is economic freedom: the oppressor of that freedom yields half of his possessions and accepts the circumstances that lead to his death. Likewise the Pakawanians accept the dissensions in their own ranks. True, there must be collusion with Gossgogock, the revolutionary, in the killing of Ted; but he is a revolutionary just the same. The Pakawanians have also managed to deal with the arrival of a group of Utopians who have eventually asked to be deported. Presumably their schemes for a perfect society have provoked a poor response and they are sent off to an island called (by Canty) Renaygia. They have turned their backs on social reality. They have no matches or cameras: they are, as Canty says, 'like a cul-de-sac-on-a-starry-night and here-comes-the-thunderbolt' (Ra p.199). They have reneged on society at large and they are doomed. Yeats did not seem to care much for photography – he refused to allow photographic reproduction of his work and he left no family album – and he uses fire (in which we may include matches and cigarettes) for the most part as a negative symbol of man's machinations: but he was not going to propose a society in which these things were banned. In the midst of his visionary nature and at the basis of his hopes and fears for humanity was a profound realism – the profound realism of a man who observes the world acutely and knows what can and cannot be expected of it.

If, like Moore's fisherman on Lough Neagh, he is looking back through the waves of time at the 'long-faded glories they cover', he is not expecting those glories to be without a proper but ruthless self-interest. Malachi was a warrior. What is idealistic of Yeats in this play is that the winning back of the collar of gold is done without animosity on either side. There is no good or bad suggested in either Ted's ready acceptance of what is a monstrous inheritance, or the Pakawanians' contrivances to get it back, and Ted forgives them for it. That is why Ted says:

Why, I have forgiven him a long while ago. (Ra p.205)

The point is that Ted has guessed all along what might happen and has resigned himself to it. The reconciliation that his family effected with respect to their inheritance in England he has effected with respect to his inheritance abroad. If there is a message to the rich and the powerful in this, it is simply to ask

them to practise abroad what they needs must practise at home if there is to be peace and prosperity anywhere.

There is still a price to pay, though. Ted and his family have had to yield to forces that are in the end more powerful than their own greed just as Ambrose has been defeated by Michael. But Michael died for that, and the Pakawanians are not yet free of the yoke, for half of what is rightfully theirs is still in foreign hands, just as Northern Ireland remains the sad reminder of a policy of possession that has run unabated from the time of Elizabeth and James. And it is only possible to make these reclamations if the poor are strong and united against their oppressors, whatever their internal divisions may be.

The Republic of Pakawana is symbolic of that unity without denying the existence of divisions. The blue shirts and the yellow trousers of the members of the Order of the Golden Wave bring together the opposing colours of the political spectrum of Yeats's younger days – Tory and Liberal. Oakin (his name represents old England just like Hardy's farmer Oak) sees the yellow of the Pakawanese sailors' uniforms and declares it to be 'fever colour'. Liberalism was always disturbing to the English mind, notwithstanding protestations to the contrary. 'Yes, fever' agrees Canty. 'The fever that flows for ever in the blood of the people of Pakawana.' (Ra p.189).

We have seen that in *The Deathly Terrace* yellow is also the colour of betrayal. The Liberals did indeed betray Ireland, but in Pakawana liberalism is 'in the blood' as well as being donned in the morning. The blue shirts could conceivably represent the beginnings of the blue-shirt fascist movement in Ireland, blue shirts first appearing in 1932 when the play was probably written. If so, General Golmozo and his son, the revolutionary Gossgogock, and all the members of the Order of the Golden Wave, Ted included, are part of it, and the old divisions of left and right are breaking out anew in Pakawana itself and it may take more than a uniform to hold them together, just as the hopeful symbolism of the green, white and orange of the Irish tricolour remains a symbol of division rather than unity. But I offer this as an idea, not a certainty. It is at least worthy of consideration. Symbolism of this kind is natural to a painter, but it is also natural to people. The green, white and orange on Glasgow's buses had to be abandoned because of protest from the protestant community who were appeased with orange on its own. Blue shirts were worn because of what they stood for. The

liberals still sport yellow; the tories, blue. At the end of *Rattle* it may be that as one trouble begins to die away, another begins.

There is one other possibility to be considered with respect to the uniforms, and that is that the blue and yellow are Uncle Fred Pollexfen's racing colours. They are also the colours worn by the Governor at the end of *In Sand* which, along with *Rattle*, concludes with a scene of forgiveness and reconciliation between the 'haves' and the 'have-nots'. It is possible that Yeats felt there was some family reconciliation effected in these scenes as well as in *The Amaranthers* (see Chapter 10), and there is no doubt that he was well aware of the significance of racing colours, for he brought a much-admired wreath to his Uncle George's funeral, made up from flowers in Uncle George's racing colours of yellow and violet.[8] It would be appropriate, then, for the troubled world of Ted/Fred's inheritance to be laid to rest in Fred Pollexfen's colours.

And so the trilogy is rounded off. At the end of this varied, complex, and humorous satirical adventure, the 'haves' and the 'have-nots', though their differences are not wholly settled, are at least charitable towards each other in spirit. In *Apparitions* there was wholesale aggression and vicious satire: in *The Old Sea Road* the combat was at a more metaphysical level and led to a mutual tragedy: in *Rattle* the wealthy forgive the poor and the beginning of an accommodation between them is possible. Yeats asks only that we understand and forgive. In particular he presents to the rich a scenario in which it is possible for them to forgive. The death rattle of empires is still audible; may they die like Ted, with grace.

5

The Context of War (1):
Harlequin's Positions and *La La Noo*

'Far' is a good adjective, every idea I care for seems far. I'm stiff sitting while the smelly ones get on with this last act of this play called 'Dirty Tricks'. However, it'll gather way presently and I can wait. The last curtain, when it does come down, will be so tattered, that it will not be able to be used under the excuse that it is a mantle of decency. It'll be full of holes.[1]

It should have been obvious from the outset that these plays, both set in contemporary Ireland, were deeply concerned with Ireland's position in the context of war, prophesied and fulfilled. The curtain rose on *Harlequin's Positions* on 5 June 1939. It was full of talk of war when everyone was talking of war. 'It is a play of war's alarums'.[2] It earned itself an unplanned second week but, in the tiny Peacock Theatre, that still left only a few to challenge the obtuse response of the critics. *La La Noo* raised the curtain on 3 May 1942, on a threatening sky, and lowered it on 'a tattered red sunset'. 'Observe it well', says the Stranger, 'If it's mad looking, with a tattered mantilla on its face, it'll be a bad day tomorrow' (LLN p.306). In 1942 curtains and sunsets were all pretty tattered. *La La Noo* was, however, welcomed by the critics, nearly all of whom acknowledged that it impressed them with a significance which they could not explain, though once again there is much talk of war and death.

Because there was very little action in these plays, they were thought by some to break all the rules of theatre. But the rules of theatre appear to be just as arbitrary and fluctuating as the plays to which they are applied, for *La La Noo* sticks strictly to the unities and *Harlequin's Positions*, which is full of small but signifcant actions, does them little injury. In fact *La La Noo*, with the off-stage death, even honours the classical proprieties; and the harlequin's positions are also part of an ancient theatrical tradition.

In both plays the main course of the action involves the arrival

72

of a stranger in a small community, and there is an element of quiet comedy in each situation – the genteel family frustrated with their baggage at the station by two characterful porters, ancestors of Gogo and Didi; or the seven women, soaked to the skin, naked behind a publican's door while their clothes are dried – and shrunk – for them. But if they are comedies, they have a shadowy sort of intrigue about them: Alfred has ambitions and a gun; the Stranger in *La La Noo* is killed in an accident that seems almost predestined; and the whys and wherefores emerge in seemingly isolated bubbles of significance: only, like a bramble hedge in autumn, as you pass along it there is hardly a part of it that is not fermenting, and this is as true of the actions as it is of the words. After all, if actions are supposed to speak louder than words, it is more than likely that a figurative painter of fifty years' experience with a reputation over two continents will be inclined to make use of them. When a knife is thrown at a card in *Harlequin's Positions* or a hat stolen in *La La Noo* it would be naive of us to imagine that these are arbitrary actions of only local importance. 'Everything's symbolical if you look at it in the right way' says Alfred (HP p.270). Look at Jack Yeats's plays in the right way and they are seen to be full of significant action.

Harlequin's Positions is also rich in terms of plot and is full of the cross-currents of conflicting motives. The action takes place in Portnadroleen: first in the house of relatively wealthy people; then overlooking the harbour; and finally at the railway station. There are two Pilots (river pilots) and two Porters and a railway Guard, and they keep an eye on the comings and goings to seaward and landward of 'The Port of the Little Wren' – as its name would be in English English. In Ireland, 'droleen' is both Irish and English for the wren, so there should be no doubt about its meaning. Here is one of those instances where the common symbolic knowledge of ordinary Irishmen of the time is put to use. The wren in Ireland is a symbol of betrayal as it warned a group of sleeping English soldiers of an Irish ambush, by tapping with its beak on their drum. It is for this as much as for St. Stephen that wrens were stoned on St. Stephen's Day in Ireland.

Annie Jennings is a Portnadroleen orphan who owns a central portion of land in the town, has just sold part of it (the old store) to a cinema company (HP p.252), and could be seen as betraying the economic interests of the locals for personal gain. There may be echoes of the Jenny Wren in the name Jennings – and of Johnnie Wren in Johnnie. His father is killed in prison 'by a falling

stone' (HP p.264) – like a wren. On the fruits of the sale, Annie Jennings, two elderly sisters (both widows), their nephew Johnnie and Kate, the maid, are to go on a world cruise. It is a last-minute plan, almost like a cut-and-run operation, which Annie keeps from Johnnie until she is sure it is well under way – why, we are not directly told. The rumours of war which put paid to the plan all come via the two porters. They unload the baggage when no one can decide what to do, and it is they who discover the visitor Alfred's loaded pistol. In the last act the sisters, Johnnie, Annie and Kate do not appear. But Alfred is there in the shadows, silent and smoking until he is turned away by the Guard.

The impression this gives is that the railway staff are more in control of events than anybody else. The wealthier inhabitants have been immobilised and Alfred is now without passport and gun. The play concludes with a little procession of Newspaper Boy, Apple Woman, the Guard and the two Porters,the Guard picturing them all as gods, heroes and supporting troops. 'I'd put out that lantern', he says, 'We're in mufti now' (HP p.296).

If there has been, or was about to be, a betrayal, it appears that the little wren, and those whose attempted escape she organised, have been contained by the local troops and the curtain can go down because the alarm is over. But what was there to be alarmed about in a cheap world cruise with a Liverpool shipping company, and where is the relevance of Alfred and his harlequin's positions in all this?

The answers to these questions extend, or are in conflict with, previous interpretations – especially Nora McGuinness's, who sees Alfred as a kind of outsider-hero (McGuinness p.84) resented by a paralysed community (McGuinness p.403). However, she admits that:

During a cataclysmic war, the values of isolation and neutrality are enhanced, even if paralysis is their price. (McGuinness p.403).

The point of disagreement between us is on the use of the word 'paralysis'. What this play shows us is the Irish community actively, but subtly, defending its assets. The community uses the weaknesses of its middle classes and – as McGuinness herself knows, because she uses the quotation – Alfred is not up to the subtleties of the railway employees or the town as a whole: 'You haven't been here long enough to hear everything yet' (HP p.290).

Because this play has been so little understood it is necessary to justify my interpretation closely from the text and this is done at the expense of analysis of the play's subtleties in terms of comic characterisation and dramatic tension. It is one of the richest and most complex plays I have ever read and what follows only aims to establish the basic understanding that is necessary before the play's artistic achievements can be properly discussed. One might ask why is such a basic understanding not obvious to all from the play? The answers are that very few people have ever actually seen it; that it was not published until 1971 when aspects of its relevance were less obvious; and that the reactions of its audiences are largely gauged by the writings of newspaper drama critics – a breed in whose perspicacity it is not good to have faith if one is interested in scholarship. Yeats kept a letter to *The Leader* from one member of the public sufficiently concerned to write at length in defence of the play against the critics – but even he was puzzled by some of its most obvious symbolic actions:

There were more puzzling episodes and ones not so easily reconciled – perhaps they are not intended to be. There is, for instance, Alfred's dismal failure to transfix the Ace – and I wish I could be sure that when Johnny (*sic*) trod so callously on the card it was not merely by accident; Annie coolly buying all her eggs in one basket, after cancelling the trip to America, and the final exasperating fiasco of the discovery of Alfred eavesdropping at the railway station.[3]

The Ace of Clubs (the card specified) is a shamrock and the shamrock is Ireland: therefore some injury to Ireland is attempted – and fails. Johnnie's action is not in the stage directions but may have been added by Yeats or the actor to underline the point of abuse of the national symbol. Kate, the maid, picks it up and replaces it pointedly. The injury involves the agency of a relation from overseas, Alfred, a man with a plutocratic background in shipping and mining who carries a gun because 'the natives might rise' (HP p.290). Jack Yeats was on the side of 'the natives' and this play ends with the middle-class travellers frustrated and the 'natives' in control. Yeats himself had long since put travel behind him – apart from trips to London for exhibitions of his work – and basically holidayed in Ireland:

An I'd rather be strolling the quay,
An watching the river flow,
Than growing tea with the cute Chinee,
Or mining in Mexico,

An I wouldn't care much for Sierra Leone,
If I hadn't seen Killenaule,
An the man that never saw Mullinahone
Shouldn't say he had travelled at all.

In Ireland it was quite possible that whoever wrote that ballad had seen most of the places named in it. Perhaps Jack Yeats had it in mind when he cast Alfred as a man from Latin America with a mining background, and who condescendingly says to Johnnie:

These little places can produce great men, if they can't use them. That accounts for your being thrown up, as it were. A star to shine in other firmaments. (HP p.271)

Such a view as Alfred's was anathema to Jack Yeats – as has been ably pointed out by Martha Caldwell in her thesis on his paintings (Caldwell pp.76 and 125) in which she reminds us that Jack's father had also resisted cosmopolitanism as 'another name for dilletantism'.[4] That Johnnie would rather shine in the local firmament by encouraging tourism is, however, no point in his favour. Jack Yeats disliked tourists and dreamt up schemes to discourage them.[5]

The theme of cosmopolitanism versus self-sufficiency was absolutely crucial to Ireland in the late thirties. De Valera's 1937 Constitution was an unequivocal statement in favour of self-sufficiency. With it came the opening of the Shannon hydro-electric scheme, referred to in the play (HP pp.286 and 288), and the assumption by Ireland of the responsibility for her own defences. Yeats had negative feelings about the march of technology and may well have had little sympathy with the shifting of ideals from rural to industrial, but on the issue of Ireland's defence I do not believe anyone would suggest that he would have been happy to leave it in the hands of the British. But it was a contentious issue and Shaw mocked W.B.'s belief that an Irish army could 'throw back from our shores the disciplined uneducated masses of the commercial nations'.[6] Shaw's response was directed at De Valera (W.B. was dead), but the target was the same in essence:

'Until Mr. De Valera admits that Ireland can do nothing for herself by herself except commit suicide nobody will waste time listening to him.'[7]

In the event Shaw was proved wrong and W.B.'s and De Valera's faith in an Irish army was never tested outside an obscure play by an artist who had wider eyes than most; for in *Harlequin's Positions*

that little national army of railway employees and river pilots is able to outmanoeuvre the enemy without striking a single blow. The ports, that Ireland had just won back from England, were not so easily entered as Shaw imagined. The pilots have not gone to the assistance of the steamer from South America: they watch her progress with mild and unconcerned amusement through binoculars:

PILOT River Plate. I had him a minute ago, I thought. But there's a bit of a haze down there. I think he's fumbling about there. Ah, I've got him now – he must be burning a horsehair mattress off a sofa. Here, look yourself. (HP p.267)

Later, the 2nd Pilot, when the company are remembering old sporting contests, recalls watching croquet played at Plymouth and the talk then turns to the view over the ocean. The connection with Drake playing bowls at Plymouth while keeping an eye on the Armada is irresistible. But it is done so deftly that it might be missed. That is the point. The whole play is a wondeful conjuring trick of the utmost simplicity and subtlety – the enemy, including those in the audience who underrated the Irish capacity for manoeuvre, is outflanked; not by anything esoteric, but by its own incredulity. All you have to do is look at this play with the understanding that there are more ways of conveying a situation than by bald statements of intent, and that situation becomes as disturbingly clear as distant mountains before rain.

The unease in this play stems from Alfred. He has been in shipping, is in need of money, and is looking up old family connections; trying, if you like, to renew old alliances. England was performing that caper, prior to and at the outset of the war, when De Valera might have bargained away Ireland's neutrality in return for an end to partition. Neutrality was a popular policy but there were people in Ireland overtly and covertly spying out the ground to see whether the Irish could be drawn to one side. Alfred comes from the same part of the world as the steamer which is struggling up river into Portnadroleen. He is spying out the ground, he may have others behind him. The 1st Porter wonders whether there are not spies at the next station (HP p.281). The Treaty Ports, though by then wholly Irish, were still under threat and remained so well into the war. The threat was of invasion to recover the ports (in the thirties the British drew up artillery-scale maps of Ireland). Shaw more or less gave Churchill permission to do it in the name of the most Holy Trinity.[8] In his

victory speech Churchill made it clear he would have invaded if
he had thought it necessary.

That their possession of their own ports was closely linked with
money was all too obvious to the Irish who had only regained
them after a long trade war with the British – one of W.B.'s
'commercial nations'. Capital and commerce are just as important
themes in the play as war, no doubt because, to a left-wing
republican like Jack Yeats, they were inextricably entangled. The
capital is Annie's inheritance, which can obviously be taken to
mean not just a small fortune, but the national fortune. She has
sold the old store, the heart of the town's commerce and social
interchange, to a cinema owner who will, no doubt, take the
profits away. The cinema, from that point of view, is a social
blight. She is offered a substantial sum for her shares in the
cinema, and it is this sum which is to pay for the trip abroad.

Obviously it was important for Ireland not to lose her assets, so
Annie Jennings does not get to leave Ireland to queen it
elsewhere. But, forced to accept the new reality, she buys a
basket of new-laid eggs (she insists that they be new-laid) to the
extent of half-a-crown's worth – half of Ireland (the other half still
being under the British crown). When the eggs arrive, however,
they have been sold on condition that Annie buys them all for an
additional shilling. Bit by bit, in other words, Ireland is buying
her independence. This sort of symbolism should have been
particularly clear to an Irish audience. It was used in current
political poetry, such as the following poem, kept by Jack Yeats
among his papers and dating from July 1938, just at the time
Harlequin's Positions was almost certainly being written:

Paddy and John Bull

In a very friendly atmosphere I've heard the people say,
The British and the Irish had a chat the other day,
We are going to send you plenty beef, we'll keep your larders full
And we'll drown your land with Irish eggs says Paddy to John Bull.

John Bull says he'll pay good prices and wants them to be friends,
but Paddy replies:

But what about the border the cause of all our woe,
Now don't you think it should be scrapped since many years ago?

John Bull, however wants to hold on to the North: he has lost
India and Palestine, he says; he needs Northern Ireland's flax and
her shipyards. Paddy replies that there can be no friendship
between them until the border is scrapped.

When you have got a divided nation selling eggs to the divider, then putting one's eggs in one basket has obvious significance. It means that you align yourself with one course of action. The question in this play is, which?

Johnnie also proposes keeping 'all our eggs in one basket' (HP p.268). He does this in the context of a political discussion with Alfred in which they imagine themselves travelling light through the oncoming barbarism of war, emerging safely on the other side. 'Well that's profound of you', says Alfred, 'Whatever happens to the eggs, we are bound to have one good big basket anyway, more useful than a lot of little ones' – and he continues by suggesting that Johnnie could use the basket to 'paddle away in it to a better pitch' (HP p.269). Since these two, as I shall show, are probably after Annie's fortune, it looks as though they aim to make off with it, carrying it into the wars, prepared to use up the fortune and then off to another 'pitch'. This is the tactic of the welcher who wants Ireland to place all her bets with him so he can run off with the money. Middle-class Unionists wanted Ireland to throw in her lot with the British in the coming war. Yeats is warning against them.

That this whole discussion with Alfred is a political matter is naturally perceived by Johnnie who proceeds to recount his dreams which he has inherited from his father. His father dreamed of Gladstone and Disraeli – looking to England for a model. To an Irish nationalist, the policies of Gladstone and Disraeli were as ignorant and brutal in effect as those of less well-intentioned politicians. For Johnnie, the figure 'haloed round with the morning sun' (HP p.269) is Shaw. Like his father's, Johnnie's dreams look towards England, where Shaw was comfortably ensconced, telling Ireland that she was powerless in international affairs. This discussion between Alfred and Johnnie is supposed to be a secret one, for Alfred asks 'isn't this place rather public?' to which Johnnie replies 'Not at all, Joey's deaf as a post' (HP p.267). But there are tensions between the two men and their discussion is more like sparring than conspiracy.

A parallel to this private conversation between Alfred and Johnnie is the private conversation of the railway staff, the Apple Woman and the Boy in the final act. The Guard refers to a ballad at the end of the play – 'This Grand Conversation Was Under The Rose'. Its title enjoins secrecy, and the Guard advises the Apple Woman to take no notice of what she hears said. One of the most

enduring lines, in the many versions of the ballad's regret for
Napoleon's failure to liberate Europe, is the line: 'The active
Napoleon did make the money fly about.' In Ireland's situation
the money needed to fly about at home. That is a viewpoint not
easily reached by internationalists, but with a war approaching,
and the vast expenditure that involves, the cost of supporting
Britain would have been crippling to Ireland. The approval of
money flying about at home is underlined by the Apple Woman,
who carries all her apples in one basket, and who wears a green
dress, perhaps suggesting that she represents Irish patriotism:

GUARD . . . But you sold your apples for your basket is empty . . . it was
a good fair they tell me. Was it so Mary?
APPLE WOMAN They were in grips at the commencement, but later on
a great quantity of money was passing.

The Guard too has been making the money fly around at home by
betting on cards all night in Droleen, but it seems that this little
town is a match for him where others have not been.

 This practice of Yeats's – using a small community such as
Cahirmahone or Portnadroleen to stand for a nation – was not
without celebrated precedent. Shaw uses the same parallel
between personal and national fortune in *John Bull's Other Island*.
Like Shaw's Nora Reilly, Annie is an orphan heiress. Like
Broadbent, Alfred is an internationalist, with South American
interests associated with shipping and commerce, and carries a
gun. Like Doyle and Broadbent with Rosscullen, Johnnie has
schemes for developing Portnadroleen. The connections
between the plays are remarkable; but Shaw's Broadbent wins
the heiress, whereas in *Harlequin's Positions* Annie remains
unattached and the money ends up in the hands of a Liverpool
steamship company (to be returned it is hoped) and the movable
estate never makes it beyond the station. Johnnie, unlike Doyle,
is at a crucial stage where he might be influenced by the likes of
Alfred – and they are probably rivals for the hand and fortune of
Annie/Nora. Among many other things, *Harlequin's Positions* is
almost certainly written in direct opposition to *John Bull's Other
Island* – a play well enough known to theatre-goers and one not
without influence on British and Irish opinion. We shall see that
Yeats himself was prepared to think of it as a riposte to Shaw.

 Shaw's declared aim was that the Irish should 'be shewn very
clearly that the loudest laugh they could raise at the expense of
the absurdest Englishman was not really a laugh on their side.'[9]

Shaw must have been a problem for Jack Yeats. They shared too much: left wing views, nationalism, and something more disturbing to Jack. As W.B. put it in *On The Boiler*:

The Irish mind has still, in country rapscallion or in Bernard Shaw, an ancient cold, explosive detonating impartiality.[10]

What was, no doubt, disturbing to Jack Yeats was that the impartiality came from a man who had exiled himself. That was a kind of betrayal; a reversal of Jack's own procedure. Also Shaw was a successful and wealthy dramatist who used his position to tell the Irish that they were powerless, a view in which he was consistently wrong. Jack Yeats refers to Shaw far more frequently than to any other writer. *Harlequin's Positions* was in part an attempt by him to cope with Shaw and demonstrate that Ireland had options. Replying to a letter from Joseph Hone (alas untraced) on this very play, Yeats wrote:[11]

I understand your feelings about the steamship company trouble. I should offer the idea of a sequel play to Shaw.
To Commemorate the Return of Mr. Shaw To The Emerald Isle
THE VICTORY OF PORTNADROLEEN
or
HOW THEY GOT THEIR MONEY BACK
by George Bernard Shaw
Every Evening at 8.15 for EVER

Presumably Hone's feelings referred to the lingering doubt as to where that part of Ireland's wealth still held by the steamship company would end up. Once Annie has been scared into cancelling the trip, she may not have a right to recall it. The play Yeats offers to Shaw is essentially humble pie for him to eat, once he realised that his lack of faith in Ireland was misplaced and he returned home. In Shaw's defence, let it be said that, towards the end of the war, he conceded he had misjudged Ireland:

Howbeit, that powerless little cabbage garden called Eire wins in the teeth of all the Mighty Powers. Erin go bragh.[12]

By 'all the Mighty Powers' he means Britain, Germany and the USA – even Roosevelt began to make longing lapping noises round the quays of the Treaty Ports.

But what of those questions I asked earlier? Where does Alfred and his positions fit in all this? Alfred is a distant relation who may have claims on the Clonboise estate, and who is an incompetent clerk by his own admission (HP p.269) and a man

who 'can't have enough' of it, meaning money (HP p.269). He
has no scruples about the getting of it and recommends to
Johnnie the method adopted by Sinbad 'where the lad threw in
the meat and had eagles pick it out again, stuck all over with
jewels' (HP p.270). He says the tale is symbolic, which it is. The
meat used was rotten, the method of obtaining wealth corrupt.
He then goes on to claim for himself an almost miraculous right to
rule – 'I was always intended for command also' (HP p.271). He
speaks like Broadbent as though he were an apologist, however
unwitting, of the British Empire which survived on just such a
conceit. Though he has offered no motive for coming to Ireland
other than curiosity, the Clonboises assume that he knows about,
and is interested in, Annie's fortune (HP p.255) – Ireland's
wealth. It is the practice of Imperialists to maintain that the
countries that are bled by them have no wealth, so it behoves us
to recall the lessons of Swift's Drapier Letters and the fierce
rebukes of Keegan at the end of *John Bull's Other Island*, and the
fact that when these supposedly poor countries seek their
independence they are usually resisted, as was Ireland, by force
of arms in the teeth of their democratically expressed wishes.

But there was a threat from within, for Johnnie surely has an
interest in Annie's fortune too. He appears to be without work
and he stands to inherit nothing from his imprisoned and
bankrupt father – who set fire to his own business to use the
insurance money to make a gentleman out of Johnnie and who is
killed by a rock in jail. As for Johnnie's mother, she is a mystery.
She must have been a sister of the Clonboise aunts, for their
father is clearly referred to as Johnnie's grandfather (HP p.253)
but she is never once mentioned – not even when the news of
Johnnie's father's death emerges, and this is made the stranger
by the fact that Aunt Claire was married to a Gillen – probably
Johnnie's father's brother. Johnnie is the only issue out of all
these and his situation exactly parallels that of Ted in *Rattle*, in
which two sisters marry two brothers, the two brothers and one
of the sisters are dead and the only issue is Ted. The question of
who gets whose money in such a situation could be complex and
the arrival of a distant relation, such as Alfred, could threaten
Johnnie's expectations.

These situations contribute to the unease, and Johnnie and
Alfred do not get on. Annie is attracted to Alfred. She ignores
Johnnie's offer of cigarettes (HP p.260) so she can offer one to
Alfred herself. She says Johnnie has no ear when he offers to

bring his music with him (HP p.261); and she is inspired by
Alfred's appearance to do a quick portrait of him. She softens on
the news of Johnnie's father's death, but he does not let her escort
him to the door – perhaps because she has just done so for Alfred.
We know Johnnie appreciates her charms from his saying that,
when Alfred meets her, 'he'll know we have beautiful women in
Portnadroleen' (HP p.255). The rivalry momentarily breaks out at
the start of Act 3:

JOHNNIE Yes, far too distant in the world, too strange, too abnormal,
 too wonderful altogether, like yourself with your duels and your
 parrots, and first of all your harlequin's positions and all your old talk.
ALFRED I had no idea I was bothering you. I was just trying to make
 myself agreeable.
JOHNNIE Oh, and so you did indeed.

This last remark implies too great a success for Johnnie's liking,
but they smooth over the cracks and get down to business. The
business is how to get and use money – including how to use
Annie's (HP pp.269-70) – a subject on which they do not agree.
Johnnie approves of 'safe, low, certain, steady interest', and the
limit of his ambitions is to develop Portnadroleen as a tourist
centre. Alfred appears to agree, but then develops wild ambitions
– 'better than a lot of mouldy capital' – with himself as the kingpin
in some great machine of government. The arrival of the 2nd
Pilot, who is not deaf, turns the talk to the decline of spirit in
Portnadroleen, until Kate, spurning Alfred's smile, arrives with a
summons for Johnnie.
 The summons is presumably for Johnnie to be told of Annie's
scheme to travel abroad, and she has kept him in the dark so that
he is bound to be caught up in her plans, despite his homing
instincts. Whatever impression Alfred has made, it has got him
no further than receiving a note from one of the aunts, telling of
the journey. In fact the note is intercepted by a hat placed
carelessly (?) over it until the morning, so Alfred turns up too late
for what would have been the departure. We are told that Johnnie
arrives that morning with an extra hat, so the suspicion is put in
our minds that he deliberately concealed the note. When Alfred
arrives he makes an oblique enquiry about the fate of the luggage
and guesses at once that 'rumours of wars' have held them back
(HP p.286). 'I suppose we might say it's that men?' says Johnnie,
as though he and the Porters were in collusion. In fact it is
primarily the Porters who put an end to the journey with

rumours which are most fortuitously timed. That the journey is a metaphor for putting Ireland's resources, partly represented by the luggage, into the war, is indicated by the Guard:–

GUARD Now, you'd have to have your eyes pierced very tight on the facts of the case, to be certain whether the crime causes the transport, or the transport causes the crime. Look at war. You can't have war without transport
JOHNNIE There's some of those that were in the old wars who say they liked them.

There were people in Ireland who wanted a war, most of them with fascist inclinations. Among them was Jack Yeats's own brother. Jack Yeats illustrated the cover for *On The Boiler* which was published in 1938. In it W.B. has these things to say:

Armament comes next to education.
If human violence is not embodied in our institutions the young will not give them their affection, nor the young and old their loyalty.
Desire some just war, that big house and hovel . . . may know that they belong to one nation[13]

The title, which is the basis for the cover illustration, refers to an old boiler in Sligo from which the local orators used to give forth. W.B., in disillusioned mood, remembered one of them and, thinking of himself, wrote 'Why should not old men be mad?' There seems to have been insufficient heckling for, reading on, one comes across the following horrifying statement:

The danger is that there will be no war.

Jack Yeats, who had planned a painting with the title 'Let There Be No More War' (Pyle p.171), was surely conscious of his brother's words from the boiler in the following passage – though too brotherly to specify a boiler. Instead, he has the 1st Porter speak of a barrel (almost the same shape as a boiler) having declared war to be 'a curse that is on the people' (HP p.285).

2nd PORTER Some people say they love it.
1st PORTER Ah, say, say, say, they'd say anything . . . You'd think dying was the finish of a glory, a winning post, to listen to the talk off a platform, by a barrel head, before a market cross.
JOHNNIE You are old men.
2nd PORTER Not so old at all. (HP p.285)

Nor so mad neither.
In all of the above, Jack Yeats's style of social satire is deft, and

analysing it suggests a portentousness about the play which it does not have, though it deals with portentous matters. He has a way of applying the concerns of the world to small incidents and demonstrating to us our own involvement in them and, by implication, our potential to act in them. Thus the relationship of war to transport – a world issue – is brought, via an Irish national issue, into the particular issues of the play. There had recently been a struggle between the transport workers and right-wing fascist interests:

We want Murphy's power to rob the Irish people 'interfered' with; we want to interfere with his power to exploit the railwaymen, tram and bus workers and others whose lives are controlled by him.[14]

If Johnnie had gone away and visited America, the 1st Porter's fear is that he might 'come back a millionaire and buy the town and make himself a Dictator.'

2nd PORTER And who would he dictate to?
1st PORTER Who but you and me.
2nd PORTER Sure he can do that now – he can say 'put them items of luggage in the van' and we must obey. (HP p.278)

The Porters even venture a scheme to fulfil their obligations as public servants, of wheeling the luggage (surmounted by the ladies) across the dried-out bed of the Atlantic – a delightfully crazy satire on their role in society, not unconnected with the theme of Irish emigration and the emigration of the Jews across the dried-out bed of the Red Sea on the way to their Promised Land. Much of that satire relates to the dependence of the public on public servants. If the commitment of the ladies to travel seems weak, it is partly because Yeats saw some vacillation in Irish opinion with respect to the war – particularly among the middle-class protestants: but it is also a quite simple satire on the vacillations that can be observed at any moment of decision in a railway station.

Between this situation and that of the Apple Woman, there is a poignant contrast. She picks up a brochure illustrating the ship Annie and all were to sail on and compares it with the ship she took to America to seek her fortune, which 'wasn't near as grand'. Poverty has been her motive to leave, not wealth; but now, significantly, she is surviving on the local trade, the Promised Land having failed her. Perhaps most bitterly ironical is the comment of the Guard in the last act:

GUARD Isn't it an audacious thing that the ballad singer should go through the street singing full of porter, while our native poets do languish in the caves of the hills, perishing for recognition? They should be supported in affluence. They should be the guards on the railways, while I should be singing the praises of Erin, the brave and the free. (HP p.293)

There is more than one target in that speech. Lombard Murphy – who kept the pay of transport workers, and hence railway guards, as low as possible – is obvious. But the 'native poets' that 'languish . . . for want of recognition' must be a particularly sharp dig at W.B. You cannot have an actor speak of native poets in a Dublin theatre without W.B. instantly coming to mind; and he was wealthy and recognised – but he was certainly not singing the praises of 'Erin, the brave and the free'. He was yielding to the necessity, as he saw it, of a Dictatorship feeding patriotism, Sinbad-like, with the stinking flesh of war, intending to keep the jewels that stuck to it for later distribution by an enlightened ruling class – for all of which *On The Boiler* provides ample evidence. But in this play it is the lowly Guard and the Porters who defend the nation's interests – and of course the ballad singers had been the most consistent defenders of Irish nationalism and were a dying, impoverished breed, mocked by the haughty. There is no question where Jack Yeats's sympathies lay. He loved the ballads and the men and women that sang and distributed them. In works as divergent as *The Treasure of the Garden* and *The Amaranthers* a ballad singer is the source of motivation for a course of right action. We have seen that the Ballad Singer in *The Old Sea Road* most clearly recognises the worth of Michael; and in his many depictions of ballad singers, Jack Yeats invests them with a kind of wild nobility – a look not to be seen on his representations of what might be thought to be members of an 'enlightened ruling class'.

There is scarcely a line in this play that does not carry with it some subtle comment on the situation, but some I have space only to outline. The theme of gambling and the imagery of snow and fire – the latter also associated with cigarette smoking – have their bearing: gambling on commerce, the snow on memory and a fading past artificially preserved in a glass globe snow scene; the fire and cigarettes on war and aggression. When Alfred fails to transfix the Ace, all the smokers extinguish their cigarettes. The Ace of Clubs, moreover, is not only a shamrock, it is a pawnbroker's sign. Jack Yeats knew of this symbolism from a

newspaper cutting he kept.[15] The symbolism was old enough and common enough for Goldsmith to have used the Ace of Clubs for an I.O.U. to the Duke of Cumberland. Ireland still had the North in pawn to the British and had only just redeemed her ports. There is also a confused hint of a parallel with the situation before the siege of Troy, in which the Guard refers to Apollo, Agamemnon and Cleopatra – possibly meaning Cassandra. Kate works like a Trojan and, not long before, Yeats had painted his prophetic 'Helen'.

Finally, the title has some bearing on the play! Alfred is the Harlequin. His wand is a loaded pistol. His positions become increasingly aggressive: Admiration, Pas-de-Basque, Thought, Defiance, Determination. He is the accomplice of Columbine, who is a wealthy man's daughter – an heiress like Annie. There are five positions and five acts. Only Alfred appears in each act, but he is ready to apply the positions to anyone's life, not just his own. He does so for Johnnie's namesake – Little Johnny. Johnny Murphy, says Alfred, 'Admires his mother'; takes his first steps (Pas-de-Basque); which are the objects of Alfred's Thought. Johnny makes a pretend scooter in Defiance of reality and is Determined to stick to his claim that it is a scooter. It is a little instance of the larger situation; the journey that is going to be taken, a young nation taking its first steps. But they do not necessarily lead away from home and after Thought – the central and turning point of the play – the Defiance and Determination shift to the guardians of Portnadroleen, in particular the Guard and the Porters, though Alfred too seems determined enough, hanging around, still smoking, as he does through the last act, until he is moved on. Harlequin's positions are traditionally aggressive in character and his nature is also revealed in a standard pose in which he clutches his purse to his side.

Basically, one can point to Admiration of Alfred, Annie and Claire in Act 1; to First Steps (Pas-de-Basque) in Act 2 as Alfred takes a look at himself and Johnnie has to face life without a father; to Thought in the planning and sparring of Johnnie and Alfred in their Act 3 conference; to Defiance in the prevention of the journey in Act 4, and the exposure (and composure) of Alfred; and finally to the Determination in Act 5 of the railway employees and Alfred to keep an eye on each other. In the harlequinade, harlequin's wand is supposed to make him invisible, but his wand is taken from him in Ireland: he has been discovered spying out the ground.

In pointing to what might have been earlier picked up from this play, I do not wish to deny that it has obscurities. In a work intended to convey the uneasy responses of people in the grip of events beyond their full knowledge and complete control, a sense of veiled mystery is appropriate. Nonetheless, Jack Yeats addresses an audience who can read the signs. The signs are clear, the parallels sustained, and the dialogue and action rarely deviate from the central topics of war and trade versus neutrality and self-sufficiency, once the scene has been set. Yeats could have specified the conditions of 1939, but the play, though clearly springing from its own time, is not to be tied to it. The questions it raises will always be relevant, and the tensions and unease which it builds up, and to some extent leaves in the air, are a necessary part of the experience we should undergo if we are to question our own motives in a situation of threatening war.

What I have aimed to do is point to the tremendous riches of the play as a work of social criticism. I have, even so, not touched upon the two widowed sisters, whose contrasting natures are gently mocked; nor have I said anything about the humorous interplay between the attitudes of the two pilots and the two porters. It will have to be taken on trust that there is plenty there for the actors to work on, even if they know nothing of the themes of the play. Those themes are presented not didactically, but prophetically. Jack Yeats did not stone his Jenny Wren. When he illustrated the Wren Boys' song he followed the gentler usage of latter days in which coloured ribbons were substituted for wrens. He espoused neither war nor defeatism but prophesied a successful neutrality with accuracy and with a wit that, to all would-be invaders, was quite literally disarming.

6

The Context of War (2):
La La Noo and *Harlequin's Positions*

And ye shall hear of wars and rumours of wars: see that ye be not troubled: for all these things must come to pass, but the end is not yet. (Matthew 24. 6.)

La La Noo was written when these things had indeed come to pass. It is probably the best known of Yeats's plays and was first performed at the Abbey Theatre, Dublin, on 3 May 1942, and published by the Cuala Press in 1943 as a separate volume. Except for the note on Synge in Connemara, it was the first piece of writing by Jack published by Cuala. It was revived by the Lyric Players, Belfast, in 1956 and at the Peacock Theatre in Dublin on 27 November 1971.

Something of Yeats's own attitude to the play can be gathered from his BBC interview with Thomas MacGreevy:

And about La La Noo and about the turning from comedy to tragedy. I was very nervous at rehearsals myself. I only attended the last two rehearsals . . . It had not been hoisted as comedy, but there had been big laughs, and pleasant laughs all along, and then it suddenly had to be ready for this, and I said to the producer 'Isn't there a danger that when the dead man is carried in, they'll begin to giggle or something?' and she said 'No, they won't' so, fair play is still a Jewel, and honour where honour is due, it was the production by Miss Ria Mooney that made it possible for comedy to turn into tragedy, and that the audience should take it quietly sitting in their seats, and understand it as much as it could be understood.[1]

It is worth keeping in mind Yeats's statement that the play was not 'hoisted as comedy' alongside his ready acceptance of the terms 'comedy' and 'tragedy'. With respect to the latter, a remark by Ria Mooney, who clearly enjoyed Yeats's confidence, is also worth setting out at the beginning of a discussion of the play:

By the time La La Noo is finished the audience should be calm and utterly relaxed, both mentally and physically; and they should leave the theatre

hoping that the concrete road which will bring machines, noise, and the stress of modern life to that quiet place, may never be completed.[2]

The plot of *La La Noo* could hardly be simpler. A group of women are driven into a pub by the rain. They are on their way from the sports on the strand to catch a bus, and they converse briefly with the Publican and a Stranger. When they are driven back a second time, soaked to the skin, the two men arrange to dry their clothes while they hide in an inner room. When they are dressed again, the Stranger offers to give them a lift in a borrowed lorry. He is an inexperienced driver and the women, watching him drive it to the pub, see him strike his head on a tree as he leans out to check the verge. His body is brought into the pub. The women leave.

The contrast between interior and exterior is fundamental to the play, both in setting and action. The setting is a small public house in the West of Ireland, but on one side it has an interior room in which the women undress, and on the other side of the stage there is an ' Open doorway. . . Outside, scene of sandy road, bent grass, sea islands near, and high islands distant. Ocean horizon'. The setting is constantly stressed in the dialogue and characterisation. Apart from the significance of his title, the Stranger speaks often of his distant travels; the women speak of the sports below on the strand; the Publican of his own immobility; and one of the women tells of her experiences in America – which is the next land beyond the 'Ocean horizon'.

In terms of action, the play is remarkable for the fact that the most intriguing events all take place off-stage. The sports were on the strand, the women undress off-stage, the accident with the lorry is off-stage and all the comings and goings are determined by the weather outside. And the one piece of independent action on the part of any of the women, is when the 4th Woman 'borrows' a hat and marches off-stage and out of the play with it. The only thing this leaves for us to see rather than imagine is the bringing in of the corpse at the end, if that can be regarded as a piece of the action.

The main contrast between interior and exterior is, however, that between a neutral Ireland and a world at war. There are several lines in the play which, to a 1942 Irish audience, were bound to bring this contrast to mind:

7th WOMAN . . . I don't want to see any man suffer.
6th WOMAN You do right. Why should they suffer wounds? Are there not enough wounds on the creation of the earth?

1st WOMAN Wounds enough!
STRANGER Wounds enough on man and woman. (LLN p.304)
.....
PUBLICAN The world away from us this day is full of terrible cruel
 things . . . there are raging vampires eating at the hearts of the people
 all over the world this evening, while you and me here in the quiet, are
 just talking a little encouragement to ourselves. (LLN p.311)
.....
PUBLICAN . . . Peace or War it's all the same to the motor bringing a
 doctor to a sick person, that might be dying but for his coming, or
 bringing cannons to be spitting death on men, women, and children.
 (LLN p.322)

The Publican then goes to look out of the window and continues
his history of transport with reference to aeroplanes bombing,
and submarines 'used for bloodshed from the first' (LLN p.322).
 Robin Skelton has already drawn attention to this relationship
(Skelton 2 p.115), reminding us also of Yeats's famous painting
'Tinkers' Encampment: The Blood of Abel' which was painted at
about the same time as *La La Noo* was written. The tinker (clearly
in an Irish setting) shows a curious public, drawn from all corners
of the world, a pool of blood, the sign of their iniquity. (Plate 7)
 The contrast between the danger outside Ireland and the
security inside is also reproduced on a more local scale. Outside
the pub is dangerous: a jockey is injured at the races and at first
thought to be dead; the weather is unreliable, if not hostile; the
drink bought in the whiskey tents on the shore as opposed to in
the pub could be poisonous; the women are walking past the pub
because they are frightened to use the little local bus, fearing an
accident; a fear reflected by the Stranger's death driving the lorry.
At a more mystical level, the Publican, though he asserts that the
ancient heroes who 'in their battles fought amongst themselves'
(LLN p.315) did so well away from his door, is frightened to test
his theory that he would feel the ground tremble where they
passed, even at that door.
 This fearfulness and 'paralysis' as McGuinness has termed it,
though it applies in truth only to the Publican, is criticised by one
person, and that is the Publican himself:

PUBLICAN This is a backward place.
STRANGER Isn't it better so. There's nothing to be ashamed of, to be in a
 quiet place. You ought to thank God for it, on your knees, you ought.
 (LLN p.309)

More than once the Publican expresses a wish that he had
travelled (LLN pp.309 and 315), but confesses it was too much

effort even to set up a stall at the Sports on the Strand. The Stranger may advise him to 'take more pleasure' in his life (LLN p.315) but himself does not recommend the wide world that he has travelled:

STRANGER You'll have a beautiful view of the ocean . . . It has the Bay of Naples and Sydney Harbour and Rio looking like a bunch of faded flowers before you. (LLN p.302)

The West of Ireland makes that statement a serious one, both in the reality of its beauty and the manner in which Yeats painted it.

Most of the people who make it their business to study literature, and comment upon it, do so from a cosmopolitan background and for a cosmopolitan audience. To defend a small corner of the world in this way may seem to them a small and foolish thing to do. Yeats would not have agreed with that. For a small nation like Ireland, trying to find a place in the world that was its own, it was a vital defence. The words of MacGreevy in the 1947 interview with Jack Yeats make this clear, and so does practically every sentence of Yeats's own *Modern Aspects Of Irish Art*. The Publican may be almost paralysed in body, but he is not so in mind. His talk is lively and imaginative; so much so that his fear to test the ground (see above) could be criticised not so much for its timidity, as for the over-active nature of his imagination. It is he who dreams of the submarine as a device that might have been used for watching 'the fishes playing theirselves' (LLN p.322). It is he who sees his own state of mind with humorous clarity:

PUBLICAN . . . Slow and steady might be better in the end. But that's not the way I ought to be talking to young women like yourselves with all your lives before you. It's all right for an old feller like me to be content with a bit of quiet old talk about the old days. But talking of old times is no pleasure to the young, they can't stay still to listen, and rightly. If it wasn't for youth dashing about and making new inventions we'd be walking backwards into the mists of the past. (LLN p.322)

And it is also the Publican who suggests that the heroes of old were thought highly of, more on account of the poets, perhaps, than themselves:

PUBLICAN . . . That's the way the poets did it. Get them mad to fight and then let them fight. And afterwards whatever they did, be it little or much, make a great song and a giving out about it. (LLN p.323)

This is more than pleasant chatter. With the poetry of Pearse, MacDonagh, and his own brother before him, Jack Yeats was giving his Publican no idle matter; and, in a way, the play carries this out itself, for the death of the Stranger, 'be it little or much', follows immediately, and the strange meaning of it has haunted the commentators ever since. This relates, too, to the World War around the men and women in the play and those watching them in the theatre: 'There's nothing to be ashamed of, to be in a quiet place' is a clear endorsement of neutrality. Yeats found no glory in that war, not on any side of it. In a remark which might have some bearing on *Harlequin's Positions*, and certainly has on *Helen*, he reveals that he had a low opinion of Churchill:

the fat lips covering toothless gums, the look as if he had vomited and now felt well again. Not a face to launch a thousand ships anyway.[3]

And all his remarks about it in letters and on Christmas and New Year greetings express only his horror at what was going on:

I would say that all the lids, big and little, are 'off' all the various hells. Peace? I don't know about it or where it is to come from. Like the lady in the play we will have to have 'peace within us'.[4]

But *La La Noo* is more than an endorsement of neutrality, for that neutrality is seen in a context far wider than one war. This is about the most homeless group of people Yeats could have assembled. The Publican is unmarried: the Smith, his neighbour (who is only spoken of) is a widower: the Stranger is a traveller, and the seven women make no reference to husbands or children. It is true that there is room in this inn – a shared bed for the Stranger if he wishes; good hay for the ladies while their clothes dry – so it is at least an improvement on Bethlehem – but in its isolation in a wild landscape it lays stress on the isolation and vulnerability of many humans, and not one of them is given a name.

Names are usually significant in Yeats, and so is the absence of them. These people have no names because they are archetypal. The women come in a magic number of seven, accompanied by a dark cloud over their heads that is bound to catch up with them, and does. The Stranger thinks it unlucky to meet 'a large body of women' (LLN p.301) – one of those remarks in Yeats which has marvellous comic potential while at the same time being almost sinister and, as it turns out, prescient. The weather and its consequences, wet and dry, water and the Smith's fire, are truly

elemental and the nakedness that results from it seems also archetypal. Skelton is reminded of Lear's 'unaccommodated man' (Skelton 2 p.115) and suggests even a possible connection with Revelations. I agree with him in both of these, but understand why he almost apologises for the latter, because this wonderfully subtle play is ready also to indulge our sense of humour 'against the backcloth of that terrific prophecy' (Skelton 2 p.115).

Except for the 4th Woman, they are all well dressed – some in their finery – and they could be reduced to a state of unpleasant vulnerability or total ridicule by this scenario. And yet they are not. They are accommodated with courtesy and decency and discreet good humour. Few dramatists would have dealt with this situation with such delicate comedy as Jack Yeats. The Publican suggests that if he had a melodeon and played a dance on it 'the ones inside could hear it through the door and be dancing for themselves' (LLN p.316), and the Stranger tells them, when they emerge with their crumpled and shrunken clothes on, that they would 'pass anywhere for a garden party' (LLN p.317), and that is as far as the men go by way of suggestiveness or mockery. Even the title of the play is the gentlest of sexual jokes, being derived from the Publican's insistence on giving the wrong gender to 'Le Nu' (LLN p.314).

What then of the backcloth of Revelations? Before expanding on Skelton's suggestion, I would like to deal with a very much closer and previously unnoticed association with another biblical prophecy, particularly as it (necessarily) comes earlier in the story of the Jews: and before that again with the early establishment of the theme of seven females in the emergence of that persecuted race.

We have seen in *Harlequin's Positions* a humorous hint of the epic journey of the children of Israel out of Egypt: the section of this work dealing with *The Charmed Life* (which precedes *La La Noo* in composition) shows that the idea is taken up more seriously; but *La La Noo* itself is fundamentally set in that context. The Irish, long persecuted by their equivalent of the Egyptian overlord, forced to emigrate in hundreds of thousands to America and elsewhere, should have had good reason to associate themselves with the Jews. The association was never taken up because of the obvious antagonism of Roman Catholicism to any such parallel; but it was there. Jack Yeats's dealer at the time, Victor Waddington, was a Jew and Serge Phillipson told me that Yeats

had created consternation by proposing a Jew for membership of a Dublin institution. The full horrors of Nazi persecutuion had yet to be revealed, but the plight of the Jews in the late thirties and after was already well known, and no doubt Yeats was alive to the parallels of ancient oppressions.

The first parallel is a loose one with Genesis 21.30:

And he [Abraham] said, For these seven ewe lambs shalt thou take of my hand that they may be a witness unto me, that I have digged this well.

The point of this is that the seven ewe lambs are a token of Abraham's right to live where he is – a thing impossible without his own water, the well having been previously filled in by men hostile to his presence. There is much talk of water and wells in La La Noo – some of which relates to Revelations (see below) – and, in particular, the Publican mentions his own well, from the good water of which he makes tea for the seven women (LLN pp.311 and 312). If you like, he waters his flock, or his neighbour's flock. The women are not all of the age of lambs, though all, bar one, are between nineteen and twenty-six and do not appear to have 'lambed' themselves. They come and go in a little flock, the one black sheep (she is described by Yeats as 'small and dark') being the 4th Woman who leads them and leaves them; and they have to shed their clothing as a sheep is shorn. They speak of their clothing in relation to wool (LLN p.319) and the association of humans and sheep is also made by the 2nd Woman when she speaks of young men as 'rams caught in the thicket' (LLN p.320). This association is doubly important because it refers to the sacrificial ram that was substituted for Abraham's son Isaac.

In a way the women and the young men are hostages to fortune. One young man has been injured in the Sports, but most young men (and many Southern Irish volunteered for the Allies in the Second World War) were away fighting. 'I wouldn't like to see them made to go where they would not want to go' (LLN p.320), says the 6th Woman, probably referring to the notion of conscription, which the British did not dare attempt in the North of Ireland. But there were plenty of young men going to the sacrifice:

To what purpose is the multitude of your sacrifices unto me? saith the Lord: I am full of the burnt offerings of rams . . . (Isaiah 1.11)

Jack Yeats was probably asking the same question, because it is in the Book of Isaiah that the next, and closest biblical association

with the play, is found. Apart from the echo of the ram caught in the thicket, Chapter 2 has the famous beating of swords into ploughshares – the Smith's fire is used for the peaceable business of drying ladies' clothes – and a reference to the idolatory of manufactured things – 'that which their own fingers have made'. Man-made things are heavily criticised in *La La Noo*. The lorry is a cause of death, the local bus is feared, the car is a killer (LLN p.305) and the machinery of transport in general is used for instruments of war (LLN p.322). The remark of Ria Mooney quoted at the beginning of this chapter has a special relevance to this theme, for the road is man-made too.

Chapter 3 of the Isaiah continues with the litany of indictments:

What mean ye that ye beat my people to pieces, and grind the faces of the poor? saith the Lord God of Hosts.
Moreover, the Lord saith, Because the daughters of Zion are haughty, and walk with stretched forth necks and wanton eyes the Lord will take away the bravery of their tinkling ornaments . . . the changeable suits of apparel . . . (Isaiah 3.15)

The women in *La La Noo* (though not iniquitous or deserving of the venereal disease which the Lord God of Hosts visits upon the daughters of Zion!) are mostly very smartly dressed, sufficiently so not to wish to squeeze in with the common humanity that is using the local bus. 'They're too delicately nurtured' says the Publican of them in relation to the exception, the 4th Woman, who is local and has guided them up this back road and run off with a smart hat belonging to the 3rd Woman. But the women are, very gently, humiliated for their vanity in *La La Noo*; and in the fourth Chapter of Isaiah the reconciliation that exists in this lonely little pub in the West of Ireland is found also:

And in that day seven women shall take hold of one man, saying, We will eat our own bread, and wear our own apparel: only let us be called by thy name, to take away our reproach . . .
 And there shall be a tabernacle for a shadow in the daytime from the heat, and for a place of refuge, and for a covert from storm and from rain. (Isaiah 4.1 & 4.6)

Obviously these are not exact correspondences, but the sequence of connecting imagery is remarkably close and it is, I believe, reasonable to think of the pub as that tabernacle and the two decent men as taking away the women's reproach. It is with these associations as it is with all of Jack Yeats: the smallest actions and humblest situations can share in the great myths and

symbols of the world: the conception of a people in search of land, water and shelter; betraying themselves by unnecessary slaughter in the name of God; worshipping their machines rather than the natural environment given to them; being cruel to their poor; overtaken by vanity. This conception need not be taken as a criticism of Ireland in the 1940s; but it is certainly a warning with respect to the behaviour of the rest of the world and the threat of that behaviour spreading to Ireland.

The centre of the play, and its title, are concerned with seven naked women; but the climax of the play is the death of one man – a stranger. He is 'wayworn', aged 55, and is well travelled; but beyond these stage directions nothing is revealed of his history. But Yeats readily described the conclusion of the play as being 'tragic', and the rest of it 'had not been hoisted as comedy' (see above). The Stranger then becomes the tragic 'hero' who has turned his back on the wars of Europe and on 'the big cities of the world that spoil the humanity of the people' (LLN p.301), only to find death through a chivalrous act to which the irony is added that one of the women could perfectly well have driven the lorry. If the concrete road, to which Ria Mooney referred, is completed, it seems likely that the war and its attendant machinery will come down it: the lorry is a forerunner. The Stranger in the pub (and we as audience are also strangers in it) knows his danger and accepts it. When the 2nd Woman says she was 'neither proudful nor ashamed' (LLN p.304) when blood was spilt for her, the Stranger says 'And it was right', meaning not to be proud or ashamed, as the following exchange reveals:

STRANGER Every man should dig his own grave, if he's given time.
2nd WOMAN Doesn't he?
STRANGER That is so, Mam. (LLN p.305)

That is to say, man makes his own life-and-death choices. When the Stranger is warned of the danger of driving the lorry he replies 'I don't care' (LLN p.318). If this is a sacrifice, then it is a willing one. The contrast between this outsider and Alfred in *Harlequin's Positions* could hardly be more marked. Whereas there is much that is sinister surrounding Alfred, the Stranger seems to be a decent and unscheming man, and if anybody is sinister, it is the body of women.

This is where Skelton's point of contact with Revelations comes in. He quotes the following passage:

Behold I come as a thief. Blessed is he that watcheth and keepeth his garments lest he walk naked and they see his shame. (Revelations 15.16.)

He suggests (besides the obvious connection of nakedness) that the women might relate to the seven angels and the announcement of Armageddon – the Armageddon of the Second World War (Skelton 2 p.115). It is possible. Yeats made a number of references to Revelations in his work. The Star of Great Magnitude appears in *The Charmed Life* and one of his paintings is titled 'There is no Night' (Revelations 22.5), and its white horse comes from Revelations 19.11. A detail from Revelations that may have been used in *La La Noo* is that of the third angel who turned a third part of the rivers and the fountains of the world to worm-wood. The Stranger speaks of 'heavy death and destruction, doing no good to anyone only cataracts of harm to man made in the image of God' (LLN p.310). The metaphor associates water with danger and he later gives it reality:

. . . for there's many a bad well and bad spring, where no man can drink and live, and to have to pull himself, and his horse, away from such a well, and such a spring, is a hard thing for any man. (LLN p.311)

When the heavy rain comes, the Stranger says 'You'd think that ought to be enough to quench hell' and the 3rd Woman speaks of the rain as coming down in 'The devil's own buckets' (LLN p.311); but the Stranger says, on behalf of the Publican, 'He means there's no harm in the rain in this part of the Universe', and the Publican adds 'There's no venom in it' (LLN p.312). Finally, the Publican says:

Isn't that a terrible thought that as soon as man finds a well he finds a poison to put in it. (LLN p.322)

Add to this the Second Angel, whose vial poured out upon the sea 'became as the blood of a dead man' (Revelations 16.3) and another chain of association is set up between the water imagery and the 2nd Woman who has had blood shed for her. Her remark arises out of talk about blood. There is no question that Yeats knew his bible well and made associations of this kind in his own mind also, outside his plays and novels:

. . . We are promised rain. Let it be soft, falling gently, like peace from heaven. They say the weather prophets are mostly right now. They were kept on their toes during the war when they had to be so reliable, so that when the killers went out to kill they didn't muff the whole business.[5]

Here, however, the connections between the play and the suggested source are loose and cannot be followed through with any consistency. They make of the women something extremely sinister and there is no doubt that, whatever they are, they talk much of death and are heralds of it. It is worthwhile going through some of these associations, as much because they reveal the very careful characterisation which Yeats has given the women, notwithstanding their being named by numbers.

The 2nd Woman is the eldest and is the one who has had blood shed for her, and to whom the image of the sacrifice of Isaac comes in response to the 1st Woman's admiration of the 'thickets of curls' on the young boys' heads. The 1st Woman thinks the sports were 'very delightful' but the first delight that springs to her mind is that a pony fell on top of its jockey and they thought he was killed (LLN p.303).

The 4th Woman – reluctant guide to the others – comes from the poorest peasantry whose main income was derived from the near-lethal illicit whiskey they produced. Her animosity towards publicans (whose trade was sanctioned by law) is not the slightest bit modified when she shelters with the others in the pub, 'I hate all publicans' (LLN p.303), and she is bitter about men in general:

4th WOMAN I never seen them die. I seen them wither and when my back was turned they died on me. Wouldn't they put the life across you? They'd like to with their tricky ways. They're in hands with death the whole time, the dirty twisters. (LLN p.304)

Coming from a young woman of about twenty and miserably dressed, one can understand the bitterness. She has probably had to nurse more than one dying relative, only to miss being with them at the crucial moment. Ironically, she misses the Stranger's death by her early exit.

The 5th Woman says 'I'll see a man die and then I'll die myself and it won't be long either' (LLN p.304). The first part of her prophecy comes true. 'Dreams', she says later, 'don't go by contraries. They speak the truth' (LLN p.307); her prescience is alarming, but matter-of-fact rather than bitter. She may be fatalistic, 'What does it matter what we do the one way or the other' (LLN p.319), but this does not seriously affect her religious faith. Sinister, nonetheless, that it is she who says 'God protect you' when the Stranger says 'I've got to watch out' (LLN p.307) . Does she know he is going to die? Of the three women inside the pub when the accident occurs, she is the only one not to add to

the running commentary: perhaps she has seen it already. When the 6th Woman says of wild young lads 'The Good God will find a way for them in a good day', she replies "Tis the truth' (LLN p.321). These are her last words in the play. It is as though she had a certain knowledge of the truth and that this particular truth sums up her nature: God is good *in a good day* – a combination of Christianity and fatalism which she can accept at the 6th Woman's suggestion.

The 6th Woman herself has been to America, but it is the elaborate tombs and artificial flowers that she saw there which she describes for an audience who know nothing of them. Her way of doing so is to imply the inevitability of death for all living things: 'and some had flowers that never grow and so they never die.' All this is told in the context of the living presence of death: 'It's nettles that do grow mostly on the graves about this part of the world' (LLN pp.304-5). But she is not as prescient as the 5th Woman and, though she can be blunt to the Stranger – 'Ah, tell you nothing' (LLN p.311) – she is also charitable about young men: 'Some young boys are very wild. It isn't harm in them. But they haven't got enough to do with their energy' (LLN p.320).

The women's clothing is, of course, an important topic of conversation, the 6th Woman telling the oddest of stories about a girl who never got married 'because a mason on the top of a skyscraper fell in love with her when little hats were in the fashion, and when the big ones came in he never was able to pick her out again'. The 1st Woman reacts revealingly to this story: 'I'm warned now. I'll never get a big hat or I'll be on the shelf for ever' (LLN p.320). She is about twenty-six and her remark is sad as well as comical, for we know she is an only child and has had no proper family life: 'A grave is ever a homely thing' (LLN p.305), she says, implying that she has spent much of her life visiting her mother's grave and identifies it with home. At twenty-six she must be lonely and genuinely worried at the prospect of being alone for the rest of her days.

This is characterisation of great skill, sensitivity, and economy; and it can be demonstrated for each woman in practically every line she speaks. The youngest, the flirtatious 3rd Woman, worries about her appearance, the state of her shoes and her swagger-coat; she contrasts well with the blunt, tactless 1st Woman and the tweedy middle-class practical 7th Woman who has learnt to drive a lorry, but is too hide-bound to say so. They leave with a sense of helplessness and scarcely deserved guilt:

2nd WOMAN It is terrible, terrible, and there is nothing that we can do
 that I can think of.
1st WOMAN I think we should go away. (LLN p.324)

The two most lively and pleasant women offer to sit with the
corpse, but the Smith is going to be back soon, so they go, the 7th
Woman driving the lorry. The red sunset which the Stranger
promised them is seen as the sky darkens.

What is left is a body, a Publican who feels he is leading only
half a life but has not the courage or energy to lead a whole one,
and the shadowy figure of the Smith, the widower who once had
a bit of a rose 'but it died on him' (LLN p.304). There is a tragic
fatalism in all of this, a fatalism which the Publican shares with
the 5th Woman. 'It's an extraordinary thing the way the weather
does back up the Almanac' (LLN p.307), he declares. 'It was
always the way' (LLN p.324) he says when the Stranger is killed.
In a way, that death provides us with the classic cathartic
experience which Ria Mooney seems to be describing (see above)
as the proper audience response. And yet there is a little touch at
the end of the play that should leave us disturbed in our seats.
Almost the last thing the Publican does before the final curtain is
to take down the Sports advertisement, crumple it up and wipe
the bar with it and throw it under the bar. The day's
entertainment is over, just as the play is over. Did we enjoy the
blood spilt for us? Are we, like the 2nd Woman, neither proudful
nor ashamed? Would we have enjoyed the sports better if the
jockey had been killed? Here we are, in the theatre – in the pub in
the theatre, sheltered from the rain, dressed for the evening
much in the manner of six of the seven women, dressed for the
day. Have we not been watching ourselves, to whom hospitality
has been given and for whom a sacrifice has been made that our
spiritual nakedness might be covered? Perhaps we will go home
and listen to the war news before bed and forget the Good
Samaritan and the Innkeeper. Once again, these are associations
which cannot be thought through in any systematic way; but they
are natural associations to make. A traveller and a publican have
looked after people who have fallen by the wayside and that is
enough, though it is only the weather that has done the women a
violence, and the traveller is sacrificed where the Good Samaritan
is not. The seven women bring with them attributes of avenging
angels, but they are not themselves those angels. A kind of
reconciliation has taken place and they have been seen safely on
their way. Their safe conduct is our guarantee that we may dig

our well and it will not be poisoned, and that, whatever our iniquities, shelter will be given to us; at least in a pub in the West it will be. But let us not forget that we were shown the way by a woman bitter with poverty, housed by a Publican we might have thought to mock for his timidity, and have, through our own improvidence (however inadvertent), caused a stranger to sacrifice himself for us.

It is by wealth of association and unpretentious presentation that Jack Yeats brings his plays into our own lives. He sees and feels the potential significance in small actions and quiet words. At a philosophical level one might suggest that a play like *La La Noo* has affinities with existentialist moral awareness but Yeats spares us its high seriousness and presents his little parable with a light touch. It is my view that this is a play of the very highest quality; funny, touching, disturbing, tragic, and unassuming. But is it dramatic? Only production can tell us that. It has the makings of good drama. The situation is entertaining, the action comes to a dramatic close, the dialogue is well balanced, rich and consistent in imagery, and characterful. The characters and their situations are well contrasted but there is nothing forced about their being together. There is not much more one could ask of it.

I opened this Chapter with a quotation from St. Matthew which connects the 'play of war's alarums' – *Harlequin's Positions* – to *La La Noo*. But the warning of Matthew, 'see that ye be not troubled', could hardly be sustained through this play, catharsis or no catharsis, humour or no humour; and with the suggestions of the Armageddon of Revelations, one might be forgiven for being only too pleased that 'the end is not yet'. However, Yeats's last play and its Prologue, written in as dark days as any of the war, bring a kindly hope that could only come from a man with ultimate faith in the goodness of his fellow creatures; and that faith had its source, as did all his work, in the West of Ireland, where each one of these three plays was set.

7

The Context of War (3):
The Green Wave and *In Sand*

In the Note on the Chronology I have argued that *The Green Wave* was probably written at the same time as *In Sand* – namely 1943. Even if it was a post-scripted Prologue, the significance of what it is and where it stands remains. The period in which *In Sand* is set covers approximately sixty years, commencing shortly after 1883 when the pro-Unionist Primrose League was founded. Its formation is referred to in the play (p.339) as though it were a recent thing. The central figure of *In Sand* is Alice and she is almost nine years of age when the play starts. Act Two Scene One is twelve years later, when she is twenty-one and has received her legacy: Act Two Scene Two is ten years later (therefore 1905 or soon after): and in Act Three, which we are told takes place 'Many years later' (IS p.351), Alice is described as 'old and stooped' (IS p.357) and must therefore be at least in her sixties. This means that the last act probably takes place round about 1943 when Alice would be about sixty-nine and when the play was written. These dates fit in with the presence of the car and chauffeur as novelties at the turn of the century (IS pp.343-4).

It is suggested to us that the green wave is an Irish wave (GW p.330) and we know the scene is Dublin because of the mention of Nelson's Pillar and The Four Courts (GW p.329). These edifices, the former now blasted away, were symbolic of British rule in Ireland, and evoke from the 1st Elderly Man an ironic comment in the form of a line from a ballad. The ballad refers to the desertion of the British Admiral Benbow by the British Fleet which lay off from an engagement, swinging on their anchors.

That there is an international political background to *In Sand* is underlined by the mention of the Primrose League and by the tunes which the woman pipers' band are to play in Act One. These are 'I Know My Love By His Way Of Walking', when the band appears; and 'The Girl I Left Behind Me', when it departs. We know Yeats considered the playing of at least the first of these

103

to be 'essential' (see Note on the Chronology): in it an Irish girl laments that her love will surely marry 'an English damsel', but still she cries 'I love him the best' and 'bonny boys are few'. It is generally taken as a song relating to the recruitment of Irishmen in foreign wars, but reflects on emigration in general. 'The Girl I Left Behind Me' expresses the corresponding longings of the men who have gone away, though in this instance the men are the Wild Geese who fought in foreign catholic countries, not for the British, and the girl is Ireland. This political background is gathered together in the last act when the Old Sailor, the Visitor and the Governor unfold the political evolution of an island community in the Pacific. The image that ties the Prologue and the play together is that of the Irish wave (green for Ireland, not blue) breaking on the sands of the world.

The image of the wave had already been used by Jack Yeats in the Order of the Golden Wave in *Rattle*. The context is similar in that the central character travels to an exotic country on the strength of an inheritance. Where Ted dies, Alice marries, but there is an echo of Ted's death in the sudden failure of her husband's wealth which causes his death. Also, the Governor in *In Sand* is dressed in the same colours as Ted and his bearers – pale blue and yellow, a reconciliation of opposites in the world of politics. A wave looks green when the blue of the ocean comes upon the yellow of the sand. For the same reason, yellow and blue, mixed on the palette, will make green. Land and sea combine. The 1st Elderly Man in *The Green Wave* seems to suggest this when he offers to turn the green wave painting into a painting of a green hill-side. Either way, it will still be Irish.

There is no plot in *The Green Wave*. It is a tiny conversation piece in which the old argument between the spirit and the flesh is continued. The 2nd Elderly Man – the flesh – is antagonistic to the painting and to art. When it is suggested to him (in line with Yeats's own aesthetic pronouncements) that he could consider man as a work of art, the 2nd Elderly Man can only see this in terms of a person in command of money: he is aggressive towards the idea of any other type being a work of art and concludes that pictures are painted by people who feel their own inadequacy. This thought surprises him, but he does not attribute the stimulation of his mind to the proper source – the 1st Elderly Man and his painting – and when he looks out of the window he is amused by the diminshing effect of height on the people below, whereas the 1st Elderly Man identifies with them. As for the

Green Wave, it annoys the 2nd Elderly Man because it does not tell him what it means and he wants to know immediately because time is important. It does not occur to him that a study of the painting might be a good use of his time.

There is no doubt that the 1st Elderly Man and his painting ask for our approval, having spiritual rather than material values, but it would be a mistake to think of the Green Wave simply as a pleasant plashing of Irish goodwill on the sands. The 1st Elderly Man takes the painting to the window so that the sun falls full on it:

2ND ELDERLY MAN I see you like it fully illuminated.
1ST ELDERLY MAN Yes, I have a feeling that a wave seems less cruel when lit up.

The green wave Yeats produced to illustrate a James Stephens poem in *A Broadside* for April 1937 was a large and sinister one, occupying almost all of the sky. Not a wave to be sported with. The sea, after all, is our symbol of eternity which is what we expect to enter when we die. *i.e. "In Sand"*

The play that follows this remarkably dense little Prologue is one of the most audacious theatrical experiments ever. Not only does it race through the years; it shifts the focus of attention from character to character, concluding with completely different people and held together partially only by the figure of Alice, who has but three words in the last Act, an act which is half as long again as the rest of the play and full of very long speeches. The imbalance is reminiscent of *The Deathly Terrace* but the play is richer in ideas and the monologues in it are not self-satisfied and pretentious like Nardock's, but full of humanity, or obvious satire. The play was much more intelligently received by the critics than were *Harlequin's Positions* and *La La Noo* and it is interesting that what a reader might imagine to be its weakest dramatic point, the Old Sailor's monologue, was uniformly praised as a tour-de-force. The praise was as much for the actor as for Yeats, and there is no doubt that in a speech of ten minutes' length they need each other to be very good, but the experiment worked for audience as well as critics (according to the latter) and it was Yeats's experiment. The actor, Brian O'Higgins, who played the part, was moved to write on the programme signed by the cast and which Jack Yeats kept:

Thanks for the privilege of playing in this beautiful Christian play.

It was produced by the famous Jack McGowran who was also profoundly affected by it[1], and Pilib O'Floinn who played Anthony Larcson, who also has very long speeches, wrote:

This was my favourite part.

It is clear from this response from actors, producer, audience and critics, that those of us who have not had the chance to see it staged will have to wait for a good production before we make any severe pronouncements on its dramatic effectiveness.

The basics of the plot are as follows. An old Irishman wills money to a local girl who is to write a goodwill message in his memory in the sand between the tides. When she grows up she spends the money on a world cruise, marries, loses her husband and is reduced to poverty on an oceanic island. But she continues to write the message in the sand and others take it up, believing there is luck in it. Amongst those others is an Old Sailor who respects and helps her and who describes the course of his own fortunes on the island. The Visitor whom he addresses involves the island's latest Governor in a symbolic regulating of island affairs, amounting to his notion of Utopia. The scheme is foiled by the early commencement of the tourist season and the Governor forgetfully breaks his own anti-slogan regulation by writing the message in the sand. He is prevented from commiting suicide on this account by two native lovers who assure him that it is all washed away by the tide.

The green wave, which the old Irishman, Anthony Larcson, initiates by his will, perpetuates the values he approved and which we may assume his creator, Jack Yeats, approved. Those values are of profound social as well as personal significance and the Mayor of Larcson's home town recognises them as such:

Maybe it would have been better if this man, whose wishes we are following out today, had never decided to leave these wishes which are in a sense a criticism of our bad old ways, and a criticism I say on even the best of our ways. (IS p.341)

He goes on to show that the wave is a cruel thing in his imagining, having been stirred out of his splendid but conventional speech by the unconventional nature of his task, into a startling extempore admission of why he is disturbed:

The ways of men, and especially men on their death-beds, are strange ways, and not to be understood by those who stand in their full health, not thinking of their last hours, but of the hours which keep coming

towards them like waves of the sea, some with crests of glistening foam on them and some dark as blood, no two waves alike. I speak out of my heart, and I don't care who hears me, and if it wasn't for the hope that I may keep my chin up above the on-coming waves, with the help of God who made me, if it wasn't for that I tell you, I would raise my hands above my head and let my cursed old body sink into the depths. (IS p.341)

Yeats was an old man in 1943 and his own flesh and spirit were approaching the parting of the ways in his own mind, no doubt; though the unequivocal statement that the play was written in 1943 does not allow us to include the deaths of Cottie and Lily as having an influence on its psychology, as has been suggested (McGuinness p.410).

What does have some bearing is the fact that the play was written in the middle of a World War, perhaps as an act of defiance against the cruelty that surrounded Ireland, and as a declaration of faith in the values Yeats's country still managed to sustain. He ended the year 1942 with a Christmas card to Thomas Bodkin, showing an artist on Dublin's Ha'penny Bridge exhibiting his wares. His printed address of 18 Fitzwilliam Square, Dublin, has Ireland added in his own hand and the message below reads:

To wish you from us both in defiance of all the troubles everywhere – a happy Christmas.[2]

Bodkin needed no telling where Dublin was, and Yeats does not usually add 'Ireland' to his letter headings: but from Ireland the defiant message comes, that the artist (perhaps with his green wave) still offers up his spirit in the markets of the world.

In the year which followed, and in which *In Sand* was written, Jack Yeats was reading proofs of Hone's collection of J.B.Y.'s letters. Perhaps his old artist father was as much on his mind as himself when he wrote *The Green Wave*, recalling the struggle of spirit to overcome flesh, which characterised his father's artistic career. He wrote appreciatively to Hone:

The shortest glance at the book gives an idea of a mortal span beginning 'Dear all of you' and ending 'The same as at the beginning'.[3]

Perhaps something of that affectionate memory passed into the play, for there too we have a mortal span – the life of Alice from nine years old to the grave – and the message of old Anthony Larcson, 'Tony we have the good thought for you still', marked

between the tides near the start, and at the end of the play. The name Anthony Larcson continues the idea of the spirit of man just as the lark is an emblem for its continuance at the end of *The Old Sea Road*. But that old battle between the spirit and the flesh that he wrote of to his father in 1920 (for which, see the chapter on *The Charmed Life*) was becoming a gentler and more yielding affair in Jack's own old age, and the distinctions were becoming blurred. The joker, Ambrose Oldbury – the Jacksport – is now Jack Oldgrove; a living grove, not a bringer of death: and Michael of the Song is now replaced by Anthony Larcson (for the lark sings) and declares himself to be a bit of a joker (IS p.333) – perhaps he enjoys a lark. It is natural to think of these two in this way – two men, one middle-aged, one elderly, following on the two Elderly Men of *The Green Wave*, in which the spirit and the flesh of the two men in *The Old Sea Road* still have their differences to settle.

These two are both bachelors and apparently pleased with it (IS p.337), so how does it come about that Larcson wants the women pipers to play two tunes which recall sadly the separation of Irish men and women, particularly by war? And is it significant that Alice marries and lives in exile and that she is widowed, but childless, after ten years of marriage?

To understand why and how these matters are indeed significant, we have to imagine ourselves in a different Ireland from that which exists now. The Ireland of 1943 was a country with little money and few prospects of making it, with emigration continuing and population on a downward trend. Many young Irishmen volunteered to join the Allied forces not merely as an expression of a desire to support the better cause, but prompted by the lack of work at home. In that context, the talk of the two men about all the eligible bachelors being snapped up is talk with a sad background to it. There are too many women for the number of men. In the past, Larcson says, there used to be plenty of bachelors. That too points to an imbalance between the sexes. Such imbalances are common when there is no work locally. A war draws away the men to find work; peacetime often draws away the women into service, particularly in a country where men held off from marrying until they had land to support a family with – which for many was not until middle age and for many others, never at all. The women became impatient of waiting.

Such a one is Alice, perhaps: but her defection with her small

inheritance is not one to be criticised as Annie's can be in
Harlequin's Positions. Alice's money is not representative of
Ireland's wealth, nor is her journey emblematic of throwing in
one's lot with the commercial nations in world war, as Annie's
is, because the period is quite different. There is also the fact
that, as with the girl in the song, she does keep a kind of faith
with Ireland and the old bachelor by continuing to write his
message on the sand.

Larcson's comment on his bachelor status is best seen as a
kind of resigned bravado. He chooses a girl because he knows a
boy won't have sympathy with his intentions; he chooses the
women pipers because he has imagined himself mourned by
Irish womanhood when he is buried in Glasnevin. Ireland is
always symbolised by a woman; never a man. This fantasy
underlines the political aspect of the play. Glasnevin was the
cemetery where all the leading Republicans were buried. In 1922
Jack Yeats painted the funeral of Harry Boland there – the only
pictorial record of the event as the young Irish Free State
Government banned all cameras in the cemetery. Old Tony
Larcson, then, is an old Republican without issue. What is there
left of his ideals?

The great beauty of this play is in the way in which Yeats
contrives to realise the essence of those ideals across the world.
Larcson lives in a republic of the mind. He seeks no 'storied urn'
but only to perpetuate the idea that we need not be bound by our
past or even our present, so long as we remember that the tide
will come and wash away our sins and our triumphs without
discrimination and with absolute certainty. The old Mayor of his
town, like the Old Sailor later on, manages to keep his head
above those waves. So too does Alice. She and the sailor have
learnt to accept what life brings – and that includes the wave.
The Sailor at one time made a living swimming outside the
tourist bathers so the sharks would get him first (IS p.355): Alice
sells shells in which the tourists can hear the sound of the waves
(IS p.358). The green wave has not brought either of them an
easy time – the 1st Elderly Man has already told us that it seems
to have cruelty in it: but he bought the painting, and its truth
does not disturb him in the way it does his less spiritually
minded companion. Nor is it intended that the pity we feel for
Alice or the Old Sailor should make us wish to change the world.
The Visitor listens to nothing the Old Sailor has to say. He is one
who plans to change things to fit his own Utopia and the

experience of the Sailor is of no interest to him; indeed it is
antagonistic and becomes overtly so when the Old Sailor says:

But these suppression governors, they didn't last much longer than the
earthly paradise ones because they weren't able to show results. There
was nothing left to suppress, not so they should notice. We got sly. This
is the slyest island on all the seas. I wouldn't tell you only I know you're
not listening, you bloody little numbskull. (IS p.360)

One is reminded, by that slyness of the people, of the cunning
of the railwaymen in *Harlequin's Positions* and of the deception of
Ted in *Rattle*. In the following quotation, the Visitor sounds
suspiciously like Alfred (see Chapter 5). They both think of
themselves as chosen people with Imperial rights:

VISITOR I hope to be able to make a considerable stay if I find myself
 comfortable. During the few hours I have been here I have
 experienced a strange, but very pleasant sensation, that of being in a
 chosen and appointed place. As though the Supreme Being and
 myself had collaborated in placing me here – my spiritual home. (IS
 p.361)

He is speaking to the latest Governor who believes in order and
hopes only for order (IS p.361) and who is particularly concerned
to stop the islanders writing scurrilous slogans. He plans to ban
all but the ones he chooses, and the ban will include 'Tony we
have the good thought for you still'. The satire upon their plans is
comprehensive and hilarious, and has something of the character
of Swift in its fantastical yet obvious relevance to all ambitious
social organisers, whether they be Governors or Mayors. The
Mayor at the end of Act 1 watches the tide come in over Larcson's
message just as the Governor does at the end of the play. And
where the Mayor is just keeping his chin up above the oncoming
waves, the Governor and Visitor are advised by the Receptionist
to 'Keep your chins up' when their revolution has to be called off
(IS p.375). The local girl, Alice, puts her arms round the Mayor's
neck and kisses him at the end of Act 1. The local Brown Girl puts
her arms round the Governor to prevent his suicide, and her
lover disarms him.

For only the second time in any of Jack Yeats's plays, there are
the obvious signs of love. There have been no real couples and
not one kiss until this play which has the young embracing the
old, Alice marrying Maurice, the Chauffeur hand-in-hand with
the kitchen maid, and the two brown-skinned lovers at the end.
One might conclude from this that love is what secures us and

keeps our own chins up, but that is not so. Alice loses her Maurice after ten years and, like Larcson and like Jack Yeats and Cottie, she leaves no children for her memorial.

The truth is that in this play, in the face of the Green Wave, we are all of us together: Mayors, Governors, Utopians, Lovers. Our plans are as nothing in the face of its inexorability. Alice is reduced from marriage to solitude and from riches to poverty in one day. The writing is on the wall for each and all of us but it is not our own hand that writes it:

MAURICE We're fancy free, nothing to stop us except misfortune – other people's misfortune – or our own. We can keep moving like the finger on the wall but we don't write anything on the wall – only on the sand of the sea-shore. (IS p.349)

The same theme is taken up by the Visitor and the Governor:

VISITOR Right, and anything outside that list, any fancy-free slogan to be barred absolutely. That's the talk! I haven't as yet seen any writings on the walls.
GOVERNOR There aren't many walls. First take your wall, then write on him. That drives the people to the sandy beaches.

There the permitted slogans are ignored and the unpermitted ones are washed away. The Visitor with his Utopian dream plans to capture that spirit by creating only the symbols of the state, not the realities. A notice will do for a swimming pool; a single stretch of wall, short or long, will serve for a prison. He claims as much:

VISITOR . . . I welcome you . . . to our State which at one and the same time is the newest and oldest establishment on this planet, afloat and now ashore. . . After a while you will notice this island earth beneath you is trembling. Do not be alarmed. The trembling will be caused by the marching of feet of myself and collaborator marching forward to greater expansion, remember that, as the poet says –
 Love itself
 Must rest
And where we rest we bivouac – on the Paths of Freedom.

But his attempt to enshrine this acceptance of change in a political philosophy is as doomed as any other plan. No sooner has he uttered it than the arrival of the tourists puts paid to the whole thing. If he had listened to the Old Sailor he would have known that already. But he cannot read the writing on his own wall. The original moving finger announced the division of Belshazzar's empire and his overthrow because he had

worshipped mammon – the flesh and not the spirit. The Visitor attempts to put flesh on the spirit of Freedom and likewise must fail. Many of his objectives would have been sympathetic to Jack Yeats – not least his proposal to add 'Art for Art's sake' to the list of banned slogans, only Jack Yeats was not in the banning business: he had come to acceptance.

The recollection of 'So we'll go no more a-roving' – mostly by Anon but yielded to Byron whose *Vision of Belshazzar* is also apposite here – is sadly appropriate. The Brown Girl and her Brown Boy roving by the light of the moon at the end of *In Sand* retreat from the sea with the Governor and the Visitor, and their love will one day be put to rest, perhaps sooner as the love between Maurice and Alice was; if not, then surely later. The one thing that just might survive is 'Tony we have the good thought for you still' – a message of affection and acceptance in the midst of war that comes out of Ireland and might one day circle the world. Yeats instinctively felt that our freedom and the freedom of nations lay spiritually between the tides where all is forgiven and forgotten – just as Ted forgives and forgets, forgets and forgives in *Rattle*. The idea had been long in his mind. Many years before, he himself had stood on the sand at the Bull island in Dublin bay and, like the audience in *In Sand*, watched a line of people standing before the sea:

. . . While when I am on the Bull, where I often go now, I must hurry along only lingering to search the beach for treasure. I was there the day the interned men were released, and three or four, whom I had seen board the tram at Amiens Street station only half an hour before, came down to the sands and strode straight out half a mile, it was dead low water, beyond the wrecks to the very lip of the sea

I am yours very sincerely
Jack B Yeats[4]

The Green Wave with *In Sand* was the last of Jack Yeats's plays and brings together aspects of several of his earlier plays. There has been a relaxing of an initially aggressive stance towards the audience (see Chapter 2), even though the actors at the end of *In Sand* have their backs to us, but a reversion to the expansive monologues of *The Deathly Terrace* and *The Silencer*. It may be that, after production of two of his plays, and with the support of Ria Mooney for his work and the absence of his brother's influence on the Abbey and the Peacock theatres, he felt confident enough to stretch himself in his last play.

I have tried to indicate that, through the diversities of time,

character and place, there is a fundamental coherence of imagery and action. There is undoubtedly a shock, to the reader at least, in the diversity of pace, but the play was made for production and I have already offered reasons for reserving judgement on that score. A connecting factor in all of his plays is the element of satire, and this often finds expression by subtle means. The Visitor's schemes are an obvious example. At one level they are absurd because they are literally unreal: at another level, they contain many imaginative and witty ideas. Such is the wall that is hard to climb and so attracts the most lively and therefore the most criminal of the inhabitants where they can easily be kept an eye on.

How Yeats's characters relate to one another, and how his dialogue works in that context rather than in the overall symbolic context, is an area I am conscious of neglecting. My excuse is that it is more important at this stage in the study of Yeats as a dramatist to understand the fundamental issues of the plays and their basic symbolic resonances. What has been presented here is largely new and makes sense of many lines which might have seemed gratuitous before, as well as explaining the significance of certain details of action, setting and costume. The plays are rich in detail and there remains much to be understood and, doubtless, these explanations will be refined and revised. But no amount of analysis will reveal to us the full riches of plays that can only truly live in the theatre, as I trust these one day will.

8

Jack Yeats and the Novel

The novelist who respects his workshop more than life, can make breasts heave, and arms wave, and even eyes flash. But he cannot give his people pulses. To me, man is only part of a splendour and a memory of it. And if he wants to express his memories well he must know that he is only a conduit. It is his work to keep that conduit free from old birds' nests and blowflies.[1]

Most novels, like newspapers, are expected to make an entertainment out of the events (real or concocted) that come to hand and if, under the various headings, the dormant reader finds no clear narrative line he is likely to become restive and resume his own. Some novelists, amused by this expectation (Fielding, Trollope and Fowles for instance) keep reminding the reader that the narrative is all their own work, the news in their sole gift: others have tried to conceal themselves in their own undergrowth; such are Conrad and James, protected often by their narrators, enjoying their seclusion like wild strawberries under nettles. Jack Yeats fits both and neither of these categories.

But by far the largest group of novelists is lodged in the intimation columns, in the hatch, match and despatch business, whatever the narrative stance; and with that group Jack Yeats does not belong; not, at least, in a way that will stop dormant readers from becoming restive. There is some of it in *Sailing Sailing Swiftly*, but otherwise Yeats is largely to be found in the despatch section with the kind of accidental deaths that would find a space in other columns. Marriage is rarely represented and when it is, though pleasant and comfortable enough, it never seems to give birth to any thrills and is usually cut short by someone's death. Maurice dies after ten years of marriage with no children to show for it in *In Sand*; in *Sailing Sailing Swiftly*, Annette is widowed within a few weeks but at least has Larry to show for it, but he dies while his children are still young; James Gilfoyle in *The Amaranthers* has a short-lived marriage that bequeathes him failing shares; in *The Charmed Life* Sally connives

114

at her husband's defection from that blissful state; Claire's husband, in *Harlequin's Positions*, has fallen into the centre of a fire on his ship; the Mayor of E-town in *Ah Well* commits suicide after his wife laughs at what she believes to be his corpse; and that, for the most part, is that.

Not that Yeats disapproved of marriage – his own was very happy and most of the marriages he describes are happy if frequently brief – but simply that he does not seem to have regarded it as central to the progress of the soul, and he is too discreet to mention the fulfilment of the body. Jack Yeats admired Joyce and no one has suggested he was a prude; but he was a gentleman and had no need to write of such things when others were managing it very well without his assistance. I have suggested that he regarded marriage as important to the progress of a nation in *In Sand*, but there is no avoiding the fact that he ignored marriage relations as potential subject matter almost studiously and the romances leading up to those relations are always brief. Some observers might want to criticise Yeats for such an avoidance. Loving, marrying and begetting are our most dependable preoccupations after eating, drinking and sheltering, which latter trio Yeats honours with generous observance. The best explanation I can give is that where sexual relations are involved it is less easy to develop individual character without the reader constantly asking when the pair are going to kiss or get engaged or get into bed together – and it is no use protesting that readers do not or should not ask those questions, because the vast bulk of novelistic literature panders to the fact that they do. In effect Jack Yeats, in avoiding sex and marriage in his writing, was avoiding a very heavily laboured conventional expectation in the novel. But outside that conventional subject matter, Yeats covers a wide range.

I have already indicated in the Note on the Chronology that there is an overall pattern in the novels and that this pattern embraces most of the possible narrative stances. It is time now to look at that pattern and its variety and to come to an understanding of Jack Yeats's radical approach to a form of writing which, like the symphony, has been dying for a century according to the specialists, but according to itself and its friends is in a remarkable state of good health. There was a time when Joyce was imagined to have written the last novel. Even Jack Yeats belonged, in a way, to that school of thought and his attitude to words was equivocal:

This word business is nearly played out unless some new language blossoms to give a few new mouthfuls. (Sl p.18)
If this is going to be the last book written we cannot be very far away from the last thing 'said.' Speech is certainly on its last legs if it ever had legs. (Sl p.42)

Having written the above he went on to produce another six novels, full of vibrant use of language. In the meantime it is simpler to forget about these fears for a wayworn language and also to forget about Joyce, whose influence on Jack Yeats has been asserted more than once (see Chapter 9). But Joyce stuck closely to a narrative line in *Portrait of the Artist as a Young Man*, and *Ulysses* has several narrative lines running nicely to time. And when the fanciful took over in *Finnegans Wake* he laid out the historical food chain in a Viconian circle, determined to respect the causal system though his genius buzzed around it like a fly round offal.

Jack Yeats displays the behaviour of a different kind of fly, but to pursue him with a swatter protesting that he does not land where expected, or crawl over his nourishment with sufficient sense of purpose, does not undo the logic of his flight. If it is 'his work to keep that conduit free from old birds' nests and blowflies', then we had better look out for something other than the laying, hatching and despatching of eggs.

Nardock in *The Deathly Terrace* uses the word 'continuosity' (coined by Yeats?) to describe his own narrative style (DT p.107). Perhaps Jack Yeats was already aware that 'continuity' was changing its meaning from the simple 'state of being continuous' (Chambers 1901 and OED 1933) to 'logical sequence, cohesion or connection' (Collins 1979), which latter definition begs many questions. As a consequence 'discontinuity' has now become synonymous with 'illogical' and is regularly applied with that implication to Jack Yeats's writings.

This notion of discontinuity in Yeats was early put forward by Beckett – 'The discontinuity is Ariostesque'[2] – and has been repeated by others such as Mays (see Chapter 9). Superficially one can see why. In *The Careless Flower* one of the leading figures dies two-thirds of the way through the novel, leaving the other to finish it entirely on his own, all other characters left behind. *The Amaranthers* is in two unannounced parts which have no characters or scenes in common until the last three or four pages. Chapter divisions are rare, and when they occur in a brief and relatively conventional novel like *Sailing Sailing Swiftly*, of the

three characters whose affairs are almost the entire substance of the first chapter, two die at the end of it and the third half-way through the book. She is survived by her son – whose birth in Chapter 3 does not save him from death in Chapter 6, leaving his Uncle Ned in centre stage. Minor characters come and go with equal rapidity and often without appearing to do anything to anybody.

There are similarly radical approaches in the first person narratives. In *The Charmed Life* Bowsie and No Matter, though well contrasted, both speak for the author; but Mr. No Matter emerges in the first person without any inverted commas or other explanation, and changes his name to Hector and then to Alexander at a late stage in the book and after Bowsie's departure, as though to reflect a change in nature. In *Ah Well* the narrator is Jack Yeats in his studio, but only for a few pages, after which Old Dusty Brown takes over the entire narrative, though one suspects he is another alter ego. As for *And To You Also*, it evolves into a dialogue between characters drawn mostly from earlier novels and including Jack Yeats himself; only it is a dialogue in which the speakers are not always clearly distinguished and at times even the assistance of Jack Yeats's own memos to himself on the manuscript is insufficient to identify them. These memos appear to have been overlooked by previous commentators.

In attempting to overcome the prejudices which the factors listed above undoubtedly produce, it is necessary to think of the novels in critical terms outside the old conventions. McGuinness has stressed the need for this and relies heavily on the word 'fabulation' as a way of explaining the nature and purpose of Yeats's books. The term has some value, combining fable and narration, but I find it such an ugly coinage that I cannot bring myself to use it. What it attempts to do is offer a line of literary and oral presentation that uses other conventions than those of most novels, and that is good.

The truth is that the conventions that we accept with respect to most novels are just as odd as anything Jack Yeats ever did; and yet we do not criticise Jane Austen because Chapter 2 is located and peopled quite differently from Chapter 1; and it does not even surprise us when the same thing is still going on in Chapters 13 and 14. In many novels this discontinuity is so deeply embedded that the novelist resorts to phrases such as 'Let me remind you, dear reader', or 'But what of X languishing in Y?' . . .

'In my last chapter but one' . . . 'back at Mr. A's' . . . the convention is monstrous, but we all happily connive at it, and we think nothing of the passing away of characters and their replacement by a new crew, so long as it is done over at least half-a-dozen novels. Let us be grateful indeed that, when Yeats wishes to give us the sensation of the passage of time and generations, he does so by *Sailing Sailing Swiftly* through a mere one hundred and seventy pages.

Even if we abandon our existing prejudices, however, that does not make Jack Yeats's writings automatically coherent. The problem lies in other areas too. As with production of the plays, the novels are hard to come by. In particular, the three most accessible to the ordinary reader – the three third-person narratives – are virtually unobtainable, even from libraries, and second-hand copies are very scarce and extremely expensive. Then there is the fact that none of these books has been produced with a scholarly Introduction, so most readers dive in without even knowing if the water is salt or fresh. Another area of difficulty is occupied by the scholars themselves. Their work is scattered in periodicals and the bulk of it fails to identify the main connecting lines of thought and imagery that give several of his novels a startling clarity of shape and purpose. Finally, Jack Yeats's manner is deceptively unpretentious. The freshness of his style, the humility and even-handed manner of his observation, and the vivacity of nearly every moment in his writing – all these allow one to wander along the shore, careless of the tides, picking up the flotsam and jetsam of some great event out to sea towards which one may not think to raise one's eyes.

In this connection it is important to remember Yeats's belief that 'man is only part of a splendour and a memory of it' (see Chapter heading). When he follows an individual's destiny he does so in a vast context in which the salient moments are as likely to be encounters unplanned by that individual, whether with nature or with man, as they are to be things intended or desired. In such a vision, every thing and person that is encountered – a blocked drain, a ballad singer, a stray horse – has some importance, though, as I have pointed out with *La La Noo* (see Chapter 6), this existentialist awareness is done with a light touch.

The novelist himself is seen with a detached and almost humorous awareness by Yeats. In the quotation at the beginning

of this chapter, the vision of the novelist, cleaning out the conduits so a greater awareness can pass on down, is a comical and humble one. It was the same when, in 1944, he painted 'The Novelist', knowing that he had written his last and could stand back and smile (Plate 9). He painted him sitting alone with his back to us: not, however, in a wholly private world, but on a rusty public bench looking out to sea. Above him on the cliffs two figures are observing the same view. At least he has not seated himself as far forward as Canute but, with the pencil resting thoughtfully on his lips, it is clear that the breaking waves are not providing him with easy matter; and there is a turbulence in the sky, ready to trouble his straight-backed posture. There is irony in the fact that he not only shares his view with the figures on the cliff, but that we stand behind him seeing the same view, with himself unaware of, or trying to ignore us looking over his shoulder. But what more can we write about the prospect than he, and might not our pencils also be resting on our lower lips?

Nothing daunted, Yeats wrote and published seven novels, and in them he explored a wide variety of narrative stances, locations and time-spans. Taken in the sequence of composition proposed in the Note on the Chronology, they show an overall shaping which can be seen as describing man's journey through life.

After the first novel, which is in the first person and uses mixed tenses, we have three journeys expanding outwards each in the third person and past tense. The first is between England and Ireland; the second between England and the West Indies; the third achieving a fantastic and idealistic goal on the mainland of the New World. These are balanced by the last three novels in the first person, journeying inward. The first travels between several locations in the West of Ireland: it is in the present tense. The second, after a brief conversation in Yeats's studio, is confined to the environs of one town, except at the very end, and basically uses the past tense. The third and last is largely confined to St. Stephen's Green in Dublin and uses mixed tenses as well as extended dialogue.

The outward and inward movement which this sequence displays can be seen as a change from first to third to first person, but there is a further sequence within the last three first-person novels. *The Charmed Life* has, as many commentators have observed, a narrator whose companion is a kind of alter ego. I shall argue that they represent the spirit and the flesh. This

narrator owns to no occupation and uses three different names. In *Ah Well* the initial narrator is Jack Yeats himself in his artist's studio (AW pp.5 and 7); but the main narrator is another alter ego – Dusty Brown 'my unshatterable friend of clay', perhaps again the flesh. Finally, in *And To You Also*, the narrator is unequivocally Jack Yeats, who continues to take part in the dialogue, identified in the manuscript by Jack Yeats as 'Me'. The progression is one of increasing revelation of himself as a protagonist parallelled by decreasing mobility. The last novel also has particular points of contact with the first. It is not just that Yeats is jettisoning his memories in person and is present throughout, or that he refers to the first at the beginning of the last, but that (as with his last play) he relaxes his hold on the structure in a manner that recollects *Sligo*, though it does not parallel it. In the last novel he gives himself a local habitation and, in the manuscript, a name. He also orders the presentation of his memories by the device of using several characters whose natures are distinct but who have mostly appeared before in his other books. And, unlike *Sligo*, the book is enclosed in time and space. So, in his old age, was his life. The overall form is that of a man journeying forth out of himself into the world and gradually moving back into himself in expectation of his death. At the centre of his life is the real and imaginative achievement of James Gilfoyle and at the end of it a last gathering of the companions of Yeats's own imagination. The form, however, is not circular: death is not the same thing as birth and the presentation of *And To You Also* is not the same as that of *Sligo*.

This is an important point to establish as both McGuinness and Connelly[3] have suggested that Yeats's structures were based on the circle, McGuinness favouring the more subtle Celtic circular form of the triskele (McGuinness p.163 and p.257). To describe a circle in a piece of writing must involve motion, and Jack Yeats was not in favour of going around in circles. Turning around in circles was what wheels were doing to the world and he did not like it.

> Those were a stylish people, those, who used only the sled and they knowing full well about the wheel, but being too proud to use it. It wasn't the wheel itself they objected to. How could anyone object to the wheel? But it was the going round and round they could not put up with. (AW p.11)

In *La La Noo* we have seen the dangers of the road and the war that could one day be wheeled down it, and one Christmas, during the war, Yeats took up an image from his brother for his

Christmas and New Year message to MacGreevy, of a butterfly breaking up a wheel with an axe, adding the words:

and I hope in 1945, taking a cue from the turning worm, that little shivering Butterfly Humanity will assert himself.[4]

Likewise the bicycle is criticised by the Publican as:

The machine that goes by the power of arithmetic. (LLN p.321)

We know that Yeats did not care for arithmetic (see Chapter 4, Note 7) and he says he dislikes circles *in propria persona* in *Sligo*:

Hieroglyphics will be no use for they will only begin the dull circle over again. Why so many circles? What a nuisance they are. (Sl p.18)

It is not necessary to find a geometrical form to match Yeats's procedures. Our sense of shape and proportion need not depend on them and, as a painter at least, Yeats can be shown to have had no interest in the relationship between geometry and art. His likening of some modern painting to 'coloured Euclid' (see Chapter 4, Note 6) displays a latent animosity to geometry as a model for artistic activity; and the relationship of geometry to early Celtic art was not explored by him at all. He knew the work of Mainie Jellett, who brought cubism to Ireland and expounded on the relationship between it and Celtic designs,[5] and he attended exhibitions of her pupils' work,[6] but he never seems to have involved himself in discussion of her aims and there is nothing of them to be found in his paintings.

A simpler way to describe Yeats's manner of shaping his novels would be to think of the motion of the tides. Such a motion has recognisable pattern, but it is not exact in its repetitions in relation to the human calendar and its effects are constantly modified by the weather and the geography of a particular coastline. But it is recognisable, and it has motion and progress. One could regard the shape of his whole output of novels as being that of the tides, with the spring tide at its centre. The fore-and-aft motion of the tide also fits in with that motion as described in *The Charmed Life*, as has been ably pointed out by McGuinness (McGuinness pp.260 and 263), and it also relates to the double journeys to an island in *The Careless Flower* and *The Amaranthers*, as well as being part of the imagery of *Rattle* and central to *In Sand*. I offer this comparison only as a way of thinking, not as a specific model, but it very clearly has bearing on the one thing that is undoubtedly common to all of Yeats's novels, and that is the journey.

I have already made some comments on the significance of

Ireland's political situation in Jack Yeats's work in Chapter 1. These should be borne in mind with respect to what is attempted and achieved in the journeys in the novels. They have their beginnings in *Sligo* with the journey of the Irishman Johnnie Ropes' family in which the question of the tides and the idea of writing in sand between them first occur as they sail from island to island (Sl pp. 49-50 and 52). *Sailing Sailing Swiftly* moves from England to Ireland and back. *The Careless Flower* has two journeys to a Caribbean island; the first is directed largely by chance, the second, undertaken by the Irishman, Mark, deliberate. There are also two journeys to an island in *The Amaranthers*; firstly, the Amaranthers themselves, then that of the half-Irishman, James Gilfoyle, across the Atlantic. *The Charmed Life* journeys Westward on the Western seaboard of Ireland from the Imperial via the View to the Pride Hotel. The centrepiece of the action in *Ah Well* is the journey above the town; and the final dialogue of *And To You Also* takes place while the characters walk around, and eventually climb over the railings of St. Stephen's Green in Dublin. With the exception of *Ah Well* (whose chief protagonist, Dusty Brown, is as Irish as Jack Yeats (AW pp.6-7)), all these journeys pointedly involve Ireland or an Irishman.

There are good reasons for journeys to England, America or to strange islands being particularly significant for Irishmen and for Jack Yeats. He himself had journeyed to and lived in England for economic reasons attached to his father; he had made the journey to America to exhibit his wares at the Armory exhibition and had sold very little and almost all of it to the one man – John Quinn: so he knew in a quiet sort of a way what it was like for his compatriots who had made these journeys under much more severe pressures and with wilder hopes. But the source of all these journeys was Sligo in which he must have met many people who had not merely visited the United States but had lived and worked there. These were people forced from their own land, frequently in the interests of everybody's economy except their own; whether as soldiers or defeated or wealthy emigrés returned, they knew many corners of the world which their English city counterparts only knew of by the chance prod of a finger on an old tin globe.

Sligo was also a busy seaport, and a centre of rural and maritime trade in which Yeats's family had featured prominently. It had its railway and was served by Bianconi's famous horse-drawn transport system (which guaranteed

same-day deliveries throughout Ireland) and it had its newspapers whose versions of the world's events were still being challenged by the ballad singers. But perhaps most important of all was its place on the West Coast.

There are many islands to the West of Ireland, but they are not so large as to disguise from the viewer the reality that the next substantial piece of earth is America. It was across the Atlantic to America that many of the Irish cast their eyes, hoping for a world of better opportunity, where freedom and equality were a great deal closer to hand than under that Mother of Parliaments whose reluctance to give birth has been matched only by her disapproval of her own offspring. If there were also many Irish people who travelled East to Britain, it was a journey for money without ideals, a compromise made with the oppressor largely on a seasonal basis.[7] Westward for Irishmen of Yeats's and Synge's generation, on those islands such a short step from their own mainland, there was still a society substantially without money, where the country people had little property and, as in many peasant communities, what they had they largely shared:

. . . we have an open mind, and the foolish civilisation of the cities and the love of money for the sake of money has not yet stolen us away.[8]

Of course the poverty of these islands was not lost on either Yeats or Synge and beyond them again was an ideal island – Hy-Brazil, a legendary island that came and went much as our hopes of such things come and go; an island of eternal youth and eternal love. The instinctive journey of such desires in a northern latitude is to the West and the South: South to the sun and the youth that it confers; West with the sun so that time stands still and still moves on:

It was an honour to think that every step was a step nearer the west. Where I am I always want to walk to the west. As well as from a desire to get to an ocean coast, from a wish to be going with the sun.[9]

So the journeys in the novels have their roots in Irish legendary and historic reality. They are journeys that would reward the heart that fought the prevailing south-westerly wind, determined as Mark to find a boat; journeys with the sun to a world unspoilt by the root of all evil, where the capitalist could not plant coin since even corn was hard to grow. That Yeats should have shaped not only his individual novels in the form of journeys, but his whole output in the genre itself as a kind of

journey is a remarkable thing to have done and I know of no parallel to it. What is more, I have no doubt that much more can be legitimately read into the sequence than I have had space to suggest. But the novels have to be understood individually before the attempt can be made.

If one can say of Jack Yeats's plays that they seem to be without precedent or issue (though they have their own curious line of descent), much the same can be said of the novels. There have only been two extended attempts to relate the novels to the work of other writers, and these were made by Marilyn Gaddis Rose, the writers being Sterne and Beckett.[10] I have found no mention of Sterne in Yeats's works or correspondence. He may very well have read works by Sterne (though there are none in what was kept of his library) but Ms Rose fails to come up with any convincing connection between the two writers. Yeats rarely draws attention to the business he is at – novel writing – and never with the blatant teasing of Sterne's manner, and Ms Rose's attempt to relate the two on the basis of failure of the characters to achieve some goal (the completion of Tristram's life story, the journey of Bowsie and No Matter to the hotel) falls down because the plan, such as it was, succeeds. They get to the hotel – a fact which she acknowledges and then ignores. Her suggestion that the same occurs in *The Amaranthers* is equally wide of the mark. Gilfoyle's 'task' is no such thing. He is in search of satisfaction for his loss of dividends, and this he gets; and he is in search of something that satisfies his dreams which he realises so success-fully that he recommends it to the Amaranthers, who join him in his new situation. Likewise in *La La Noo* the women do not fail in their 'task'. They get their clothes dried and they drive off in the lorry in time to catch the bus.

Ms Rose applies this same idea to the relationship with Beckett and it fails for the same reason. Of course nearly all Beckett's work post-dates Yeats's and the only influence anyone has proposed is of Yeats on Beckett, not the other way round. Pyle quotes Yeats as having thought, disapprovingly, of Beckett's work as 'amoral' (Pyle p.146). The possible influence of Yeats on Beckett has been widely referred to but it is not the place of this work to pursue it, though much could be made of it. Hilary Pyle writes that 'Colourful expressions were taken straight from George Borrow' (Pyle p.138). This is not true. Her only backing for her remark is a letter to Ria Mooney in which Yeats cites Borrow as backing for a usage he was insisting on and which he

already knew from frequent delving in slang dictionaries[11]. He was always noting down odd phrases in England and Ireland in his sketch-books, and his early *Manchester Guardian* articles are full of colloquialisms and slang. He had at least four slang dictionaries in his library. His friendship with Masefield may have had some influence on his use of slang, but given that he spent several years reporting sporting events in and around London as an artist, there seems no need to look further to explain his familiarity with slang and cant.

Other writers have been mentioned as possible influences on Yeats's novels. Pyle states that he owed the inspiration for the Ropes family in *Sligo* to *Erewhon* (Pyle p.138). Again this seems to have been prompted perversely by what Yeats wrote himself:

Now do not let anyone think for a moment that the history of Johnnie Ropes' ancestors as told by him was in any way like Erewhon. Ropes had read it, he thought it a fearful bore. (Sl p.48)

This was Yeats's opinion too. He disliked Butler's work and wrote to Hone saying so in no uncertain terms.[12] A little later Yeats acknowledges a more likely progenitor in Swift:

But after all telling these Gulliver's Travels to gullible people leads the gullible people nowhere and, as the saying is, 'what's the use.' (Sl p.59)

What makes the Swift more relevant is the fact that the Ropes family pass through several societies on their travels, just as Gulliver does and as 'Higgs' does not. Writers whom Yeats enjoyed, and some of whose books he possessed, were Bret Harte and Mark Twain. With the former, there are some genuine points of contact. He painted a 'Homage To Bret Harte', depicting the end of *The Outcasts of Poker Flat*, with the deuce of clubs pinned to the tree and Oakhurst dead beneath it; and Yeats wrote in *Ah Well*:

. . . if it hadn't been for an Irish Jew, called Bret Harte, wistful and envied in the mornings, looking on the coast of San Francisco for comfort and making it for himself with Romance, there would be no film industry. (AW p.6)

Harte's and Yeats's leading characters live mostly in unsettled ways and are observed with a sympathetic detachment. They show the law scant respect and are never more than humorously deprecated. Harte's recurring hero, Oakhurst, cleans out many a pocket and rifles the honour of a crippled wife only to find that his

partner is at the same game with the same woman, for which Oakhurst kills him in a duel. Mark in *The Careless Flower* steals and eventually sinks a luxury motor boat without the slightest compunction, and James in *The Amaranthers* shares in the spoils when his guide Oh-Oh robs a train; and also in *The Amaranthers* is a marvellously told story of a jealous Captain who takes his lighter through a hurricane to get back to the harbour where he has heard his rival has re-appeared (As pp.249-51). It has the same economy and laconic observation and drama as Bret Harte at his best. There are other passages in 'Wild West' style, such as the description of the murdered man in *Ah Well*, in which the Mayor does not call an inquest; or the playful description of a street fight between boys in *The Charmed Life* (CL pp.78-80), or of the touching miniature tragedy of the story of the man who went to Spain (CL pp.94-99). Finally, Mr. No Matter, equating it seems the West of Ireland with the West of America that Harte celebrates, says of the wild and open spaces:

I love them wild, and if they aren't wild, I'll wild them. And, if 'open' means free – then they are free to me. Through or over, I go in without a ticket, except a complimentary one. I give myself that one. (CL p.3)

This recalls Jack Yeats's own epitaph as noted from him by Terence de Vere White:

I have travelled all my life without a ticket: and, therefore, I was never to be seen when Inspectors came round because I was under the seats. It was rather dusty, but I used to get the sun on the floor sometimes. When we are asked about it all in the end, we who travel without tickets, we can say with that vanity which takes the place of self-confidence: even though we went without tickets we never were commuters.[13]

Jack Yeats most certainly entered the world of the novel without a ticket. In fact the whole metaphor can be applied without damage to his work as a novelist. I shall try in the following chapters to clear a little of the dust, if only to watch it in the sun; but if we are to come to an understanding of and with Jack Yeats, we are going to have to get under the seat with him, because whatever ticket we may think we have, it is not valid for this journey.

9

Sligo and *Sailing Sailing Swiftly*

I have determinedly, and always, resisted the honest vanity of writing about how I write. I have never myself written a blurb for a book of my own, and I cannot do so now for all of them. But I got great pleasure, and honour when a bibliography of my books appeared in Dublin Magazine (July-September 1945). . .

In my writing, as in my painting, my inspiration has always been affection, wide, devious, and, sometimes, handsome . . .

The first full-sized book of mine to appear was 'Sligo,' it came out in 1930. In it I explained that my reason for writing was to jettison my ideas. And that is, I believe, the true reason for all the books I have written. And also, I must say that in every book there is somewhere in it a memory of Sligo, where I was brought up, and to which lovely place the beak of my ship ever turns, as turns the beak of the rushing carrier pigeon of the skies to his old harbourage.[1]

Jack Yeats's first book, *Sligo*, is indeed a book of affectionate memories as much as it is a novel. Yeats was the last person in the world to write an autobiography and so the memories gathered here are not personally revealing in any ordinary way. Yeats is simply not active in them: he sees, hears, feels, smells, tastes and records; but he never moves, rarely converses, and the succession of memories does not appear to follow any ordered sequence. There are no chapters; paragraphs are frequently pages long; and time and space are trundled about as unpredictably as barrels by an author who never confesses to a presence in either of them as he writes, but only as he remembers.

The temptation has been to classify it as a stream-of-consciousness novel, but it has nothing to do with that mis-named genre at all. It is all very conscious, whereas stream-of-consciousness writing encourages bundles of mental paraphernalia, many of them turning up from the unconscious without invitation, to find room among its utterances, whether they are the author's or his characters' thoughts. *Sligo* is a true narrative, a telling full of knowing: nothing un-knowing about it. It is also, (in its own way,) remarkably coherent, and this is

achieved by a thorough control of the nature of the things remembered. Yeats never permits the thoughtless interpolation of a 'did I put the milk bottles out?' kind to break into his narrative. He also avoids any development of character. This is what makes this narrative so unusual and also what gives it its unity. We are so stuck with the convention that events are only made coherent through the perception of a human that we expect always to have the events in a narrative presented to us as part of a person's life history with some clue as to the periods of both the memories and the memorising.

Of course it is true that no narrative can take place without a perceiving human, but there is absolutely no requirement that we be in a position to place that person in order to appreciate what he or she has to say. The nature of what is observed and recalled can be revealing enough, especially when, as in this book, it is accompanied by a wealth of opinion. The consequence of this rare approach is that the events in *Sligo* shine out more truly on their own account, following on one another by verbal associations or by characteristics they hold in common with each other, rather than with the life of the author. In other words, Jack Yeats has done a wonderful job of editing his memories. He has kept his family and close friends completely out of them, and his presence in them is achieved without his having to interpolate any plan or decision of his own. That is an upside-down way of achieving coherence, but it seems to have revealed more of Jack Yeats to us than many a self-confessing autobiography reveals: so, at any rate, thought Sarah Purser who had known him for many a long year and who wrote to him about *Sligo*:

. . . The book is all about races and boxers and ships and oddities – all things along with Dickens I fervently hate. And still I keep on reading it through and up and down with *great* pleasure and admiration – it is so like you and so unlike any other book in the world. It must be a satisfactory thing to be yourself and not like people on the stage the colour of the light thrown on them.[2]

Jack's big brother liked it and had similar feelings about what it revealed of Jack himself:

It is a most amusing, animated book, showing more of the mind and life of Jack Yeats, than Jack Yeats's biography will ever show. It is the best of talk and the best of writing and at the top of a fine fashion – I think of James Joyce's linked associations. 'My new book is about the night and I have had to put language asleep' he said to me a few days ago.[3]

The first part of W.B.'s comment is good, but the temptation to liken Jack's work to the nearest thing that it remotely approaches does not really help. The linked associations in Joyce are intimately involved in the here-and-now and in personal revelation of the characters but, whatever tense it uses, *Sligo* is always shifting around in the past and its author and narrator never once so much as blows his nose in our presence because, his opinions notwithstanding, Yeats is humble in the presence of life, letting it speak for itself in *Sligo* as nearly as is possible. The connections in this passage from *Sligo* are used to hold together observations on sleep rather than to evoke an image of or insight into any particular individual asleep:

And you can sleep to a hurdy-gurdy, but it will tear your heart if you wake again to one. And the long sleep where hours go in the flick of eye. Thump thump. Boots falling. The creak of a bunk. Farewell to Wales. Thump, thump. The creak of bootlaces, 'he's putting them on again. Is this Dublin'? And cat naps during the Music Hall song for the leg weary pounder of pavements. The too sloping rhythm of the song's refrain. Cat naps awake in verse, sleep in the refrain. (Sl p.120)

There are technical similarities with Joyce in the use of sentences without verbs and in the stringing together of images, but the function of these techniques in broader terms is quite different, and this can be demonstrated in the character of the syntax that Jack Yeats uses when he does employ the stream-of-consciousness technique – and there is nothing like it in *Sligo*. Here is an example from *The Careless Flower*:

This is written, the bill, the paper, the train, all in a chain, my legs chained. Ironed, oh iron, iron, iron, iron, irony. Oh, loose its chain, cometh up like a flower in the midst of life we are in death, oh, stick it, stick it, stick it, old son of the roads, oh God, no more clocks, running blind, second wind, second leg, turn again Whittington, Whit, Whit, Whit, ing, Ton. Oh, come on. (CF p.26)

There is a similar passage in *The Charmed Life* (p.149); but it is interesting that in both cases the technique is used for someone tired, running or walking, on which occasions one frequently keeps oneself going by such conscious but unplanned urgings. The technique is not used to give a privileged insight into the inner consciousness, but as a touch of realistic observation. In other words, the debt to Joyce is superficial, even where obvious. He dedicated *Sligo* to Venus with the words 'I leave it to you mam'. At least its first reviewers, also pouncing on Joyce,

believing them to be bed-fellows, did notice that there was nothing venereal in Jack Yeats. His dedicatee was the goddess of love rather than sex and whatever went on behind the curtains he did indeed leave to her and her alone.

Most of the reviewers of *Sligo* make no attempt to find any formal structure in it. James Mays goes so far as to deny the existence of linked thinking in it, which goes to show that, for some, the connection with Joyce will have to be found in some other quarter:

Continuity indeed is explicitly rejected, the chains of linked thinking are deliberately broken – 'Everything I break's my own, as the man said when he broke his word' (Sl p.28) – and the relation of parts to one another and to the whole, or rather contrived absence of logical relation, makes *Sligo* a book less to be read through than dipped into. (Mays p.37)

The trouble with this is the old trouble with selective quotation, for the very next thing that Yeats writes is:

But it is very difficult to break up your thoughts and keep them apart. We are nearly all chain Thinkers. And if anyone ever succeeded in working his thoughts in independent jolts, he would soon find himself seeking a specialist in these things. And I don't believe they understand the little jokers. (Sl p.28)

Joseph Connelly[4] suggests that the novel has a circular structure, pointing out that the first and last paragraphs of *Sligo* use similar imagery. This is true, but it takes more than two paragraphs to make a structure and he offers no further clues. Nora McGuinness claims that the 'form', which she defines in terms of its being held together by 'themes', is misunderstood:

None of the critics has seen the form [of *Sligo*] as suitable to the expression of Yeats's primary theme, the need to express randomness and give up attempts at control; none of them has seen the connection of this theme to the political and social situation of Ireland which prompted it. (McGuinness p.199)

It is hard to see how 'randomness and giving up attempts at control' can ever be mirrored in anything that can properly be called a 'form'. As to the political and social situation, I believe it has been misread (see Chapter 1). In a way McGuinness admits defeat in attempting to find a form in *Sligo*, though she makes interesting observations on formal procedures in other Yeats novels. It is much simpler to forget about the word 'form' in this book and simply think of it as a procedure and nothing more.

That at least accommodates the idea of journeying through one's memories, and the one extended episode in *Sligo* – the story of the Ropes family – is a humorous and satirical account of an epic journey.

In the case of *Sligo* I do not think that there is much more to add to existing comment on the absence of structure and narrative intent, though, as with all the novels, there is much to delight in and comment upon in the incidents which go to make it up. But in the case of *Sailing Sailing Swiftly* Nora McGuinness is the only person to have understood its mythic significance – 'the necessity for harmony with nature and its God, for acceptance of (not resistance to) the rhythms of the Universe' (McGuinness p.221) – and she is able to support this from the text.

The plot of *Sailing Sailing Swiftly* essentially charts a course into increasingly dull middle-class waters in which the one hope of a memorial to the love between Ireland and England, symbolised by the marriage of Thadeus O'Malley and Annette Dunaven, is finally drowned. That hope is Thadeus' posthumous son, Larry. But the whole thing is doomed from the beginning. For a start, it is essentially an arranged marriage, set up by Thadeus' hopeful English friend, Jasper Newbigging. He likes his Christian name (SSS p.5) which means 'treasure-master', and we are told that 'more than money he loved the men who could handle money' (SSS p.7). The initial cause of his feeling for Thady was Thady's ability to handle a group of cheats and force them to return four hundred and fifty pounds to Jasper. But:

In the queer little world of the spirit which had little spirit fingers which sometimes pinched the little sinews round his heart, he was not quite so much at his ease.(SSS p.5)

Thadeus (meaning 'strong') O'Malley has a fine Irish rebel name of Grace O'Malley (Granuaille) fame, and he comes from her country – Mayo – the country from which the singer is sailing sailing swiftly in the ballad that gives the book its name. The ballad refers to the flight of the Earls after the Jacobite failure and marks the beginning of the compromise of the Irish with England, hence the lines:

> They are altered girls in Irrul now;
> 'Tis proud they're grown and high.
> With their hair-bags and their top-knots,
> For I pass their buckles by;
> But it's little now I heed their airs

For God will have it so,
That I must depart for foreign lands,
And leave my sweet Mayo.

Thady sings the ballad frequently but is willing enough to come over to England and marry an English woman with the intention of bringing her to Mayo. But whatever one might hope for from this union between Thady and Jasper and Thady and Annette is not to be. The friendship of the two men is not wholly natural. Jasper's spirit is troubled by Thady (see above) and Thady to some extent plays the part of an Englishman's idea of an Irishman, though 'John Thadeus O'Malley, in his own Mayo, did not pass for any wonder for mercuriality' (Sl p.5). Annette's love for Thady is also born of those pleasant misconceptions because it is inspired by the fact that, when Thady O'Malley entered her shop, she was reading Lever's *Charles O'Malley or The Irish Dragoon*, an entertaining picaresque novel with about as much depth of perception in it as can be expected from a may-fly. She comes from a family, perhaps Irish, who have anglicised their name from Donnevan to Dunaven (SSS p.16). The moment of their encounter is deliciously satirised:

'O'Malley' and 'Thady,' she almost swooned. 'Be still heart.' 'Fate defend me.' It was the attitude she saw her mother take, when her father lay cold and still, and the landlord, neither cold nor still, bounced into the little drab parlour demanding rent, rent, rent. . . . It was the attitude, the hand between the throat and heart, which her landlady took, when, the second day at the lodgings, she asked if she could have another towel. (SSS p.19)

Right from the start Yeats has shown us that commerce is at the back of these relationships in Jasper's admiration for Thady's ability to handle money and Annette's gesture associated one way or another with paying rent. And there is, behind the warmth of feeling for the Irishman from these two English people, a slight fear that pinches Jasper's sinews and requires 'Fate' to defend Annette.

But they are doomed in another way, for Thady and Jasper belong to the old world of horses and horse-trading – that is their business. The iron horse of the railway, representing, in the eighteen-sixties when the novel commences, vast commercial interests, is too much for these smaller kinds of business men, and a runaway engine quite simply cuts them out of the train (SSS p.42). Likewise, a riding school is sold out to the railways –

'Progress' – under commercial pressures (SSS p.68). Later, at the climax of *The Amaranthers*, the commercial railway interests are faced up to and defeated, but in *Sailing Sailing Swiftly* we are only on the first journey in the novel sequence. Annette makes a journey to Mayo to Thady's uncles, but they die shortly after her son Lawrence is born and all connection with Ireland is broken.

McGuinness has shown how the uncles in essence initiate the unborn child into a world harmonious with nature and she sees the character of Annette's former employer, Oldbain, as continuing that initiation. He teaches Larry to paint, to ride and to swim. But he dies too and Edward Devinne Tarleton becomes Larry's chief guide. I think that McGuinness is right to describe him as 'life-defying' (McGuinness p.223), though Larry's own acceptance of him as 'rich guard' (which is what Ned means) is Larry's responsibility, and he never makes any attempt to break away from it. Uncle Ned's other names are also unpromising. Devinne was the name of a famous but not very artistic printer, and Tarleton was an English general from Liverpool who fought against American and Irish independence, among other things. It is Tarleton who arranges for Larry to be employed by a furniture maker when Annette dies, designing and finishing the ornaments. Jack Yeats did not think much of ornaments:

The man who ornaments the ceiling is practising a bastard rickety art produced from crossing the effigy maker with the piece worker. The result is a freak to amuse the hollow headed ones who cannot look on a plain surface without feeling miserable.[5]

Basically the whole motivation from this point on is towards commercial success, and in this search for respectability Larry becomes more and more conventional. As their companionship develops, it is Ned who continues going to the boxing matches watching men 'with their souls in arms' (SSS p.127), whereas Larry tires of it and takes to occupations on wheels, such as roller-skating, cycling and motoring. We have seen in Chapter 8 that Yeats's attitude to wheels in motion was not positive.

This search for respectability is also symbolised by Larry's love life, such as it is. He dithers with the first girl he loves, Sally Belfield, who is a polisher in the furniture factory, and loses her when she marries unexpectedly and emigrates to America. Larry eventually marries the boss's niece and becomes a partner in the firm, but when Sally's son seeks him out he recognises her voice

in his and takes a brief walking tour with him to where his ship for America is anchored, and Larry cannot help comparing his own course with the more adventurous one of Sally (SSS p.153). Nowhere does Yeats say so, but essentially Larry has missed his chances. He dies almost immediately after, falling into the sea trying to catch (symbolically enough) a business letter blowing away on the breeze. His dying words are the first lines of Old Mother Hubbard.

The choice of the nursery rhyme for Larry's last words is not a random one. Larry's nurse is about to go out and buy food for him, and Larry in effect tells her not to bother though he falls asleep before the lines 'But when she came back/ The poor dog was dead'. It must have pleased Yeats to use that rhyme. He knew it had been written in the old Pollexfen family home of Kitley near Plymouth – possibly the port where Larry dies – for he kept newspaper cuttings both of the house and of the story of the rhyme. He probably also knew that it was first printed in St. Paul's Churchyard, which is Uncle Ned Tarleton's first address anent which 'Oldbain said he would be delighted to read any book recommended him from a churchyard' (SSS p.78). The book recommended is a shilling dreadful – *Called Back* – set in London and Siberia. Annette will not read it: 'she distrusted fiction, she thought it dangerous to memory' (SSS p.78).

The point of all these associations is that they are all half dead. It is not the flesh that has failed in Larry so much as the spirit that has been dying in him, perhaps particularly with the reminder of his lost opportunity with Sally who, we are told, married a man who 'took the cream of the chance' (SSS p.148). For Tarleton, the romance of life is to be found in a book and Annette is scared even of that, the reality being so fragile. Ned Tarleton not only lives in a churchyard but visits a graveyard for the burial of a man with the same name as his own and originally from the same address – but makes a hasty escape when two old flames turn up thinking the dead man is Ned himself. Perhaps his determined bachelordom is a kind of freedom, but it is also sterile. He is a poor swimmer where Larry was a good one, but Larry ends up unable to keep his chin above the waves; and Tarleton ends up drinking himself nearly sick after Larry's funeral on his way back to his friend The Squire, who lives in a house not unlike Kitley. As for Larry's widow, she finds herself drumming her fingers on his coffin lid (SSS p.160).

Much of this is very funny, but behind it all is the sadness of the

title song. The marriage of Ireland and England is doomed and the spirit of Mayo gets thinned down in the atmosphere of genteel commerce and convention. The old Pollexfen home of Kitley, which Jack's grandfather believed was rightly his (Murphy p.37), provides it with its Mother Hubbard epitaph. It was all too late and they were all too feeble. Ned Tarleton is given fire-water by a blacksmith to bring him back from the extremity of his drunkenness and declares himself 'in the folly of the moment that he is the Phoenix' (SSS p.167) but he ends up in a torpor. That old battle between the flesh and the spirit appears to have been lost. In this connection, the name of Thadeus quite possibly carries more than the meaning 'strong'. St. Thaddaeus, better known as St. Jude (though probably mistakenly), was regarded as the patron saint of hopeless causes, perhaps because he was rarely called upon for anything else, his name being too close to that of Judas, the betrayer. Hardy described his own *Jude The Obscure* as a tale 'of a deadly war waged with Apostolic desperation between flesh and spirit' in which the spirit's loss could scarcely be more miserably underlined. More gentle, by far, is the sad falling away from old ideals in *Sailing Sailing Swiftly*, and so perhaps more credible and more pertinent too. But, in the light of the apostolic succession of Mark and James in the ensuing third-person novels, it is not too much to suggest that the words of Saint Thaddaeus are relevant:

These be they who separate themselves, sensual, having not the Spirit. (Jude 19).

In all of this, the skill and delicacy of Jack Yeats's narrative delivery is outstanding. The speed of travel through time is achieved without any sense of rush and the closer one looks at the detail the more clear it becomes that there are many cross-references and parallels to be found, helping the narrative to cohere. The novel ends as it began, with two men, one watching the other sleeping. The opening song of 'Sailing Sailing Swiftly' is likewise echoed when a drunken stoker, outward bound also, sings a song of farewell to a land which could no longer hold the singer. In this instance, though, it is not that the singer has been driven out as were the Wild Geese of 'Sailing Sailing Swiftly'; but his own inability to face the coarser realities of the land of romance – the Injun land. This obviously has a bearing on the general softening of the spirit of Mayo by the genteel middle-class ideals of England. This is the stoker's song:

My stomach was too del-i-cate
To stand the Injun meal.
And when I sailed away,
Not a blessed one was there to say,
'Good-bye, old son, good-bye.'
And when I sailed away,
Hell's blast the one there was to say,
'Good-bye, old son, good-bye.'

Jack Yeats, prompted ever by that 'affection, wide, devious, and, sometimes, handsome',[1] was, however, standing on the dock to wave those old days and lost chances a kindly and humorous farewell through the medium of *Sailing Sailing Swiftly*, before himself setting off on the voyage West in search of *The Careless Flower*.

10

The Careless Flower and *The Amaranthers*

The date of 1933 (see Note on the Chronology) that I have given for *The Careless Flower*, making *The Amaranthers* its successor in the sequence of the novels, is not the only reason for considering these two works together. The two novels have so much in common that one can see *The Amaranthers* as a kind of mature version of *The Careless Flower*. What they most obviously share is a common symbolism in title and in structure, but when a writer of the stature of Samuel Beckett says of *The Amaranthers* that

There is no allegory . . . there is no symbol . . . there is no satire',[1]

the world is inclined to agree. This may explain why much of the meaning of this book has been missed and it is the reason for this chapter being an exegesis rather than a critique. There is no point discussing the merits of a work until we have at least a basic understanding of its salient features. Running away from the symbolism may have pure motives, but it has had poor results for the reputation and currency of the work. Perhaps Beckett had in mind Yeats's own remark:

and that's not a symbol, for there is none. (As p.5)

Though only a few pages on he writes:–

The railway scheme was flat ere it was raised, though symbolical in reverse, the Arch remained upright. (As p.27)

One can scrabble up many good plants, grubbing for symbolism; but when a book is called *The Amaranthers* after a fabulous flower which is, and always was, a symbol of eternal youth and love; and when even those real plants of the genus Amaranthus also carry that symbolism with them (Jack Yeats had E.P.Dutton's *The Language of Flowers* in which the Globe Amaranth stands for immortality and unfading love); and when Jack Yeats takes the common noun, amaranth, and turns it into a proper noun with an implication of action in it, and applies it to the members of a secret

137

society; then one is kicking against the pricks to say that there is
no symbol.

Beckett writes of a 'single series of imaginative transactions'; of
'stages of an image'; and of 'imaginative fact' as his alternatives to
allegory, symbol and satire. He insists that *The Amaranthers* 'is art,
not horology', fearing perhaps that the usual method of
discussion will reveal only the works of a clock, rather than the
motion of the sun. 'The discontinuity' he writes 'is
Ariostesque. . . obnoxious to the continuity girls'.[1] But if these
poor maligned souls were to follow Beckett's 'stages of an image'
and arrive at his 'single series of imaginative transactions', might
they not end up with something that satisfied their depraved
desire for continuity? We do not need Beckett's periphrastic
approach, and it does no service to the book to claim
discontinuity for it, particularly when there is only one central
narrative break from start to finish. All that matters is that we
remember that the symbolism is servant to a wider conception
and that things are what they are as well as what they might be.
Jack Yeats himself writes of symbolism from both sides: the
swimming turtle in *The Careless Flower* that

brought to that man some message, was a symbol of something
happening, past or to come. (CF p.235)

does not have to be symbolic:

was that sea a symbol of width, or was it just nothing but its grand self?
And it came to him in a moment that he was not a symbol of a peddling
day, nor the captain a symbol of command, nor Bowlin of mens sana in
corpore sano. But they were no less than James, the Captain, and
Bowlin, in a chart-room, on a ship, balancing, on a gently breathing sea.
(As p.150)

The shared themes, structures and symbols in the two novels
are not hard to identify. The themes are those of the attempt to
realise the ideals of eternal love and eternal youth, in spirit and in
fact; and of the dark and sometimes cruel setting, human and
natural, in which the attempt is made. They also involve freedom
from materialism – Mark, Gaw and James are all poor and do not
seek much in the way of wealth or goods. The stuctures are, in
each case, those of a double journey; first by a group, then by a
picaresque individual. In the earlier novel the second journey
occupies only the last few pages, whereas in *The Amaranthers*
James' journey occupies half of the novel. But in both cases it is

the second journey that forms the dramatic climax of the action and, the conclusions being different, the final effects are widely divergent. The shared symbols include the flower that never dies, the island remote from ordinary society but not beyond human reach, the elemental power for change of the hurricane and, of course, the journey as a symbol and fact of human experience.

In both cases the journey is to the South and West, the significance of which has already been touched on in Chapter 8, but which also relates to the Christian message via Masonic symbolism. There are a number of references to the Bible in both books, including the fact that their respective 'heroes', Mark and James, have apostolic names. Love, Hope, Charity and Fearlessness (which I relate to Faith) are clearly and deliberately made a part of *The Amaranthers*, and the image of the suffering and sacrifice of Christ is deliberately evoked at the end of *The Careless Flower*.

Briefly, *The Careless Flower* tells of Oliver James Gaw's successful attempt to secure a job as a lecturer aboard the *Scrutineer*, cruising from Choughport (Liverpool) to the Caribbean. He forms a friendship with Mark Trimbo, an Irishman, also elderly, also low in funds, who joins the crew. They are marooned with two youthful passengers, Gladys and Ralph, whose respect for the conventions does not yield to the temptations of the island, which include each other and drinking from the spring of the careless flower. The spring water appears to be conferring eternal youth on Gaw and Mark, and under its influence they increasingly inhabit a world of memory which develops into a joint fantasy or vision that transcends time and requires no speech. All four are rescued, the two older men reluctantly, but Gaw dies in Choughport and Mark makes his way back to the island on a mixture of charity and theft. As he reaches the top, a young man shoots Mark unthinkingly and then, too late, offers him a shell full of the water from the spring.

The Amaranthers starts on an island almost free from capitalism and whose band is celebrating the defeat of the railway speculator who had hoped to link them with the mainland. To this island come the remains of the Amaranth Club, a secret society in the nearest city, suspected of communism and broken up by the police. They occupy a building where they can set up their model railway and docks, a country of which 'they themselves were the inhabitants' (As p.71), recruit a local and

endear themselves to the islanders at the performance of a play called Old Care. The account of this play occupies much of the novel.

With an abrupt shift in time and place we are introduced to James Gilfoyle, an impoverished half-Irishman who emigrates, surviving as a pedlar, a servant and, later, as brother-in-law to a smuggling sea-captain. The Captain and James' wife both die, leaving James shares in South American railways. Provoked by the eventual failure of the shares to pay dividends, James joins a ship to search out the company and obtain redress. The strange encounters of his journey in South America include his acquisition and loss of a magnificent cream-coloured horse, his creation of a language made with pictures to communicate with the natives, and his growing ability to inspire the loyalty and friendship of people as independent as himself, until he finally confronts capitalism in the form of the railway company and, just defeating his own despair, secures the use of the cream-coloured presidential coach for life.

James then travels the system, eventually supporting himself by gathering and transporting extras for a film-maker up in the mountains. A hurricane devastates much of the country and James is recruited to help a hard-hit island. It is the island of the Amaranthers and their building has collapsed. James talks them into joining him on his railway coach and they cross the frontier to the film-maker's town.

A society whose aims are the attainment of eternal youth and eternal love (for one assumes that this is why they call themselves the Amaranth Club) is a society that seeks to be without cares. We are still a little uncertain in our minds as to whether it is good to be careful and bad to be careless: we still know what Browning meant by the thrush's 'first fine careless rapture' and some of us are familiar with Saint Paul's exhortation to 'be careful for nothing' (Phillipians IV.6). But on the whole we approve of care, extol a 'caring society', and scold each other for carelessness; so it may be that not all will be drawn to the rejuvenating stream in which grows the careless flower, or will see in the Amaranthers anything but childish, careless play. For Jack Yeats this is not the case. The careless flower draws Mark back across an ocean, and the Amaranthers are chosen by James as the most suitable to join him in his imaginative journey.

But these are fanciful environments and Jack Yeats lived in the real world as well as the world of fancy. He knew that to shed

one's cares is not only a thing few can hope to achieve, but that it can be seen as subversive by those who cannot shed theirs, or who even set about creating more for themselves. So it is that in the first of these novels Mark and Gaw are clawed back from their paradise and, in its successor, the Amaranthers are regarded as subversives. Both at the personal and at the social level such idealism is vulnerable.

The stress that I place on the word 'care' is derived not only from the title of *The Careless Flower* but also from the play called 'Old Care', which occupies thirty-five pages of *The Amaranthers* and which, according to Beckett, 'invades' the first part of the book and is presumably part of the Ariostesque discontinuity. This play concludes with its prime mover posing, statuesque, as Care at the Corner. He is an unlovely old devil who pretends death in order to ensure that the absurd demands of his will be carried out by his three sons, but who ends up no better off than he was before, a symbol of Care, worrying even about what will happen when he is no longer there to worry about it.

One does not have to act as an executor very often to realise that this is no fantasy but one of the prime preoccupations of man – and one not unknown to the Yeats and Pollexfen families who had their little troubles over wills, as outlined in Chapter 1 in relation to Frederick Pollexfen, who was also eased out of the family business.[2] James in *The Amaranthers* is likewise eased out by his family and goes to England with wild schemes, ending up selling bootlaces. According to his grandson, Patrick Graham, Frederick Pollexfen had been let down in particular by Russian railway shares.[3] James in *The Amaranthers* is also let down by railway shares, and the cream-coloured coach was inspired by a gallery coach on the Russian railways (see below).

It seems to me highly likely that the idea of the failing railway shares, and the search for some kind of redress, were inspired by the misfortunes of Uncle Fred, whose love of horses and racing and gambling no doubt had its appeal to Jack Yeats. And the sad divisiveness of wills, which is the subject of the play of Old Care, must have had a particular meaning for him, given that he acted as Defendant in the friendly suit, taking, as it were, his uncle's side. It was a peculiar, almost a hypocritical position to be put in with his Uncle in the court sitting in attendance (see Chapter 1).

Although the occasion brings together the islanders and the Amaranthers, there is no solution to the problem of the will at the end of the play of Old Care and it virtually concludes the first half

of the book. The journeys that have to be made to enable us to shed those cares have also as part of their background the Irish inheritance. As in *Sailing Sailing Swiftly*, *The Careless Flower* pairs an Irishman and an Englishman, but this time their journey is more fantastical and more symbolic. It is also much longer and allows a close and kindly relationship to be developed between them. But the ultimate goal is achieved only by the Irishman and it is achieved only to be destroyed cruelly. It is also set against a background of isolation from normal society so that the spiritual quest is, to a degree, protected from reality. In *The Amaranthers* the hero, James, is part-Irish and the other half possibly English. But his Irish inheritance is thinned down in spirit and in cash, and it is from England that he initially receives the latter. Ireland, however, provides him with the yen to break away, and the failure of his South American shares gives him the final push. But this journey does involve society at large and does achieve its end without any final disaster. Put crudely, the spirit triumphs over materialism and that spirit has its source in Ireland.

I have mentioned in Chapter 8 the significance of islands and the journey westward for Irish people, and Yeats's belief that his country was not yet spoilt by love of money for its own sake, and in this connection there were obvious transatlantic comparisons to be made:

New York is in my mind away out there a leap or two over high waves to the West. And down on the shores of our Bay, looking out through the horns of it, with the tall pale lighthouse on your Southerly hand, the Sun that is sinking wild and tattered here is glistening on the boys and girls of Coney Island – That is their Coney Island, not our own, and the earlier, Coney Island. (Sl p.13)

Hilary Pyle suggests that the island in *The Amaranthers* was inspired by Coney Island in Ireland (Pyle p.151) and there may be an element of Tawin Island in it, the proximity to the city being relevant:

We were away for a month at the end of the summer at the Island of Tawin in Galway Bay, opposite the city, three miles away, but ten or twelve miles by road, there was a bridge between the island and the mainland. It was a delightful place. No part of the island is more than about fifty feet above high water mark. To be on it was like being on a raft. When the sun was shining the little rocks and green fields glistened.[4]

There is another reason for associating Tawin Island with the island in *The Amaranthers* and that is its name, which means a

number of things all to do with stasis and security – 'rest', 'home', 'idleness', 'death', 'block post'. It is a place where the cares of the world are brought to a standstill, though it has a view of the city; and at the end of the novel the only people on the imaginary island who are in any way seriously disturbed by the hurricane are the Amaranthers themselves. The islanders, like many West of Ireland people, had little to lose, and looked to the future not so much with concern as fatalism. They do not always welcome 'improvements' such as roads and railways. In the West of Ireland Yeats and Synge watched them building roads at the command of a foreign power to relieve themselves from starvation; but they did not plan those roads, for many of them walked barefoot and even a well shod foot passenger is cruelly treated by a road. Yeats recalled Synge's delight at the grass verges put there for the bare feet of the children,[5] and Mark dreams of a path made for a barefoot woman (CF p.164).

Roads, and railways, are obvious symbols of man's attempts to dominate nature and his fellow creature. Ralph in *The Careless Flower* attempts to build a straight path across the island. It takes on a kind of significance for him that is bound to lead to disappointment. The island's geography is not so easily tamed, as this kindly and compact satire on human endeavour indicates:

They stood there gazing down at this crooked thing which crept its own way and could not be got to creep the engineer's way. The four stood in a half-circle 'reading' as they were saying, in the illustrated newspapers at that moment all over the English-speaking world 'from left to right' – Gaw, Gladys, Ralph, Mark. They looked down in the depths of a general gloom, the head of whose navigation was Ralph. He was so put out with that centre path that Gaw and Gladys would have begun to feel sorry for the simple intractable thing, moving a few feet away from them, for they stood on the path almost on its very end. And then Gladys might have said something to show her sympathy with that foolish path, Ralph would have said something acid, and Mark would have called out a cry to put encouragement into the boldness of that little curling path. But nobody said anything and in a little while it was too dark to see the cause of all the worry, so they trooped back again to the house to smoke silently into the night, the lights from the pipe bowls the only glowing spots in that country round about them. (CF p.168)

The connection between paths, roads and the future is obvious enough. In *La La Noo* it is the central image of the possibility of war making its way down the road to Ireland; in *In Sand* a road into the interior is symbolic of authority's attempts to control the

islanders (IS p.359), and the defeat of the railway speculator by the islanders in *The Amaranthers* is equally significant. But at the same time journeying is fundamental to any quest, good as well as bad, and can lead to better things:

How peaceful the avenue of our futures would look if we could count out all our too vitiating care in a count of ten. 'You're out,' 'you're out,' 'you're out,' go home to your noisome tenement and let me always circle away from it. (ATYA p.117)

The move away from the city into the wilderness is a move away from the cares of the noisome tenements of the world. To be without cares is to accept the present rather than have concern for the future. Mark and Gaw seem to recommend this when they suggest to Ralph and Gladys that they live together. But Ralph and Gladys are too tied to their pasts and too concerned for their futures to take advantage of their situation. Gladys clings to her property, her little suburban house they have built for her on the island, and Ralph struggles with his road. Gladys protests that she has not met Ralph's people yet, and Ralph remembers his Brazilian girlfriend. They bring to mind the suburban deadliness of Larry and his family in *Sailing Sailing Swiftly*.

For Mark and Gaw, and for James and (to a lesser degree) the Amaranthers, the move from the city, the journey into the wilderness, and the effects of the hurricanes – even when these seem to be against their interests – are accepted without protest. When the skipper of the *Scrutineer* risks his life to persuade Mark and Gaw to leave the island, they respond selflessly, not worrying themselves, but with understanding of the worry of others:

They had a strange calm look in that roaring core of wind. He raised his hands, palms open a little way to show that he was unarmed . . . When he got to them he put his face close to theirs, and roared out his offer of peace.
 'Come now freely. I won't lay a hand on either of you, but come. I can't go and leave my ship's company. Ruin me for ever. I'd never stand on a bridge again. Will you come?'
They bowed their heads . . . and followed him, slinging careless from one hold to the other . . . (CF p.186)

Though this rescue leads to the death of Gaw, there are no recriminations. The absence of care on the island in *The Amaranthers* after the devastations of the hurricane is equally marked. It is necessary to quote a lengthy passage to get the full

effect as the main verb 'he walked' is deliberately withheld for a paragraph, the grammar as casual as the man, yet disrupted in truth:

The balcony and stairs had fallen forward over the upturned bar below which lay the whole tasteful front of the building.

The landlord with an appearance of serenity, which came either from expecting no less, or from a sweet curve of the lips acquired in his apprenticeship to the bottle trade, when every afternoon he learnt to polish the torsos of bottles, and judge his success by the clearness with which his visage appeared. His lips would twist to Cupid's bow, or as the lips of Venus, who, having scrubbed Cupid, prepares to impress a kiss upon her handiwork.

Now serene in seeming, he walked about in the wreck of his estate lightly moving with his foot a shattered bottle, and he thought that these were the happiest dead. One rattler in the ribs and the life gushes out at once and all is over. No mending up, no superior nurses, no fussing important doctors, no old cronies with better wounds to boast of. He thought that men in life's battle should be supplied with one vulnerable part – a button which once touched would crack all. (As pp.263-4)

It is true enough. The caring society is a terrible source of worry; seeing no future in death it must have life at all costs.

In contrast with the static life on the island is the mobility of the hero. The island men are filled with a 'wild honey melancholy' (As pp.18-19) only alleviated by the presence of children, their pointer to the future. James does not share their fatalism and uses the hurricanes as opportunities. The impersonal power of nature – in both novels there are two hurricanes, the first effecting a lucky landing, the second an equivocal embarkation – is a reality that destroys all plans, even the 'plans' of the Amaranthers and of Gaw and Mark to sidestep the future. But the power of the hurricane is not only the weather we must live in; it provides the stimulus for change and is part of the force of inspiration in man:

I think the two most beautiful pieces of man's handiwork are the old-fashioned plough and a sailing ship. In each every curve is there at the command of the elements, and not for the little pride of man; though there are houses and walls in the country, and nature and the elements by their powers have ruled the shapes of the houses and the building of the walls . . . In the country the veil between the artist and nature is more transparent. He feels he is part of everything that surrounds him. He knows what is happening every hour; the corn is springing, or a storm is coming and the floating archipelago of clouds

are banking together. He may find himself in the very centre loop of a whirlwind . . . of all this the artist has been a part.[6]

So the hurricane and the whirlwind are almost to be sought as a kind of apocalyptic experience. From the centre of such an experience Job heard the voice of God, and after the same Elijah also was comforted. Put this together with the innocence of fantasy and play of Mark and Gaw on Fire Top, and of the Amaranthers with their toy world; and add the simplicity of poverty and the absence of care eventually applicable to them all, including James and Gaw, and you have the central themes of a truly Christian doctrine:

Be careful for nothing (Phillipians IV.6) –

the flower is careless.

Verily I say unto you, Whosoever shall not receive the kingdom of God as a little child shall in no wise enter therein. (Luke XII.17) –

the Amaranthers are child-like.

For it is easier for a camel to go through a needle's eye than for a rich man to enter into the kingdom of God. (Luke XII.25) –

all three leading figures have known poverty and do not seek wealth.

Consider the lilies of the field, how they grow; they toil not, neither do they spin: (Matthew VI.28) –

there is a marked lack of interest in future planning and work ethic among Yeats's leading characters, and he saw this in national as well as individual terms:

. . . he spoke of the Irish and their determined bent for freedom and he quoted the old Song:
 'As well forbid the grasses from growing as they grow,' and so do I. (Sl p.158)

These stories are allegories, not plans of campaign, and it would be sad if readers were to react to Jack Yeats as though he were recommending what is to some the fatuous as the means of attaining the impossible. Let them reserve that criticism for Christ. We are not invited to drop everything and stow away to a Caribbean island, or to hide in an attic with a model railway, surviving on God-knows-what; for Jack Yeats knew (as any self-employed artist knows only too well) that, taking the idea literally, there are not enough cream-coloured presidential

coaches to satisfy the world's dissatisfied shareholders and displaced model railway enthusiasts: but, interestingly, the coach Yeats imagined had its roots in a reality which brought an offering of beauty to all:

In Russia there was a very well arranged system by which a picture exhibition was brought to the far part of that land. A long Pullman railway coach was built, suitably lit for showing pictures . . . The coach was hauled free by the different railways to any place where the road penetrated, and a travelling secretary lived on board the coach.[7]

Yeats was also realistic enough not to expect us to espouse poverty for its own sake. Mark, Gaw and James are ready to accept at least sufficient money to enable them to meet their present needs; and although, in Mark's and Gaw's case, the sums are tiny and they have to work for them, there is no doubt that they appreciate their usefulness. In fact it is their material poverty that brings them together, and the richness of the spirit that keeps them together. The couple they are contrasted with, Gladys and Ralph, are brought together by their material wealth, which includes the physical wealth of their comparative youth, but their spiritual poverty separates them. The voyage of the *Scrutineer* searches out their strengths and weaknesses and, as a scrutineer does, passes a kind of judgement upon them.

The development of these relationships concentrates largely on Gaw and Mark and the effect that drinking from the spring of the careless flower has upon them, which is essentially to free them from their material selves. They begin to feel and receive the world and their own thoughts like children:

But we want you to taste it now. We think there's some special virtue in the taste of it, don't we Gaw? Like a couple of childish old men, that is; I'm like one childish old man, and Gaw's like a cheerful old three-year-old. (CF p.120)

Ralph and Gladys refuse to taste it, fearful of its powers:

But no, they were both 'Conservatives. What's good enough for the father is good enough for the son, or the daughter'. (CF p.121)

The conservatism of Ralph and Gladys is further underlined by their attitude to memory. Ralph cannot remember a song and when Gladys' song 'Let you take the high road' stimulates her memory she is frightened by it. Jack Yeats finds a beautiful image for her fear:

Now, after singing, she felt a little frightened . . . Details that she had thought were gone into mist in her memory, and now, singing they came back to her like little foxes into her heart. (CF p.122)

Perhaps Yeats is echoing the image of the little foxes in the Song of Solomon, only these are foxes Gladys does not wish to take to her breast, alarmed by their mysterious attraction.

But spring water leads Mark and Gaw beyond the personal memories that they begin with. Early on, Mark understands this. It is he who states it clearly (see above) and it is Gaw who usually brings him back to reality after their dreams on Fire Top; and Mark it is who alone voices an opinion on the value of what they are experiencing. He does so in terms that anticipate an other-worldliness of genuinely Christian dimensions:

And the singer was singing everyone into a state of pity, and her reward was small pity in small pennies. And even now, high on his tropic look-out miles and years away from even the memory of the pity for the wandering song of the wandering mothers who wandered nowhere, but on the dismal heath of lonely women's minds, he felt a pity for every living and unliving thing, except himself and Gaw over against him in the shade. (CF p.125)

Bit by bit, Mark and Gaw acquire the full freedom of their minds. First they make up, or share a vision together (CF pp.136-7). Then Mark looks out to sea and sees things without having to close his eyes. Then each has a vision of events on the road. Gaw's vision is of a highway robbery, and he then sees another theft on the same road, but a century-and-a-half later. Ralph's literal road is transformed into an adventure of the mind which now penetrates history. Mark's vision has more of the mythological in it: his road is to the West and, later, it is the road made for the barefoot woman who is visited by a faun; and above the road on a vast plain, horses with star-shining eyes, men leaping, using their spears and, suddenly, the stars dropping twice in the sky and then settling as before in an image of cosmic unity (CF p.166):

And Gaw said, 'I saw them at the pole jumping. I saw them well, they are my friends too. Ah, Mark, my old friend of Fire Top.' (CF p.167)

From now on they share their vision simultaneously. This is not merely a joint hallucinatory experience. It is a breaking down of the barriers of time and place that bind us to our bodies, and it is achieved by the elixir of carelessness. Whatever they see does

not distress them, even if it brings tears to their eyes, and when the *Scrutineer* returns to rescue them they race back to the top and cut away their ladders. Gladys and Ralph have meanwhile been deteriorating in their spirits and the return of the ship is a blessed relief to them. Yeats nowhere criticises them for this and we are nowhere given any sense of moral obligation to follow the path that Mark and Gaw have taken. This is not a missionary work – there are no Empires of the soul to be built – nor is it a selfish one, for not only have Mark and Gaw shared with each other in perfect amity, but the pair of them return to the ship when the Captain puts his career on the line for them, though the return is sad for them both and leaves Mark solitary in his quest, following Gaw's death.

As soon as Mark has buried Gaw decently, he makes his way back to the island, using every little opportunity. His final theft of a wealthy man's boat is described without comment. Indeed we are surreptitiously asked to accept it in the spirit of 'he that hath two cloaks, let him give one to the poor'; for immediately before, a larrikin has stolen a hat from a passing carriage and its owner happily kisses it goodbye. It is not long before Mark, reaching Fire Top once more, has to kiss goodbye to everything. The climax of the novel is the most horrifying thing in all Yeats's work; but it too is without recrimination. It is a beautifully sustained piece of writing and, as with most of Yeats, it is difficult to make oneself quote briefly from it, as the effects are often built up over several paragraphs. Here is part of the end. Mark has just been accidentally shot by a young man defending himself from assailants in a boat below:

So, as the flower waved and as the water gushed out, he, staggering but with contained and easy movements, came down to the spring, filled the shell and knelt beside the now feeble Mark. Mark did not see him at first. He saw only the spring below him on his path. He cried 'Christ' and it was just an exclamation. And then he cried 'Christ' again, and it was a prayer. 'Ah,' he thought, 'the thorns, spiked, Gothic, barbed wire. Ah, Christ!' And he saw his flower waving in the spray and he thought, 'Not like the stem of that flower.' With his heavy eyes he now saw the young man holding the shell towards him. At that moment a gush of blood came up his throat and spouted forth on the rock before him. He looked down on that lake of his own blood, and in it he saw himself, for the last time on earth. He turned his eyes again to the young man. And the young man held the shell, overflowing and dripping, towards his lips.

But he shook his head slowly, and then with one slow tremor, fell forward with his face in the lake of his own blood.

The young man there on his knees, weaved his head from side to side, dazed, and then took the shell to his own lips and drank; his small mouth not able to take the wide pouring from the shell's lip, the water ran down the sides of his mouth and over his breasts. (CF pp.239-40)

Mark's last words echo desperately the mood of the crucifixion and, in Gethsemane, Christ's own triple cry to God to spare him this final tragedy. In this connection the name Mark is significant. It means a target or wound, and it was the name of the evangelist who was also driven ashore to an island by a storm. His gospel is regarded as being from the testimony of St. Peter (from whom Yeats drew the character of Silvanus in *The Charmed Life*) who called Mark his 'son' and who wrote:

Humble yourselves therefore under the mighty hand of God, that he may exalt you in due time:
Casting all your care upon him; for he careth for you. (I Peter V. 6-7)

That is the meaning of the careless flower, and Mark's cry at its loss is not a selfish one. The reference to Gothic spikes and barbed wire recalls war, and the cry is a longing for an end to man's destructiveness. A more cruel image of that destructiveness could hardly be conceived, and yet it is not without hope. The hollow shell, perhaps the pilgrim's scallop shell, is offered after the third cry. Irresistibly one recalls the Irish saga of Diarmuid and Grania. Yeats painted 'The Death of Diarmuid' (now in the Tate gallery – Plate 11), depicting Fionn offering Diarmuid (whose death he has encompassed) a drink from a magic well which would save his life. But he has twice spilt the water and on this third attempt he is too late. In some versions of the story he lets the third handful of water spill also, but it is usually assumed that he does genuinely mean to bring it the third time.

In *The Careless Flower* it is a young man who brings about the death of the old, but he genuinely offers the shell of magic water three times, and with these last healing gestures at least leaves us some small hope for the future. With the body and blood of Mark beside him, washed with water from the shell with which the young man himself then drinks, he is as one who takes the sacrament, though that hope is troubled by his little mouth, too narrow to accept the full draught of eternity. Deeply Christian though these images are, it would be wrong to conclude that Mark is a perfect example or a dutiful purveyor of Christian doctrine. His role is both more complex and easier to identify

with than that. We are told all with compassion, but without advice.

The Christian background to *The Careless Flower* is also present in *The Amaranthers*, but it is developed at a much more complex social level in which the 'carelessness' of the islanders and of the Amaranthers themselves is not observed without irony. Like Nardock in *The Deathly Terrace*, the islanders make their money out of the foolish appetites of the rest of us, selling poor quality whiskey, reminiscent of the twenty-four-hour whiskey sold at fairs in the West of Ireland and well known to Jack Yeats as a major source of income to islanders. But as regards their internal organisation, they enjoy a kind of communism:

The whole of the male population of that Island lived in Charity, taken away, from first to last, by East, by West, by South, by North, by round the beaches, and by the cliffs. But true and open charity, charity to each other. (As p.25)

The women were more down to earth and tended the gardens. In fact the theme of charity underlies many sections and gives to the protagonists a greater power for effecting change than exists in *The Careless Flower*. The 'three thousand silver pancakes' acquired by the railway Speculator represent a perversion of charity. Silver pancakes were coins; the Speculator acquires them on Shrove Tuesday (As p.4), traditionally a day of charity when real pancakes and/or money to buy them were handed out to children. It was also the last feast before the 'famine' of Lent, so for the Speculator to gather the pancakes to himself was to make a famine out of a feast at a critical moment.

The Arch, removed by the Speculator from a fairground, was originally intended to suggest learning and romance: but in its new proclamatory railway aspect, the islanders see it as a threat and hire a journalist to keep the Speculator at bay. He does so successfully, recommending the arch as a perch for the pelican and the turtle, the former a symbol of sacrifice for others (it was believed the pelican bled itself to feed its young) and the latter a symbol of true love. The identification of love and charity is made explicit at the crucial moment of decision for James as he recalls a day in Dublin when, without waiting for money, a ballad singer put into his hand

a verse of passion, of a kind that chilled James' forgotten stomach. It was what he called political . . . (As p.116)

The recollection, in which

he heard a man's voice, rich with indiscriminate charity, cry of love (As p.135)

is immediately followed by the news of the failure of the railway shares, and by James' decision to combine his search for the company with his desire to unlock 'the sideboard cupboard of Whither and Why-so' (As p.134).

The failing railway shares (which James inherited as a consequence first of the charity, followed by the love of a sea captain and his sister) immediately evoke the railway Speculator of the first part of the novel. But, Christian or Communist, it takes more than charity to realise the kind of dream that Jack Yeats's heroes are after, for the cares of the world keep drawing them back. Mark and Gaw are retrieved by the captain's cares and concerns; and the Amaranthers are, until near the end, attached to their possessions like the old man in Old Care, and in the city they are also under the threat of death.

The mood of the city, the violence and fear, the newspapers paranoid about intrigues against the state, evokes a society all too easily recognised – particularly by a Dubliner of Yeats's generation and not least in the mid-thirties when Fascism was spreading at home and abroad. Even curiosity is frightening:

It is asking too much of oneself for the unknown role of the saunterer in that land where Death walked so delicately with the hand just above the human shoulder, floating there, so poised on the air of uncertainty, that one movement might be to brush away an annoying, stinging fly, or to call the citizen to join the others in the Shadow Land.

Every field was a field of honour. Every turning might be the last, so every moment had its importance. It was not that life was cheap, for life was not for sale. Itself and love were perishing. The whistle of the knife, the song of a bullet, the scream of a motor-horn, the soft pad-pad of disease interrupted, hiccoughing in the concert of the world. (As pp.42-3)

If this stark vision of society was somehow to be circumvented or relieved, it was not to be by the Amaranthers. Their world of toys was not secure against the violence of man or nature, for the hurricane exposes their privacy. Nor is Mark's dream secure. When he returns to the island it is held by another. And yet the Amaranthers are not without hope. They make their friendship with the islanders secure at the 'Hope On' hotel. Perhaps only in a theatre of that name (for it is there that the play, Old Care, is

presented) can the cares of the world which stand symbolically immobile, be left behind.

None of the performers ever appeared in a play again, as they went about the world no one suggested it to them, and themselves they were in no way stage-struck. They had been along the Quay of Old Care and where Old Care was gone to now was something they couldn't fathom, fathom was the word. (As p.109)

This opposition of Hope and Care with Hope as mobile and Care as static, trying (in the play, literally) to parcel the future in the laws of inheritance, is parallelled in James' journey on the ship the *Holly Tree*. She is evergreen like Hope, her function is motion; as her captain says:

Curious that an anchor should be the symbol for hope! Seems to me if your anchor's down and holding you're at ease and comfortable. Now the lead taking soundings, that's for hope. (As p.149)

To live in hope is to have an ambition towards something better; but when you are taking soundings your security is greater when you are in deep water rather than the shallows close to land. It is not a simple image, for the hope of all voyages is to come to harbour, and the island seems to provide such a harbour; but in *The Amaranthers* the Amaranth Club is broken up by the police and their new home by the winds of heaven; likewise James is left unsupported by his family, and when he finds security in his home in England his restlessness is given practical shape by the sudden failure of his sources of income. There is no final harbour: the coloured coach at the end journeys on: we have here no abiding city.

That restlessness in James, which is the chief distinction between him and the Amaranthers, is given its first real stimulus by the ballad singer and by the restlessness of nature of which he seems a part. The mood of the occasion matches that of one of Jack Yeats's best known paintings – 'A Westerly Wind' (Plate 12). In the painting, as in the novel, it is evening and we are looking west from near the same bridge, O'Connell Bridge. On the sidecar a golden-haired boy – an emblem of youth and hope in several of his paintings – seems miraculously to have gathered the light that would normally have made of him a silhouette. It is a vision inspired by the westerly wind and the setting sun; the wind from Sligo, the Atlantic and beyond; the distance suggested by the long shadows, the awareness in the alert ears of the horse:

Wherever I am I always want to walk towards the West.[8]

Here are extracts from the relevant passage in the novel in which practically every detail has some importance beyond the moment described:

He knew that there was a time when the bridge he stood on was called Carlisle Bridge, and White Horse Bridge too, for there never was supposed to be a time, during the busy hours, he supposed, when a white horse couldn't be seen crossing it . . . and there, sure enough, tackled to a sidecar came a white horse, fat and long-coated. James was looking about him in a merry way, perhaps that was the reason a ballad singer . . . took one ballad from the bundle and put it in James' crumpled short left hand, the ballad-singer waited for no money, but went pattering on his way. James sidled towards the parapet of the bridge, and turned his right cheek to the west so that, holding the ballad close to his face, he could make out the opening verse by the failing light. It was a verse of passion . . . what he called political, but he was reading on and leaning more upon the beam of light that came to him, when some eddy of wind up from under the bridge, heavy with the smell of sewage meeting sea water, caught the ballad, plucked it out of his hand and threw it on the ebbing tide. James looked stupidly at his empty left hand. Then he turned his face up the river and took into his glare the advertisements . . . And he knew there was a train that left a station in the city every evening to the cry of 'This train stops nowhere' . . . (As pp.115-16)

Later, James recalls this moment, longing for 'his bridge and the sky over it and away from it' (As p.134) and he leaves for Ireland only to realise that the message from that moment is telling him that 'the love he sings of is of the Ocean . . .' (As p.135). On the final leg of the journey that brings him to the train that 'stops nowhere' and to the island and the Amaranthers, he remembers the words of the ballad. They are indeed political:

> I wear two lovely emblems I wear them on my breast
> A harp entwined with shamrock are the emblems I love best
> They're symbols of old Erin the land that gave me birth
> The sacred soil of Ireland, the dearest spot on earth.

Jack Yeats kept a copy of the whole ballad. In fact its politics are the politics of unity. The last verse goes:

> I'd like to see old Erin's sons united heart and hand,
> To eradicate the prejudice that spoils our dear old land,
> Let's smother party feeling, and let the whole world see
> We love our native emblems, and we live in unity.

The use of the ballad is crucial. At the moment of its recollection it represents the final fulfilment of the translation of Hope into

Charity. That Hope and Charity are themes in the novel I have already shown. Faith itself is not mentioned and, of course, we are not obliged to complete St. Paul's triad. And yet, on the bridge of James' symbolic crossing point, that snatching glimpse of the message against 'the beam of light that came to him' has caught some shafts of the light that shone round about and effected a more famous conversion on the road to Damascus.

As in the ballad and the invisible wind in the picture:

faith is the substance of things hoped for, the evidence of things not seen. (Hebrews XI 1)

I have referred above to the relevance of St.Peter to St.Mark, and so to Mark Trimbo. Saint Peter is traditionally pictured at the feet of Faith, and does not James share his name with an apostle traditionally pictured at the feet of Hope, holding her anchor? It is the business of a painter to be instructed in such iconography, and it is abundantly clear through all the preceding chapters, as well as this one, that Yeats made it his business as a writer to be aware of the significance of names. Putting these together, it is quite reasonable to propose a connecting thread of Faith, Hope and Charity in these two novels: and by adding the ballad verses we can see clearly how Ireland becomes involved in this imaginative realisation. It is Saint James who 'looketh into the perfect law of liberty' (James I.25) and sees that 'by works was faith made perfect' (James II.22). Thus it is that by works of Charity (in the full meaning of that word) James 'makes perfect' through his pilgrimage what was started by Gaw and Mark.

Every Irishman is born into the inheritance of his country's beauties and its troubles. Jack Yeats believed profoundly in Irish unity and clearly felt that 'the perfect law of liberty' was not being properly enacted: that was why he bitterly opposed the pro-Treaty forces, like many others knowing what terrible seed was being sown. But his voice, like that of the ballad singer, is 'rich with indiscriminate charity'. He kept faith with the ideal but he did not claim the inheritance only for himself, as the three sons attempt to in Old Care, though defeated by their father who has skilfully managed to divide and rule. The attempts of the British to divide and rule were familiar enough in Ireland, so for Yeats unity was central and the inheritance must be shared.

Given the extent to which the ideal of Irish unity was, and remains, a religion to those who care deeply for it, it is not too much to regard it as

The inheritance incorruptible and undefiled, and that fadeth not away, reserved in heaven for you. (I Peter 1.4)

The careless flower, like the amaranth, fadeth not away, and the inheritance is also symbolised by the bridge on which the charitable message is handed to James. It is crossed by all and sundry; it spans the river of time that divides its earlier name, Carlisle Bridge, representing a former Lord Lieutenant of Ireland and Imperial rule, from O'Connell Bridge, representing the great Irish patriot. Yeats draws attention to the names. It is the right place to begin a journey of reconciliation and, after a false start to England in the East (but one filled with affection, not bitterness), it is the recollection of that moment on the bridge that sends James South and West. It is the same symbolic journey that is made by the Freemasons, first to the South and then to the West, from darkness to light. The parallel is a natural one on other grounds. *The Amaranthers* takes its title from a secret society accused of being a communistic nest: the Freemasons are a secret society dedicated (ideally) to the equality of man. Jack Yeats had a guide to Freemasonry in his library, frequently underlined, perhaps by himself or by his Uncle George Pollexfen, who was a Master Mason. Freemasonry is associated with anti-Catholicism and Unionism in Ireland, but that does not necessarily make it all bad in Yeats's eyes and its ideals, when properly adhered to, would have had some appeal to him.

At the time *The Amaranthers* was being written, the blue shirts and neo-fascists, backed by the Roman Catholic church, were all for hunting out communists in Dublin, who were mostly identified with the remains of the anti-Treaty forces. The equality of man was under attack and the nation under threat of further division. *The Worker* (referred to in Chapter 1) was one of the very few publications in Ireland to speak out against what was going on, because communism was a pet hate of the Catholic church. No doubt Yeats saw it , typewritten, low in funds, doing battle with the wealthy and very right-wing *Irish Independent*, as a parallel effort to that of the ballad sheets which had kept alive the faith of the Irish in their independence and their hope for unity also against the official press.

Where the hired pen had saved the islanders from the railway Speculator, now the chain of events started by the ballad singer on the bridge would lead to something approaching the apotheosis of the Amaranthers in which at last a place, not of refuge but of participation, would be found in society; a place

where they could play a leading role because they were idealists, not materialists, at heart. That is why Yeats delays revealing the words of the ballad until the crucial moment of their rescue, so that the connection is, for the reader also, the revelation that it is for James.

I used the word 'apotheosis' because there is another more mystical level of meaning to the novel. It is there in the name of the bridge, this time its popular name which James recalls – White Horse Bridge. The white horses have a double significance representing the sea which, unlike the land, is possessed by none and across which Oisin returned from the Land of Youth (on a white horse), just as St. James, patron saint of pilgrims, was reputed to ride on a white horse. James, too, is a pilgrim and the pun on travel by sea and by horse is appropriate here, for just up the river on another bridge over the Liffey, are cast-iron sea-horses with webbed feet. They are featured in *Lives* (I.6) and in a drawing for Padraic Colum's *Outriders*, where the future is represented once again by a little boy, his toy horse prancing as gaily for him as the toy boats did for the Amaranthers (Plate 8).

The white horse also features in Revelations where it is ridden by the risen Christ. There are several references to Revelations in Yeats's work, and the white horse appears in his painting 'There Is No Night' – the title itself is drawn from Revelations XXII. 5. When James reaches South America he meets a cream horse, and it is a cream-coloured railway coach attached to an iron horse that he travels on at the end, the cream being, of course the best, that which floats to the top. James is given something of the aura of one higher even than his namesake the Apostle James, for at one point he has a disciple (see pp.132-4) – but he loses him, just as he loses the horse, for he is still learning himself. That the horse is significant not only to us but to James is made clear:

For some time, being at ease in the saddle, James had been wondering how the horse became his so easily, and sadly came to the idea that it was a Stolen Beauty! because it was given him by Rip van Winkle before he had time to be tempted by the horse beauty. That made James wonder, there in his place of comfort, if the horse had a name, and if it had, was it in connection with temptation. Was St. Anthony tempted by a single glory with a name? and James was ashamed he didn't remember. (As pp.159-60)

The connection between the horse and the railway carriage is also made clear, as is the relationship of both of them to the

theme of love, in the following passage in which James hears an old song:

A thin tall girl sang it, she didn't know why except that she'd bought it cheap from another girl who didn't want it – a song of unrequited love.
　　There you go
　　on your big black horse.
The girl was nervous about her song so few in the audience showed any liking for it. Her nervousness made James anxious, and so, as soon as the song was finished, he hurried away to his big cream-coloured house, his mount of luxury. (As p.216)

His house is the railway carriage and, as we shall see, it will carry James and the Amaranthers on a journey of requited love (I shall refer to the temptation of St. Anthony later).

But how is one to secure a cream-coloured railway coach, never mind a mystical horse? In the context of an allegory (and if it is not clear by now that this is an allegory, then I return the reader to Samuel Beckett with compliments) the coach and the horse are emblems of what can be achieved in the mind, by the mind, though they have their physical and social relevance too. One must overcome fear and have faith in one's right to things hoped for. The man to whom James yields the horse does not have to ask for it, any more than James did. James simply has not the courage to continue riding it as though he had a right to it. On the railway carriage there is an emblem: a woman presenting a sharp sword to a yellow-haired boy (remember the yellow-haired boy of *A Westerly Wind*). Underneath there is this motto:

I fear neither Friend nor Foe. (As p.213)

The boy is supposed to represent the President of the Railways who, until James' arrival, has had complete faith in his right of ownership. But there is not much of charity and hope in the failing Railway Company, and its President's image appears as a perversion – 'that old face on the young body' (As p.214) implying youth and vigour in the system but not in the head that manages it.

James' success in confronting the President of the Railway is not one of youth over age – James has no pretentious emblems – but he does need to be fearless and to have absolute faith in himself. He needs a youthfulness of purpose and, despite his long travels to reach this point, and all the experience and self-confidence he has gained from them, at the crucial moment

he loses faith in himself when he is told at their place of origin that his shares are worthless. It is one of the delights of Jack Yeats that he should give to a street pedlar an almost apostolic mission, while remembering that he is an ordinary mortal (as were the apostles) who, to keep his courage going, needs a stimulant. Drink is important to Yeats, be it from the spring on Fire Top in *The Careless Flower*, or the drink of ROMANCE which floors the 'wayworn bastard' who drinks it hastily and without understanding.

A human wrestled with an angel and the angel touched him on the hip. (As p.48)

comments a man in the bar. But Jacob got his blessing just the same, and so does James (Jacob is a version of the name James). The barman who provides it knows that James' life hangs upon it. He mixes a 'Western Railroad Engine'. It is, of course, symbolic too: symbolic of the enterprise that went into the making of the railways as opposed to the decay of the company in which James has shares: and symbolic of the power of the imagination, for the man who invented this cocktail had never seen any locomotive engine. The combination of enterprise and imagination is just what James needs.

The choice of a Western Railroad Engine was just the Great Barman's inspiration. It worked, it built a fire, it fanned it, rang a bell on its back, that was the cognac. In twenty minutes James was walking in the street, a crusted calm without, within a forest fire. But with no fear, at the second gulp that had left him. Now he did not even fear for others. (As p.212)

By the time James has dealt with the President he is a fit person to travel in a carriage with the motto:

I fear neither Friend nor Foe.

The General Epistle of James again makes relevant reading:

Let him ask in faith, nothing wavering. (James I.6.)

James' achievement is a splendid one: he has confronted capitalism and obtained that to which the capitalist system gave him a right. What is there more for him to do except travel the railway network, served by its servants, secure and serene? But it is here that the curious little hint that was dropped when he found the cream horse comes into play: was the temptation of Saint Anthony a single glory with a name? It was nothing so

simple. Saint Anthony was tempted by many things: the desire to return to the security of family life; the attractions of comfort and, perhaps most significant here, the pride of success. Family life James has long since left behind him, but comfort and pride and even a certain selfishness are inherent dangers in his situation, sole rider of his 'mount of luxury', not far different from the President of the Railways himself, except that James does not even exercise the responsibility of management.

He felt as if his tale was told. The happy ending in luxurious surroundings had come – and then he was rushing down again, alive, 'O'. He was singing.
 I wheel my wheelbarrow
 Through streets broad and narrow
 singing
 Cockles and Mussels
 Alive, alive, 'O.' (As p.218)

But the quotation is ironical. Molly Malone dies of fever in that song and its last verse is sung by her ghost. *The Amaranthers* does not spread its seed in that direction. What more, then, has James' tale to tell?

Fearlessness and faith, hope and charity and love are, in Christianity, all closely connected. The cream coach, 'I fear neither friend nor foe', the Hope On Hotel, the cry of 'indiscriminate charity' are likewise related. Writing to Mrs Morgan on the death of her soldier husband in the Second World War, Jack Yeats said:

I associate the thoughts of affection and bravery with him. Perhaps they are the same thing.[9]

A remark like that makes a loop out of a long string of ideas, and when one day James sees, from his cream coach, a boy so hungry that he eats the paste from behind an advertisement, he throws all his money at the boy:

Indiscriminately he lifted it from his pocket and threw it – charity in the yellow dust. (As pp.224-5)

This obviously echoes the 'indiscriminate charity' from his experience on White Horse bridge. From that experience and his awareness of the suffering of others develops a new enterprise in which he shares his coach. He sells cheap tickets to city people so they can travel up to the film lot in the mountains, there to act out as extras the roles they can never otherwise hope to fill. The

Director – the Great Man – unlike the Railway President – combines business with charity:

The Great Man looked very plausible lolling there in the widest chair . . . every time some nobleness of his own rose in his brain, his breast rose in sympathy. It rose thus in sympathy with the gambler, who had nothing to gamble with but his own personality. The defenceless men and women with nothing but common beauty. The passionate, and the passionless. The obdurate heart and the little piping, brittle one. The bristling mind hiccupping with ideas, and the dull one a flat plain under the black arc of an empty skull. (As p.235)

James' final commission from the film director whom, unknown to himself, he has been voted to succeed, is to find 'half-a-dozen really shining ones' for parts. In the spirit of his own philosophy Jack Yeats seems to have softened his attitude to the cinema, accepting the reality and working with it, compared with the aggression of *The Deathly Terrace*. It is the hurricane that picks James' cast and they are, of course, the Amaranthers. This is the crux of James' achievement, that from his earlier acceptance of unearned income, he has come to a position where he can share and do good with it. It becomes no mere materialistic success, but a spiritual one. What James offers to share with them by sharing his coach is not the moving picture gallery of the literal Russian example; nor is it literally the fancy world of the movies: it is, rather, the moving pictures of memory and imagination, like those of Mark and Gaw. The ideals of undying love and eternal youth; the love that was the fragile ideal of the Amaranth Club members is at last requited; the toy secret, the best of childhood preserved in affectionate memory (and necessary for entrance into the Kingdom of Heaven), can be shared openly and in full scale.

It was part of the process of James' learning that he was able to leave his picture gallery (described with much affection 'as if they were brothers', As p.128) and learn later to help create a picture language to talk to the South Americans. The picture he now carries is one he makes for himself and can, as he explains, cross the frontiers between dream and reality:

The country on either side as you look out of the window, with your chins in your hands, after lunch, will look just as each of you likes it to look. To you it will look like distant strong blue hills . . . And to you it will look like a bog of land, sunk inside a sea, with ocean rollers licking the sky. To you it will look like a town of smokey rooves . . .

And first you begin to stop emptying your heads, every time they begin to fill with thoughts, and then you will begin to think, and then you will stop thinking and begin to talk . . . And then you will stop talking and begin to fancy, and then you will stop fancying and begin to imagine. And by that time it will be morning. Some morning. It will be a morning after all the worst harm of the hurricane, on the track above, has been cleared away . . . (As pp.271-2)

What James offers is a 'life Anno Domini defying' (As p.269). The careless flower and the amaranth are not plants that we touch briefly and then die. Were that so, we would capitulate to the fatalistic inertia of the islanders or the sterile conventionality of Gladys and Ralph. Instead we become familiar with the frontier of death, crossing and re-crossing it with that part of us which offers freedom from our material natures. Like the Russian railway coach, it crosses state divides, the frontier also that divides Ireland, perhaps, and that which divides the rich from the poor. It is the frontier which Oisin crossed on the white horse's back, coming from the island of the land of youth only to fall from his horse and age like Rip van Winkle. When James encounters the cream horse, it is led by a man whom he names Rip van Winkle – like Oisin, unable to return to the land of eternal youth. But James and the Amaranthers can, because for them it is a state of mind. It is a frontier which, when crossed, is essentially the same state of mind which allows you to enter itself, so you forget its significance on the other side – and when James shows what he has written about it on this side on a piece of folded paper, it turns out to be quite blank.It is a state of mind in which the value of existence can be sustained by the reality of imagining with the full force of something approaching a Berkeleyan philosophy. It is not appealing to everyone:

The white-necked driver shouted, his eyes so on the track it was a wonder he took any notice of James' palaver. 'I don't go not me.' 'No,' James said, 'he doesn't go – yet, he stays where there are roads. He comes in the end.' 'Leave me out I don't go' – 'in the end where there is a perfect road, painted to look perfect there he will be.' (As p.270)

This naturally suggests Plato's ideal forms. To an artist whose painting had long since transcended the art of the illusionist and who was producing a different and imaginative reality (though still based always on nature) it was a world which had a tangible present in the form of novels, paintings and art in general. Not exclusive art, but travelling round the country in a coach; and not

only produced by approved artists, but painted and written in the minds of any who wish to create it with the paint and ink of the mind. It is a journey which, if we once have faith in ourselves, no President of the Railways can deny us:

And what James foretold came to pass.

The lovely siding came. The morning came with the garlanded engine and the President of the Railway, and the President ran away and climbed up into a plain car of a downward-bound train, come suddenly in answer to his prayer, and there he sat muttering as he went sliding down the slopes to the city. (As p.273)

Jack Yeats knew well enough the strength of the obstacles in the way of such a journey. In *The Careless Flower* it seems to be defeated by the force of Chance itself, the very thing we have to seize upon; but the Amaranthers and James take that chance and it ceases to be relevant whether they live or die, for they already inhabit the world of their desires and it is suggested that such a world transcends life and death, just as Mark and Gaw were able to be present in places outside their own time and place. Mark's death is cruel because he has not yet re-entered that world, having been dragged away from it. James has reached further than the isolated island. His is a New World; a continent inhabited in the present, where he has found like minds; and found a continent of the mind itself. From this high point, where was Yeats's writing to go? It returns, like a flood tide from that far shore, to his own land and to a more detailed and searching examination of the struggle between materialism and idealism, flesh and spirit, in his own person. In his next novel, taking your chance becomes a more complex affair, for it amounts to taking it against the background of a Last Judgement. 'It is his Faust', wrote W.B. in *On The Boiler*.[10] There were to be no more third-person novels.

11

The Charmed Life

And now comes my brother's extreme book, 'The Charmed Life.' He does not care that few will read it, still fewer recognise its genius; it is his book, his 'Faust,' his pursuit of all that through its unpredictable, unarrangeable reality, least resembles knowledge. His style fits his purpose for every sentence has its own taste, tint and smell.[1]

Sadly, the only part of W.B.'s outstanding insight into *The Charmed Life* to draw attention has been the phrase 'unarrangeable reality'. The 'Faust' part has been totally ignored, as has the careful wording of 'least resembles knowledge'. And yet Faust has an immediate and obvious relevance for a novel with such a title, and the true nature of knowledge is integral to the Faust legend. He wanted to know everything; that was the life he acquired by charming it up from hell. His was indeed a 'charmed life'. But knowledge is, in the Christian religion, man's first step downwards towards hell. As Jack Yeats himself put it:

The knowledge of Good and Evil! without blasphemy, I hoped that Christ had died that we might forget it. (ATYA p.107)

Jack Yeats's charmed life is clearly not going to be one that pretends to know all things, or judge all things. Even as a first-person novel it keeps itself free from the history of personality, and this is true of all the first-person novels. We learn virtually nothing of the narrators outside the time of the action. In *And To You Also* it is only one night long; in *The Charmed Life* it lasts only four days; and in *Ah Well* such time as there is passes without bequeathing any substantial history, and the little town in which it is set seems to be outside time, though time is occasionally heard to bump against it. Given that the narrators are leading characters, this lack of background becomes very deliberate and we must take them as they are, without the aid of history or convention. We cannot judge them on anything other than what unfolds under our own observation. This, very briefly, is what does unfold: Two companions, Bowsie and No Matter, journey westward in autumn along the coast of Ireland, staying

PLoT

164

first at the Imperial Hotel, then the Island View in E town and finally at the Pride Hotel, on its own by the sands. They encounter, amongst others, Tim Devany and Julia Starrett. The latter, having saved Tim as a baby from a flood, dies of a fever brought on by a soaking in a rain shower. Tim, too late to deliver her red shoes for a dance at the Pride which her death cancels, inadvertently causes the near-drowning of Bowsie. Following his accident, Bowsie meets a legless man called Silvanus, who restores him to health and his companion. Bowsie departs the scene for a job and respectability amidst wild ambitions, after which No Matter adopts the names of Hector for the Judge and Alexander, when he remains to take part in an expansive conversation among seven of the hotel's guests. This conversation virtually concludes the novel as dusk and moonlight overtake them on the sea-shore. There are other characters and stories, but the above identifies most of the main features of a landscape in which almost every feature is significant.

The Faust story concerns itself with the ambition to acquire ultimate knowledge within the limited time-span of a human life. It is the same ambition as Eve's and Adam's and because they succumb to it, it is inherent in human nature. It partakes of the sin of Pride, is symbolically cleansed by baptism, a ritual undergone even by Christ and echoed in the ritual of confirmation. The prophecy of God with respect to these events is that the seed of the tempter will bruise the heel of humanity, but the seed of humanity will bruise the tempter's head. This latter act is supposed to have been accomplished by Christ already, though its ultimate fulfilment awaits the apocalypse.

Christ or no Christ, humanity has not yet shed its Faustian ambitions and in the Britain of 1988, we seem to be deteriorating into the same materialism into which Faust deteriorates, leaving him but briefly gratified in the flesh and impoverished in the spirit.

The Charmed Life is obviously not the Faust story all over again (hence W.B.'s use of inverted commas) but it could be that it somehow enacts its opposite. In such an enactment we might expect to find man at the command of the elements rather than in command of them; accepting of that reality; unbound by contract but baptised and confirmed; bruised in the heel but more spiritual than carnal; humbled rather than proudful; and awaiting

judgement with equanimity. The central drama behind all these is that of the human soul, the spirit versus the flesh. Such expectations are indeed to be found in this novel, but they are insinuated into the work as subtly and pervasively as a tide can creep up on a boy digging for lugworms. Sometimes, finding or pointing out the bait in Jack Yeats seems to be a similar activity. Lugworms are plentiful, but discreet. It is only when you look up that you see there are millions of them and notice the tides that time their lives.

The combat between flesh and spirit is embodied in Bowsie and No Matter. Of this we can be quite certain because their names very plainly tell us so, though it has not been noticed before. A Bowsie is a boozer, a symbol of fleshly pursuits from Silenus on. No Matter thinks Bowsie's 'knowledge of souls is limited' (CL p.116).

Bowsie's name means nothing to him. I gave it to him because I knew what a Bowsie meant and he didn't. He, I guessed, would be too proud to ask me what it meant, and I was too proud to tell him. (CL p.42)

No Matter means, of course, without substance or flesh, therefore the spirit. The name is arrived at because the person to whom it refers will not give his proper name. The spirit is free from the fixity of a name, and if a name must be had then 'No Matter' is as good as can be had because it is immaterial in both meanings of the word.

The relationship between the spirit and the flesh has never been straightforward, and Yeats respects that. In letters to his father and Joseph Hone he had outlined the theme long ago, and had already used it in *The Old Sea Road*.

You speak in one of your letters of the coming fight between the have nots and the haves. I think behind everything will be the fight between the lazy and the alert. The ancient fight between Flesh and Spirit, which has been dormant for a time, owing to the fraternizing of the armies brought about by the influence of the ridiculous money. But as the tusks of money become more and more useless through growing too long then you'll see a fight for something worthwhile. Prohibition is the first battle, and the lazy flesh has won that. But the fight will go on until the flesh and the spirit have stripped to the buff and until all the prize ring rules have been forgotten. The amusement for the lookers on at the ringside will come from watching who backs the spirit and who the flesh. And it will be amusement well laced with surprise. But after a time the features of the battlers will be so obliterated that it will be only a clear and sportive eye which will be able to tell quickly which is the spirit and which the flesh.[2]

Spirit and flesh, mind and matter, are used more or less as
equivalents by Yeats, as the following letter to Hone indicates,
accepting the same difficulty in separating them:

I would be pleased to follow the Mind versus Matter fight to the finish or
as near to a finish as our minds and matters will let us. The trouble is if
you start arguing, with one of the boys, and you think you have got mind
pinned down on the board, and under fine observational circumstances,
the Boy says 'that's not mind at all. That's Matter, the thing I keep telling
you about'. It is just the same if you have got matter preserved, dead, in
alcohol, in a bottle. This boyo says it's his mind you're corking up.[3]

Mr. No Matter has a way of disappearing from view, being
spiritual, but:

There was one man from whom No Matter never vanished, that was his
worn old friend, Bowsie. Bowsie was a medium-heighted man, his
bones well covered. (CL p.2)

In other words he was fleshy. On his waistcoat are 'the specklings
of many breakfasts', on the thrush's 'are the specklings of God'
(CL p.55). McGuinness has drawn attention to Bowsie's character
as an 'artful blackbird' (CL p.5) and points out that 'The blackbird
in mediaeval Irish literature is a Dionysian force' (McGuinness
p.252). This obviously fits in very well with the concept of Bowsie
as the flesh.

 In the end, spirit and flesh are separable. At the turning point
of the novel, following the coincidence of two deaths by water
and Bowsie's near-drowning, Bowsie, the flesh, departs
Eastward for a job and the 'ridiculous money'. The spirit in the
shape of No Matter is left – sad, yes, but accepting the absence of
his friend. No Matter then changes his name to Hector or
Alexander, as it were inhabiting a different body. Bowsie goes to
something like his death, as we shall see. The journey Eastward
was not the spiritual journey:

I turn my back on the road Bowsie has taken, and I stroll along the dry,
sandy, cream-coloured road to the west. (CL p.232)

Jack Yeats was in his middle sixties when he wrote this book
and there is no doubt that he at least partly identified himself with
No Matter and Bowsie, as McGuinness has pointed out
(McGuinness p.253). Early on in the novel the narrator reports
Mr. No Matter as claiming:

Through or over, I go in without a ticket, except a complimentary one. I
give myself that one. (CL p.3)

Yeats echoed those words in the nearest he ever came to an epitaph for himself:

I have travelled all my life without a ticket[4] (see Chapter 8 for full text).

This identification is ratified by the fact that the narrator continues, no longer using quotation marks for No Matter, though it is clearly No Matter who still speaks:

Do you notice, Bowsie, my child . . . Bowsie is being impressed; he has turned a little away from me . . . (CL p.3 and pp.4-5)

The association between flesh and spirit is referred to several times in a manner suggesting that the two do indeed inhabit one another as well as being father and child and close and affectionate companions following the compass needle by which they choose their direction:

There, between the left and the right eye, swinging between flesh and spirit, a breathless thought is always pointing for us to one of our small towns. Bowsie, my dear friend, Bowsie. (CL p.26)

This recalls the relationship between Mark and Gaw – 'Ah, Mark, my old friend of Fire Top.' (CF p.167) – distinct but also sharing thoughts as though one person. Yeats has placed the compass needle in the position of the Third Eye of Eastern yogic practice, in which the search for the spirit involves the focusing of thought through that eye and the control of breath – 'a breathless thought'. Jack Yeats refers to Eastern philosophy and yogic practice later in *The Charmed Life*:

'The mahatmas in the East are all for passing through self-consciousness, into the unconscious, or into the great consciousness, lost in a kind of filmy state. Put your finger into the mist, the finger makes a hole, withdraw it, and all is mist as before.'
 'It doesn't appeal to me.'
 'Nor to me. I am of a fleshly school. I believe that it is possible that the ingredients of the film are within me'. (CL pp.266-7)

The speakers in this conversation are not identified – they do not know each other well and they are sitting in the dark – and even if they were, none of them have proper names; Yeats only gives them attributes for names – Haggard Cheek, Hound Voice, and the significantly named Small Voice of whom it is said:

I do believe he is as free of egotism as any man might be. (CL p.206)

Here indeed is an anti-Faustian stance. The removal of egotism achieved by the removal of fixed personal identities, referred to

above in relation to Bowsie and No Matter and carried on through much of the book. The narrator is both No Matter and Jack Yeats: sometimes he uses 'I', but for long passages he is a detached observer so that we have the remarkable phenomenon for a first-person narrative of a narrator who does not seem to impose his view on the events narrated. The final conversation of the novel is conducted essentially by disembodied voices, temporarily freed spirits. It is a simple and beautiful idea, conversing in the dark: one listens so much better, and one is less tr)ubled by others' reactions.

The relationship between flesh and spirit in Bowsie and No Matter is not to be taken as a stark division. They are like Castor and Pollux who traditionally represented death and life, for Castor was the mortal child of Leda and Tyndarus, and Pollux the immortal child of Leda and Zeus and from whom Jack Yeats liked to fancy his Pollexfen blood was derived, as shown in Chapter 1. But, like Castor and Pollux, the immortal brother chooses to share the mortality of the other. What this suggests with respect to the two brothers in the Yeats family might give rise to much entertaining speculation. It was Jack who came up with the idea in a letter to W.B and it was Jack who painted *Death For Only One* just over a year before his brother died. It is widly held to anticipate that death, though Jack:

thought that he had left to him two or three years still to enjoy the power of his brain. About two years ago, it was in the club, he was talking about some one, I forget who, and he said 'what will history say about him' and then, it came to my lips without a conscious thought, I said 'men of genius are not in history' and I immediately knew I meant himself.[5]

That remark, which must have been made shortly before or when the picture was being painted, does suggest that W.B.'s death was in his mind; and it is an interesting remark from another point of view, and that is the idea that men of genius are not in history. In other words, they have a kind of anonymity and are outside time. Here again is an anti-Faustian stance. Faust is the prototype of genii, but he is named and placed precisely in history; so it is quite natural that 'Death For Only One' should picture two anonymous tramps, one dead, the other standing beside the body surveying it sadly (Plate 10).

Returning to this kind of relationship in *The Charmed Life*, No Matter does, naturally, appear in material form, interested in eating, walking, etcetera; and Bowsie does have a spirit of his

own, as Silvanus tells him when Bowsie is recovering from his
near-drowning:

The man who has never been handled fully by the tide of the sea is
always in fear, not so much of his body, but of his spirit. He thinks the
sea will try and get a piece of it anyway, though he believes perhaps he
can resist the sea, and get away with it. But a man such as yourself knows
that the spirit of the sea will never touch your spirit – your spirit lives
above the waters – anymore. (CL pp.188-9)

Bowsie nonetheless comes down on the earth-bound side of his
own nature, unable to respond to the inspiring talk of Silvanu ;
(whose significance will emerge later):

You are a serious-minded man, and no doubt you are able to penetrate
the ambiguosity of my shell, and know me better than I know myself,
whatever that may be worth. I have no desire to know myself any better
than I do, at this moment. To know which is the weak leg, and which is
the weak shoulder, is useful to me – that's enough. (CL p.190)

Beckett, no doubt, took note of such sentiments. As for No
Matter, Bowsie lingers on in his mind. His last mention of him
pictures him 'having his chop, and chipped potatoes, at his hotel'
(CL p.294). But No Matter then goes to dinner himself, with a
good appetite. Twenty years after writing this book, Jack Yeats,
very old, and lonely, in Portobello nursing home, said to Serge
Phillipson that, having lost his taste for whiskey, he was 'ready to
go'.[6] The Bowsie in him was finished.

One of the main features of the Faust story is the contract with
Mephistopheles; the contract with Hell. It is a contract that must
be annulled in The Charmed Life since it is anti-Faustian, and in a
way it has to be a contract which we have not signed ourselves.
That aspect of the contract, signed on our account by Adam and
Eve is, clearly enough, original sin. How we handle it is partly
demonstrated by what contracts we ourselves enter into
willingly. There are three contracts of sorts in the novel and two
of them represent annulment. The third contract, however, is
willingly entered into by Bowsie and there is no word of its being
in any way wriggled out of.

The first contract is that between a former criminal, and former
visitor to the Pride Hotel, and a judge. The criminal, though
rightly acquitted, eases his conscience by confessing to a more
exciting crime than any he has committed and promises to go
straight.

He looked when he came out on the street again like a Faust who had

sold his soul, and then found there was a crack in the document and got it back again. (CL p.49)

He keeps that promise, and whatever crimes he has committed are not punished because the judge forgives him and in fact leaves him a legacy. The criminal, as inheritor, takes upon himself the name of 'Judge' and is a kind of prototype for the Judge at the end of the novel, with this important difference, that the second judge's title is bestowed on him by others, though he is no Judge in the official sense any more.

The second contract mirrors the usual second contract between Faust and Mephistopheles, in which he is given the chance to win back his soul at a game of cards. In *The Charmed Life* it is a bet on the races, and it is undertaken when Bowsie and No Matter are at the Island View Hotel in E, or Shutter Town. This town, which in modified form is the setting for *Ah Well*, represents much the same stasis as the island in *The Amaranthers*.

We thought it might have grown, and spread out grandly, since we last saw it. But it is not so. We count six new buildings, and two of them are sheds. (CL p.120)

It is called E town because of its shape of a back-to-front E: E for Emerald Isle, E for Eire, E for Ever; 'The shape of which . . . [is] set for ever' (CL pp.120-21), but with its back to the sea. In *Ah Well* it has its back to the river. It is not a bad place, but half the spirit has gone out of it and Bowsie, the flesh, insists on staying there:

Bowsie turns to me coldly and tells me I should telephone to the Pride to have our suit-cases taken back here to the View for to-night. (CL p.126)

The two companions are bored there. They listen to old records. Bowsie sings 'Maid of Athens', an old song of old love – 'Though I fly to Istanbul / Athens holds my heart and soul'. He tells a story badly – 'He is finished, a depleted story maker' (CL p.131). They hang about the next morning waiting for the result of their bet. They have won, they can move on. The allegory here is interesting. The bet was recommended by the landlord who had dreamt the winner. They trust the dream. In those versions of the Faust story (for instance Auden's libretto for Stravinsky's *The Rake's Progress*) in which Faust (Tom) wins the game, he does so by trusting to a vision of the right card. They win because they have accepted instinctive rather than acquired knowledge and

they have therefore humbled themselves and accepted their place in the natural world; not in command of it, but part of it:

We wish, for a moment, we had been more full of ready money for the sure venture. But now we know the sum was the right sum for the event. The event opens to the moment. The height of the sun which opens the daisy, is neither more, nor less, but sufficient. Two daisies, we. (CL p.124)

The third contract is Bowsie's with the Dublin Government for a job as a minor official. Though pensionable and under no superior, Bowsie has essentially opted for materialism, even after his accident and encounter with Silvanus.

Bowsie is very much above himself, but he is also timid within himself, as he raises this monster, which he believes he may become, which he believes, he hopes, to become. He is afraid that some uneasy plank is his bridge, the bridge that takes him from his old self to his new, may tip over, and bring down the whole concern into the depths. (CL p.217)

This brief vision is not unlike the descent of Faust through the trap-door, only Bowsie believes that hell is what this job will save him from. This, I suppose, is the central tragedy of life. That the flesh we inhabit is of the earth, earthy, and cannot be other. So the fleshly man retreats from the ocean because he cannot face death. He is fearful of the depths – of nonentity. He is going to join a club and play golf and make a name for himself (CL pp.216-7) and must believe in that as his only salvation, when in fact it is his certain spiritual death. He bequeaths to his spiritual partner a new name – Alexander (CL p.226). Alexander means 'one who saves another', but Bowsie gives the name jeeringly, annoyed with No Matter for suggesting that he looks a mess. It is the last moment of defiance in Bowsie's nature, the last squeak from the spirit before he tidies himself up:

He thinks that this is the most ridiculous moment in his life, since . . . he became, in the world's eyes, the master of his own fate. He thinks it is ridiculous that he should leave this pleasant place of sun, and sea, and air, and hurry, hurry, birds. (CL p.227)

But Bowsie is a blackbird, not a seagull, and away he goes: 'Well rest his soul – when it's required of him' says the Judge (CL p.201).

Of course that last defiance from the spirit was one of hurt pride (see also CL p.9), and pride is the greatest of the Deadly Sins. It is Faustus' main motivation. In this novel, as we shall see, it is most certainly humbled, but not wholly condemned.

The Pride Hotel is the ultimate destination of the journey from East to West, from river to ocean, from big town to market town to holiday resort to a small cluster of buildings round a hotel; from Imperial Hotels to an Island View Hotel to the Pride Hotel; from the dominance of man to the dominance of nature; from the cinema to the gramophone shop to the cancelled end-of-season dance; from friendship to separation; from life to death. The characters see themselves, or are seen in such contexts.

Now, down into a sloping stroll, to bring the battering hearts to quietness, and we are in the Pride's mouth. Successful wanderers from no prosaic shore. (CL p.149)

This is neither a gross nor a squalid sort of Pride that they arrive at, but tempered with humility:

Hayden thought of the Pride of the Sea and that seemed presumptuous, and then he smalled it to the Pride of the Atlantic, and then to the Pride of the Bay, and that he felt would put out the other hotel men . . . 'Running water in every bedroom and three baths' are the Hotel Pride's pride within a pride. (CL p.36)

The running water and the baths relate to an important theme of cleansing and baptism, and the Pride is also a legitimate destination for a nation seeking independence, but these points are taken up later. But it is made very clear to us that the Pride is the last stop before death for the characters in this novel:

Many of Hayden's visitors are Americans home for a summer, and a few bacchanalian servants of the public on the eve of retiring on pensions. Snatching at life, in the fear that it may be snatched from them, on the brink of freedom. (CL p.37)

It is the end of life for Julia Starrett:

The landlord of the Pride is not in sight, and the lady dead upstairs – well, the abandoned dance is her requiem. (CL p.178)

The abandoned dance marks the victory of death over life and has humbled even the little pride of the Pride Hotel. The bacchanalians will have no bacchanalia, and Miss Julia Starrett, a woman with 'the remains of much looks' (CL p.19) does not live to wear the little red shoes that Timmy is bringing her. Hans Andersen's story of the Red Shoes is a nightmare tale of divine retribution for Pride, in which Karen desires red shoes like a princess's, and becomes so absorbed with her new status that she is unmoved by her confirmation of baptism, ignores her dying

grandmother and is punished by the shoes which will not stop dancing and which she can only take off by getting her feet axed off. She then teaches humility to other children. Jack Yeats no doubt knew the story as well as the rest of us and has side-stepped its horrors, but with many abiding ironies.

Julia Starrett has had three lovers and a dozen suitors, but has accepted none of them to share her looks and small fortune. That is her pride; that and her maid and her claret dress and red shoes to match. But she, a sea captain's daughter, at the risk of her own life, saved from a flood a poor woman's baby in a wicker cradle – like the daughter of Pharoah rescuing Moses. The baby is Timmy. Now he sells shoes. These shoes too are dangerous. Timmy has struggled through wind and rain to deliver them on time:

He is saturated with rain, and his own sweat. He's black as some hunted thing moving fast with fear. (CL p.173)

Bowsie, kindly, stops him to tell him Miss Starrett no longer needs them – she is dead. The shoes slip, Bowsie, trying to catch them, falls into the river and is presumed drowned, and Timmy

the grown knight riding for a lady's pleasure, becomes, in that instant, a child, a child trapped. (CL p.174)

When Bowsie escapes the flood, 'he thinks of the boy Timothy standing proudly by his package of foolish shoes' (CL p.179). Even Timothy, 'very thankful to those who baptised him with romance' (CL p.32), finds that his pride in fulfilling his mission to the woman who once saved him is thwarted by death: and by Bowsie's accident his thoughts are chased back to his 'baptism', in his case 'a child trapped'.

The basis for this is laid earlier by Jack Yeats. Timmy reads and re-reads a page in a paperback about a man saved from drowning:

'Ah! his chin is uncovered, and presently the water only washes his shoulders. Saved once more as a brand from the fire! And wherefore? To do good in his day and generation, or to work iniquity and clothe himself with crime as with a garment.' (CL p.53)

Are Miss Starrett and Timothy Devany being punished for their unrealised romancing? In fact no. Miss Starrett is betrayed by vanity or pride into a lack of respect for the elements, walking by the sea she loves without a coat, perhaps to display her red dress; and Bowsie does not drown, so Timmy is again released from the trap. After all, though Timmy delivers Miss Starrett's shoes and

has been saved by her, he is not likely to step into them. But there is, in these clearly identifiable strands of thought, a warning of kinds. Pride is not reserved for the high and mighty, and it is also a necessary thing, even in association with shoes:

He was a man, even though he knelt at your feet and polished, and breathed his breath on the toe for the final shine. But I once had my shoes cleaned by his helper, his understudy, his employee. I could have wept on his bent head, or perhaps my tears would have fallen on his neck, to see a human being so lowly, bowed before me. The gestures were the same but there came some little tinkling spirit of pride, like an aura, from the crouched figure of the Chief, which this man had not got. (CL p.215-6)

Yeats's compassion is everywhere evident, even when he laughs at human follies, but nowhere more so than in that expression of a feeling that must have touched the heart of any sensitive person who has had his shoes shined by such a one.

At the end of the tourist season, at the end of that life in which we are all tourists; in what is (literally in the case of the Pride) the last resort; the last to dance is death. And whether we make the dancing shoes or sell and deliver them, or wear them to match our dress, we must hope that they have not 'clothed us with crime as with a garment'. To clean another's shoes – what little pride is left in that can do no harm:

If I then, your Lord and Master, have washed your feet; ye also ought to wash one another's feet. (John XIII. 14)

Shoemakers and shoes, and how one walks in them, feature frequently in *The Charmed Life* – but there is one man, Silvanus, who has no need of them, for he has lost his legs like 'Johnnie come marching home', in which the line 'Your dancing days are done' first occurs. But Silvanus lost his legs, not in war like Johnnie, not to save himself like Karen, but preventing a railroad accident. He is therefore a better exemplar. To stand in another man's shoes is to usurp his place in life, but with no feet you have no place yourself: you are humbled utterly. Here indeed is the bruise to mankind's heel – that original sin which took its first form in covering its carnal knowledge with clothing. Silvanus atones for it by unforced self-sacrifice.

Saint Silvanus (Silas) was companion to Timothy: the bearer of Peter's Epistle, the message he bore was of One who was conveyed by a donkey. Silvanus is conveyed by a donkey. Peter's Epistle featured in *The Careless Flower* and *The Amaranthers* by

association with Mark as the scribe of what was Peter's gospel, and in the relation between Faith and Hope, Peter and James. In *The Charmed Life* he features by association with Silvanus, the scribe of his Epistle. Peter could not write, so if a writer were to presume to give a tongue to a Saint, Peter would be a thoughtful choice. There are several points of contact between Peter's Epistles and *The Charmed Life*. The phrase about clothing (from Amos IV.11) that Timothy read in his book is echoed in it:

not using your liberty for a cloak of maliciousness, but as the servants of God. (I Peter II. 16)

And Timothy, as pointed out, was a companion of Silvanus. But the most important contacts are with respect to the idea of baptism in relation to the Flood, and of prophecy shining like the moon in a dark place. These points I shall take up later.

Silvanus is also a god of the woods, but on the west coast of Ireland woods are not abundant, to put it mildly. He is, however, very clearly identified with nature and, failing to make any real point of contact with Bowsie on the subject of the sea and baptism, even though he tries to interest Bowsie in the idea of it as some kind of 'secret understanding' (CL p.189), Silvanus begins to talk of little birds and grasses and bushes and Bowsie eagerly joins in. He is back on terra firma. Yeats, in the character of the narrator, No Matter, indicates Silvanus' failure to spread the gospel into this particular bit of flesh:

And Silvanus in the cart seems to say 'There's your middle weight cupid for you, washed up by the tide, and Silvanus.' (CL p.200)

The Epistles of Peter have no time at all for Cupid.

The theme of pride has another bearing on the Faustus legend, and that is with respect to the making of nations. Faust shows off to the Emperor of Germany, conjures up the great Empire builder, Alexander, and makes a fool of the Pope. Empire is not part of Ireland's ambition, but a little country can legitimately have an ambition for its own freedom from Empire.

I have said that the journey in *The Charmed Life* can be seen as the journey of a nation. Many of the tourists at the Pride are Americans 'home for a summer'. They are ex-patriates. So is Hayden, who runs the hotel. They do not go to either of the Imperial hotels: for them Empire – the British Empire – is dead. They are past the Island View Hotel, too. So too are Bowsie and No Matter, and their progress is symbolised by the unblocking of

a drain. As with so many details in these novels, it is full of significance beyond itself, but not, most definitely not any greater than itself, as this quotation indicates in relation to Empire:

Some link is rattling in my brain between Romans making aqueducts and ourselves directing the gutter flow. And it comes to me, in a flash, that those voluminous long and baggy double kilts, one time called plus fours, appeal to so many men, because they flop about them like toga ends, and I believe that those, to whom these flappings appeal most, are those who do not feel within themselves that noble pride, which remembers that 'The noblest Roman of all' is dead. (CL p.148)

The plus-fours brigade are typical British Empire types, full of false pride. The noblest Roman was Brutus, who tried to over-throw Empire for honourable motives. To be proud, knowing there have been greater patriots than yourself, that is an accepta-ble pride.

The American tourists have crossed more than a culvert. They have been to the 'Promised Land' of America, in their millions, literally. Like the Jews, they have become a displaced nation and they return to a nation not yet wholly free of Empire. The idea of a nation crossing water to escape Empire is well soaked into the fabric of the novel and it re-enacts the survival of Timmy, Moses and the Israelites, and of Noah too. The sea is death:

We are as men on a raft, surrounded by a sea, into which the dead fall. (CL p.265)

The image recalls Tawin island referred to as a raft by Yeats and possibly related to the island in *The Amaranthers* (see Chapter 10). It also recalls Moses, who is referred to as 'a man of the people' and 'His canoe must have looked very fresh and green, with the giant bullrushes waving overhead' (CL pp.251-2). Green is Ire-land's colour. Timmy was in a 'canoe' – a wicker crib caught on a green island, rescued, as suggested above, by a Pharoah's daughter. It is she, Julia Starrett, who dies from the deluge of rain which caught her by the sea, as did the Egyptians in the Red Sea. Bowsie, having survived the flood

has plucked, from history, the Red Sea Miracle, and he walks the depths of his Hellespont – But no Hero looks out of any window for him. (CL p.232)

And who was Bowsie's Hero? Julia Starrett, the woman who admired Bowsie from her window (CL pp.12 and 19). These two

may represent some unfulfilled matrimony in the Irish people – Julia Starrett, her old pride clinging about her, living opposite the Imperial Hotel: Bowsie, the flesh and blood reality of Ireland, ending up as a bureaucrat, leaving the spirit of the nation behind in No Matter and the idealistic emigrés far out in the West, dreaming the old dream. This match, that might have been, contrasts with the marriage of Ireland and England (Thadeus and Annette in *Sailing Sailing Swiftly*) which thins the blood, and the marriage of Alice abroad (which is sterile) in *In Sand*. But the rescued Timothy, the young Moses, may represent a more hopeful future.

Bowsie is so upset at Miss Starrett's death that he goes out into the rain and to his accident. He has never met her, but probably hoped to dance with her, knowing she had been admiring him from a distance. This is Bowsie still in his old self, unbaptised by the sea. Now that any chance of a coming together is over, he must change or die. At first the guests at the Pride think he has died. It is just after the declaration that the abandoned dance is Julia Starrett's 'requiem' that No Matter is given a stiff drink by the Judge because his friend Bowsie is missing. The Americans, the free men of whom the Judge is one, associate No Matter with Bowsie's old yearnings towards a marriage with Miss Starrett and what she represents. In this awkward honouring of his unhappiness No Matter feels

Almost as though a republic drank to a monarchy's good health. (CL p.178)

That old monarchy still lurked on – the Elizabethan tower (CL pp.232 and 247) and the Norman tower (CL pp.55-6) are not remembered kindly, but the fading cultural imperialsim of the lady 'a landmark sinking in the sands of more democratic days' is modifying itself as she adopts the native accent (CL p.52).

So the journey is away from Imperialism and towards Republicanism – cause indeed for pride, cause for the emigrés to return. But with Julia dead and Bowsie gone across his Hellespont to meet the dead pride of materialism, what can we hope for in the future? Are we baptised and confirmed into nothing more than a cancelled dance at the fag-end of the year and are we all, and the nation with us, going the way of Faust?

We have seen that baptism features in relation to Timothy, and Bowsie's near drowning is also seen in that light by Silvanus:

You were in it, rolled in it, lost in it, found in it, and the tide left you, so you are a son of the sea. The Good God has rinsed you in it. (CL p.188)

Peter's Epistles uniquely connect baptism with the flood:

. . . when once the longsuffering of God waited in the days of Noah, while the ark was a preparing, wherein few, that is, eight souls were saved by water.
The like figure whereunto even baptism doth also now save us (I Peter III. 20-21)

And Timmy's escape is described as a rescue from 'death in the Deluge' (CL p.53). The Pride is referred to as though it were a tabernacle lined with pitch (CL p.149). It is a double image. A tabernacle is an ark, and Noah's ark was lined with pitch. But Yeats refers to iron tabernacles – coffins – preserving bodies beyond their time. The Pride is the tabernacle in which mankind survived through the first act of universal judgement, and it is also the tabernacle of the flesh we must be prepared to leave:

Yea, I think it meet, as long as I am in this tabernacle, to stir you up by putting you in remembrance;
Knowing that shortly I must put off this my tabernacle, even as our Lord Jesus Christ hath shewed me. (II Peter I. 13-14)

The weather has taken over and imposed a different kind of last rite; and that evening, instead of the dance, seven of the hotel's guests go out for a stroll and discourse on the subject of death. 'Seven just men' (CL p.273) is the minimum number required for a jury to give a majority verdict. Eventually they gather and sit on the ribs of an old boat half buried in the sand. This is an ark without much pride left in her, but they have the Judge, strolling about to captain her, and is she not, like the old imperialist lady, 'sinking in the sands of more democratic days'? Here, as near as we will ever get from Jack Yeats, is a vision of justice and judgement on that ultimate limit to the Faustian ambition – death. Adam and Eve never ate the fruit of the Tree of Life, and if they could forget the Knowledge of Good and Evil, Eden would be restored.

The knowledge of good and evil is administered in an imperial system by centralised laws. In Ireland's case those laws were passed often in England. In the USA they were both centralised in Federal Law and decentralised in State law – just as Moses was advised to do by his father-in-law. The Judge is American. But out in the West of Ireland (and of America), men were reluctant to become involved in Justice:

Already men, who knew they may be called on to build up a jury, are slipping away into the corners of the land. (CL p.202) . . . But when they are rounded up these same men will give the same great care to arrive at a true verdict between the body on the table and the world. (CL p.203)

Small Voice thinks that

justification should be kept on ice – in the hope that it may never be required. (CL p.224)

No Matter recalls the rough justice of former times in a mood almost of nostalgia:

Everyone expects a coroner to be a man to arrive with a rush and hustle about. But why should they? The dead can wait a little longer, and nowadays when amateur revenge is frowned down, there should be no great hurry on the relatives of the dead. Death may have come quickly, but even under the very chariot wheels the victim may see the shadow first, and at that moment, he is not, in his mind, clear about the measurements of time. There on his back in the road – on a cliff edge where time ceases and the endless, boundless looking-glass back of no time begins. (CL p.205)

This cliff-edge between land and sea, life and death, time and no time, relates to the figure of the Judge, whom we may imagine as the ultimate arbiter in these questions. It relates to him because his name is Grover Cleveland – cliffland. And we are told that he inhabits such country for, as quoted already,

He isn't jealous of the dead; he lives with them in the past. 'Without the bother of a body. . . ' (CL p.240)

In some ways, the dead begin to come among the living at the end of *The Charmed Life*. Mr. No Matter becomes Alexander and then Hector for the Judge only, taking on the name of the dead as well as yet again shifting out of an established identity:

This conversation between Hector and the Judge becomes a secret affair – a mist which dissolves into fragments . . . (CL p.237)

The two characters are isolated as archetypes by their names and by the curious sensation of an extra observer who is not 'I' and who dissolves back into Hector within the same paragraph. These narrative shifts are a deliberate part of the undermining of ego and fit well Jack Yeats's favourite hobby, that of being 'an eccentric incognito'.[7] Hector is a significant name to offer the Judge. Hector died a humiliating death protecting a society which itself was annihilated. Was Jack Yeats fearful of that for himself –

he, who had kept faith with the ideal, but, in 1937, feeling the end of hope approaching in the form of a fascist war? If this name is his way of making a confession to the Judge that he would never make to others under the proud name of Alexander ('strong', 'helper of others'), then the Judge has some comfort for him:

Well, we know that those people, the people of what they call the Heroic Age, didn't have the same discomfort about death that I have, and I'm not so very bad about it. We know they had the way of being here, and there. God bless us all and them also. . . I have no great sin on my conscience . . . My idea is that there must be an enormous mass of spirits like my own, since the world began, crowding the shores in every place, beyond the dancing floor. (CL pp.243-45)

His suggestion is that death is not going to bring a moment of final judgement but will be an entry into a new dimension. 'Hector' need not be too fearful of that. Nor need others fear the Judge, for judgement is the thing we have wrongly taken upon ourselves and in fact the Judge is therefore what we choose him to be:

'When we think of you, Judge, we are not counting heads. We are weighing, by a scales that weighs earth, air, water, feathers, lead.'
 'You are very good to me.'
 'Not at all, Judge, we are good to ourselves.'
.
'I myself, and you all, imagine the Judge. So that he is our own Judge, and then he, in return, imagines us.'
'Oh, begob, that's clear enough, and a better Judge I never saw. He loves us, and we love him.' (CL pp.273-4)

It is clear from this that there is not in the end going to be any kind of judgement enacted for us because no one is on trial, other than the seven themselves as they sit about waiting for the moon to rise. If they have knowledge of good and evil, they are not going to presume to make judgements on its basis:

'You mean thumbs down, Judge. Well, this back-cloth here, the darkness about us, has no thumbs down for us. By it we live, by it we die. Here we sit, in the shape of a ship, and what we say, and what we think are two different things. We live in the little light that rises from the colour of the sands, and in the darkness so deep about us. And our ideas and feelings cross about, and make a basket-work formed to hold us all. And then it lifts us, some wildness lifts us, and our basket rises, till the superfluous nonsense of our thoughts gushes away, through the opening in the basket-work, and we are lifted, like glittering fish, with feathered scales, for land, or sea, air, or nothingness.' (CL pp.278-9)

This image has parallels with *In Sand* where all that we have written between the tides is washed away. The scene here is also on the sea-shore and we are no more bound by our utterances than in the play. The basket is also a parallel to the ark with its old ribs sticking out of the sand. The suggestion is that by some mysterious transformation we will be able to leave behind the last of our human pride. Death will perform that transformation and, as in *The Amaranthers*, it is just across the border, only a step off the dance floor.

If there is one thing that is required of us it is not that we should prepare ourselves for judgement but that we should cease making judgements ourselves. The knowledge of good and evil is something we can at least try to forget, to let slip through the basket-work. The judge of the first contract in *The Charmed Life* promised to forget the crime confessed to him, just as the criminal promised to sin no more: the people of New Garden Street abandon their plan of retribution for one of their citizens who has murdered for a dollar (CL p.135): the people who might be called for jury service try to hide away. As for self-knowledge, Bowsie wishes to know no more about himself than he already knows: Thin Stern 'knows himself far more than most men know themselves, and he wishes he was better worth knowing' (CL p.167), and when it comes to other forms of knowledge they are not seen as desirable. The man who has never seen snow has no desire to (CL p.144): the man who went to Spain took Spanish lessons that led only to the saddest of discoveries (CL p.98).

The mood behind all this is that we have no need to seek out knowledge. It is all about us. It is in the blocked drain, the shower of rain, the cancelled dance, the red shoes. It is a seagull or a blackbird, according to our temperament. It is land or ocean and they are there to be felt and responded to. These are not things to be put in a balance and found wanting, and human nature should be part of them. They are what 'least resembles knowledge'. But they are things that we can truly know. The chance encounters by the wayside are an important part of this philosophy. People are accepted for what they are and are ready to reveal of themselves as we chance upon them. Most of us select our company and when we meet new people our first questions are usually designed to give us the kind of knowledge we think will allow us to make a judgement of them. 'Where do you live?' 'What do you do?' 'Where and what did you study?' 'Are you married, and do you have a family?' Yeats himself keeps clear of such information,

providing it, significantly, only for the Julia Starretts of this world, or for Timmy who is not yet old enough to voice his own credo.

Yeats is very artful in these chance encounters by the way. He has succeeded in making nearly all his critics believe them to be truly by chance in even the author's mind, and it is richly entertaining to notice that they have not been aware of their significance, because they do not resemble knowledge as they think of it. I cannot go into the details of each such encounter, but one particularly fine one is that of the Man who went to Spain. 'He does not seem to care anything for what may have happened in Spain of the last few years.' Considering that the Spanish Civil War had seen the triumph of fascism over socialism at the time this book was written and published, this reveals to us a person living in the past. But what his sad story tells us is that this is, for him, a tragic impossiblity. Curiosity took him there, and the beauty of a woman persuaded him to learn Spanish. He advertises for a teacher, and the teacher who comes is the young woman and he studies with her in her house. He notices her parents trying to conceal their tears and the next day he discovers why. The girl points to the words 'Queen' and 'daughter' to indicate that she is a princess and 'King' and 'son' and indicates that he is a prince whom she wants to marry. She, as were many of the Spanish royal house, is a lunatic.

In the context of their sojourn in the second of their Imperial Hotels, near which the tale is told, it is easy enough to see its significance for Bowsie and No Matter. A nation that tries to stick to its dynastic imperialism is bound to go mad. Spain had long since gone mad and, after a brief attempt at a new social order, had reverted to its old insanity, with support from most Irishmen and their church. The story, however, is told only to No Matter, and immediately after its teller slips away, Bowsie appears, dispirited, with an artificial rose, his leg hurting from an old bicycle accident:

'But the bicycle came and it was its own propulsion. The alibi of the body was within reach of all. But away with mechanical folly. I have the power of the alibi of the spirit, and that's the one that counts. But let us give the road the go-by. Here the Imperial door is on the jar, push it gently, with the finger-tips, not the elbow.' (CL p.102)

Whatever he says, Bowsie's 'alibi of the spirit' leads him back to the old Imperial; and the next day both hover around the town, reluctant to move on. When they do, Bowsie fixes the rose to a

furze bush to 'wave over the little young things of the wild'. The truth is that Bowsie is ageing and done for. The rose was begged by him from a young woman who gives it to him as to a dog a bone, 'back handed' (CL p.101). Hand it back he must, to 'the little young things of the wild'. He is too old for love and his love is too much of old things. No Matter recalls the days when 'full of skill' (CL p.107) the sea was no frontier to Bowsie. But we know later that it is, and he turns back. Spain came to a frontier and turned back also. The tale of the man who went to Spain should be a kind of prophecy for No Matter that the flesh will desert him; and a warning for Ireland not to turn back also. But what of those who do not turn back from the frontier, those seven on the sands: what prophecy are they vouchsafed as they wait for the rising of the moon, uncertain that it will even appear (CL p.273)?

The token of light in the darkness they face when confronted with death does appear. The moon rises and, in the words of St. Peter, once more:

We have also a more sure word of prophecy; whereunto ye do well that ye take heed, as unto a light that shineth in a dark place, until the day dawn, and the day star arise in your hearts. (II Peter I. 19)

The moon in scripture is associated with prophecy and it is symbolised by the pearl. As the moon rises and the company of seven moves off, one of them, with a gesture of charity, buys a tiny pearl from a boy who has been waiting all that time through the dark for them to come by so he may make a sale (CL p.287). It is Haggard Cheek (as it were one who knows suffering) who buys it; and it is Hound Voice who approves the sale. W.B. wrote in his last years a poem of that name; probably one that he showed to his brother:

The last few years . . . he would talk about everything that was interesting to him or tell me some new ballad he had made . . .[8]

The poem has a sense of a frightening apocalyptic vision, though it ends positively:

> We picked each other from afar and knew
> What hour of terror comes to test the soul,
> Some day we shall get up before the dawn
> And find our ancient hounds before the door,
> And wide awake know that the hunt is on;
> Stumbling upon the blood-dark track once more,
> Then stumbling to the kill beside the shore;

Then cleaning out and bandaging of wounds,
And chants of victory amid the encircling hounds.

Who knows which of the dioscuri of W.B. and Jack, Castor and
Pollux, first gave voice to that hound. But for Jack Yeats the
judgement of blood was not to be. There was a pearl of prophecy
on offer, and all that was wanted to acquire it was a little charity.

So, as was to be expected, there is no Faustian end to *The
Charmed Life*. The magic is in the moon, a token in a tattered sky,
maybe, but risen just the same, and nestling in the hands of a
little boy. And, if we are to trust Saint Peter, it is a sign of
redemption.

So rich is the interweaving of images in this novel that I have, in
spite of devoting the whole chapter to them, left out many. The
elements pervade it, the birds inhabit it, the people who come
and go all have a significance in it. There are seven companions in
the first town visited, just as there are seven at the end of the
novel. But I have no space to pursue these significances. There
are tales that are not interpolations but part of a well-organised
pattern of motion to and fro. Nora McGuinness has done
excellent work in drawing attention to these as part of an overall
structure that follows and enhances the underlying structure of
the journey westward (McGuinness pp.259-266).

As a brief instance: the man who has never seen snow places
himself deliberately between Bowsie and the sea; he tells a tale of
a boy who nearly suffocates in snow, prefiguring Bowsie's
near-drowning; he comes from the landward and goes landward
via a rabbit path. He is associated with animal life, and therefore
is interested in Bowsie. Snow represents for him more than
frozen water. It is the frozen spirit, frozen life from which the boy
is saved by human love (CL pp.143-4), and the tale relates to
Bowsie's encounter with Silvanus, whose loss of his legs is
caused by snow. Pervading this rich world of controlled
associations, there is ever and always the vibrancy of the
language, the sharpness of the observation and the humorous
delineation of character and situation.

Truly, this is a work of genius, as W.B. recognised; and in this
effort to bring out what has been so strangely missed in it, I am
myself humbled by having missed so much more. Meanwhile it
remains, like that which its author wished for himself, a kind of
eccentric incognito; and I can only hope that what I have done
will serve as sufficient stimulus for others to look more deeply
into the unlimited treasures of this great work.

12

Ah Well and *And to You Also*

Jack Yeats's last two novels are his shortest and both concern themselves with the subject of death. *Ah Well* was probably written between 1938 and 1940 (see Note on the Chronology) and shares with *The Charmed Life* an E-shaped town. E town in that novel was the scene of the winning bet which allowed Bowsie and No Matter to move on to the Pride, but in itself it was a static place. The town in *Ah Well* is static also, and the book ends with the narrator of the town's story, Old Dusty Brown, leaving it. In common with *The Charmed Life*, it has two characters, the artist and his companion Old Dusty Brown, who seem to have the same kind of relationship as Bowsie and No Matter. As with *The Charmed Life*, there is a group of men gathered at the end who are identified only by nicknames and whose identity is in any case not always clear, and the same is true of *And To You Also*, save that one of the characters is a woman.

But *Ah Well* is unlike any of the other novels in the overtly fabulous setting of E town and the extent to which attention is focussed upon it. There are many improbable settings in Yeats, but this is the only impossible one. It has two theatres called The Round and The Square, set in the outer prongs of the E: at the top, The Round Theatre with a fountain and yellow paved square; at the bottom the Square Theatre with a white sanded square. The spray from the fountain often reaches the sanded square and it falls 'on the malefactor as well as the honest citizen' (AW p.13). As in *The Charmed Life*, this town is not interested in passing judgement on people. It is a town

where no one ever spoke the truth but all thought it (AW p.12)

and when a murder is committed in its main street

There was nothing in the nature of an inquest . . . the revenging did not devolve on them. They forgot it all and stood by their brown river and they were pleased that it should be strong with heavy old showers. (AW p.31)

186

Even in plays with 'Plotting, murdering, virtue triumphant and villainy triumphant too' (AW p.28), the citizens

never spoke of their feelings about the plot, they never had any feelings about it. The play was a miniature event which happened inside a glass ball. (AW p.28)

When they punished their children they gave

first a gesture of punishment and then a gesture of apology. (AW p.18)

As for the government of the rest of the citizens:

No one ruled that town. Not the mayor, for all he had his golden chain. It ruled itself. He ruled himself, with the varied tone of the river. (AW p.18)

Their economy is also remarkable, for they produce no food themselves. Crops are grown by 'the unfortunate tillers of the soil' (AW p.21) beyond the hills; meat is brought in to them (AW p.23), and they survive on trade. They are in 'a rosy condition financially' because they export so much more than they import. But though it has its craftsmen, its cooper and its smith, we are never told what makes the money and in any case:

They neighed after the things they saw in the shop windows just when they didn't have any money. . . They loved owing. They thought it brought out all the real human virtues. (AW p.29)

The story is told to Jack Yeats himself, for Dusty Brown addresses the artist as 'Jack' (AW p.33). Dusty Brown sports a name that signifies penitence and death (dusty); and spiritual death, or the fear of it in the form of renunciation of the world (brown). He is Jack Yeats's 'unshatterable friend of clay' (AW p.5). He is a kind of Adam, or Everyman, formed from the dust. If he has sojourned for a while in E town, one might be excused for imagining it to be a kind of Eden. Nobody kills animals in it, nobody tills soil, it has a river running through it, and the fountain is to be found in the square of the Round Theatre. The Round, or circle, is the symbol of Eternity and its courtyard is paved with yellow stone: so the fountain is a fountain of life, like the Tree of Life and the stone is a firm foundation and, taking yellow in its positive symbolic use as an emblem of the sun and of divinity, its colour also symbolises eternity. But there is no equivalent for a Tree of Knowledge of Good and Evil in the courtyard of the Square Theatre, which is covered with white sand. The square is the emblem of the earth and earthly existence, used in painting as the nimbus of living persons, but

the sand (dust) of its material nature is white, for innocence. So, at any rate, they must think or wish, since this is a man-made town, an attempt at an earthly paradise, where money is easily had, the responsibility of land and animal husbandry is avoided, and the problem of Good and Evil is ignored, though it has malefactors and honest citizens.

It was a sinless place, a kind of fool's paradise. A sort of Tom Tiddler's ground.(AW p.22)

In *The Amaranthers*, Yeats writes of 'lovely women, sinless and therefore unrepentant' (As p.40); so whatever these people do – and man, woman and child they do some very odd things – we need expect no act of repentance from them. The E shape of their town may stand for Eire or for Ever or for Eden: but for any of these suggestions it is back-to-front. Taking this layout in conjunction with the absence of judgement among the people, and the absence of a Cain to till the soil and an Abel to keep flocks one has a very remarkable and fabulous invention. It is a would-be Eden in which the inhabitants are trying to eat of the Tree of Life, not of the Tree of Knowledge.

That does not mean that it is without Evil or unhappiness, only that it is without the desire or ability to *judge* between Good and Evil, joy and sorrow. The Bible never states that there was no evil in Eden. On the contrary, it makes it quite plain that, in the form of the snake, there *was*. The snake entwines himself round the Tree of Knowledge in many paintings, before Eve has tasted the fruit but:

Where there is Romance there is the grain, the seed of the charlock bui, the wild gold weed of a free sovereign people growing. It was in Mother Eve's Garden and when the snake came sliding he circled it. He knew his match, my friend. (AW p.7)

By 'circled' Yeats obviously does not mean entwined, but avoided. This town rules itself, so it is 'a free sovereign people growing'. The charlock bui is yellow like the sun and the paving stones. One might think from this that it is a town that Yeats would favour, and he seems to. Does not this town put the men of Darkness and Revenge, two pirate ships, into confusion? When Dusty Brown describes it as a 'God-damned town' he excuses himself on the next page, declaring he meant it affectionately (AW p.20). But he describes it as 'unctuous' a page further on, and the people are not growing (see below); and

drinking from the Fountain of Life (which in summer time they can only keep running for three days a week) does not make the people any happier than eating from the Tree of Knowledge has done for the rest of us:

Fun to him, as to most of the men of the town, and all the women, was just a faint rattle drum accompaniment to the rolling up and rolling down of the dark spectacle of being alive; for to all the grown people of the town, after they had had their morning's milk, the sky was wrapped and rolled in a blasting blue tragedy of night in day. (AW p.30)

There is a very good reason for this underlying tragedy and that is that the people in this town do not die naturally. Nor do they appear to be born, or to change age, though they are of all ages:

It was a town of people always in the prime of life. There were young children there, running and tumbling, hither and yon, and two asses, which gentle mothers had foaled a month before I got into the town. But all the time I was there, there were no births, and no deaths. It was curious there was a kind of stagnation in the trades, the people in the town themselves noted it. No deaths, no buryings. It was no loss to anyone, for queer enough there was no Undertaker in the town. (AW p.31)

Yeats does not state that there never were or will be births and deaths (there are suicides), because, like Dusty Brown, we are discovering the town, and so the author can only speak of what Dusty Brown knows. But he tells us the people notice the absence of birth and death, as though it were a condition that they were growing into, rather than had always been in. Dusty Brown, we might rightly guess, is going to have to leave it, because in the square which is his symbolic counterpart, there is no fountain, only a few drops when the wind blows from the sea. In the end, the Adam we know has no place in this Eden in reverse, this town in the shape of a reversed E. Nor does Eve. Dusty Brown actually asks after her when a woman by the fountain is about to tell him a wise woman's secret. Brown interrupts his tale to say to Jack:

There was a wise woman once. Keep that to yourself and don't forget it . . . Was her name by any manner of chance Eve? I said . . . 'No,' the fountainy woman said to me. 'She came from a different strain. She passed by Eve in a whirlwind and left her chewing her apple. (AW p.45)

This seems to confirm that the inhabitants of E-town do not share Eve's desire for the Knowledge of Good and Evil – so its women are 'sinless and therefore unrepentant'.

But what of the fountain that the townspeople drink from, symbolising eternal life and into which the fountainy woman nearly fell? Given the absence of birth and death, it may have some characteristics of the spring in *The Careless Flower*. In certain ways these seem to be careless people, not least when Dusty Brown saves 'a little man-child' who resists his help:

His idea of death wasn't the same as mine was . . . but he knew there was death and little children went into it as well . . . but in the river so strong with the sleep of death, it was the rolling . . . of the river which called him in to play . . . (AW p.39)

After his rescue, the boy struts off as though nothing had happened. Respect for life seems to be at a low ebb. An old man tells Dusty Brown that

'There's nothing in the death. They have us humbugged. Sure half the people in this town are dead . . . Do you know the Mayor? You do, well, there is a man alive, and he is living so that he may die, for he has to die.' (AW p.41)

The fountain does not seem to be doing him much good, or the young men either.

But every now and then it became something else and some sugar plum filled young bull man would walk down beyond the dark trees where there was a small cliff above a deep pool in the salt tide. He'd choose the full ebb, and shoot himself so that he'd fall in the waters and have his body rolled away. It was a kind of gentility with them to do that. (AW p.22)

Their fountain, perhaps, reflects their condition rather than stimulates it. Their life-force is fading. The fountain is cut off for four days a week in summer. It was artificial to begin with (unlike the stream in *The Careless Flower*) and as such it may represent a false ambition. For at least the length of Dusty Brown's stay, suicide is the inhabitants' only means of escaping 'the blasting blue tragedy of night in day'. We are told that this is how they see it, not how they have to see it:

It seemed so to them, while reason, if they had cared to use it, would have told them that on either hand the sky was in reality flat with serenity. (AW p.30)

The tragedy of their situation is made no better by the fact that

they knew always, awake or asleep, walking or sitting, leaning or springing up, that there was a happiness. (AW p.28)

Just as Adam and Eve invited Hell on Earth by eating of the Tree of Knowledge, so the inhabitants of E town have invited a different Hell on Earth by drinking from the Fountain of Life.

They had Hell and hate and evil desire and they nursed backbiting. They encouraged it in each other. They were dishonest in argument . . . They loved owing. They thought it brought out all the real human virtues. (AW p.29)
If they drew a dagger from a sheath it drank before it was stabled again. (AW p.36)

This reveals a society which it is not very difficult to recognise: a society which has little idea of what is a virtue or an evil but, having these things, nonetheless confuses them. It is in many ways very like a capitalist city. It exists only by trade, not by food production; unnatural death in the form of murder and suicide is a symptom of urban life: and backbiting, dishonesty and debt are also a part of it. The citizens of E-town may wish to forget all about the Knowledge of Good and Evil, but it seems they do so in a partial way. They go to plays about it and ignore their significances, and they think debt is a virtue.

The second half of *Ah Well* describes the day trip on horseback of seven citizens, plus Dusty Brown, to view the town from the cliffs above. The seven mostly have nicknames – Pigeon, The Turk, The Absolute, Pizarro and Carmine. The remaining two are Foley and Alec. I have been unable to make anything of these names that seems worth pursuing, but it is probable that they represent more than mere fancies, given the fairly consistent importance of names throughout Yeats's work. Temperaments or national types are possibilities. From the top of their climb they have a view away to the South. Pigeon sees it as a lonely country:

A man should be impervious to the false draggings on of hope, who would attempt to cross a waste like that. (AW p.67)

The Absolute sings a song of a sea journey, south, north, east, west, but the flowers he picked from his home headland are brought back and buried in the sand of it at the end, as though the trip had achieved nothing beyond the passing of time. One of their number is silenced forever by a derisive response to a suggestive remark, and their conversation begins to turn in upon themselves and finally settles to recollections of boyhood, all involving death. The last of these recollections is of the speaker as a morbid boy who keeps presenting flowers to his mother, who

says he should be giving them to a girl. The sterility of the boy's gesture, the inward-looking nature of it, reflects the journey of the flowers back to their headland, and, quite suddenly, they all catch hands and begin to sweep Dusty Brown with themselves towards the cliff-edge. When he prevents this rush to launch themselves into eternity:

The men looked at me without either blame or forgiveness. (AW p.85)

Even at such a moment they pass no judgement on the situation. It is a crucial turning point. Their journey has been East and they now return Westerly, following the sun. Dusty Brown

looked down by my horse's gentle side, and in the soft ground I saw, that symbol of my life a crescent on a crescent reversed and interlaced. (AW p.85)

The crescent is a symbol of growth and to have it facing both ways implies a waxing and waning, a coming and going, like the flowers in the song, like the tides of *In Sand*, to the brink of death and back. But Dusty Brown, the 'unshatterable man of clay', has prevented the breaking of that cycle. When he reaches the town, the fountain seems stronger than he has ever seen it, but the next day the Mayor had thrown himself off the same cliff-edge. His end could hardly be more unhappy:

He had been carried up to his room and laid on his bed, unmoving. His wife had looked in through the door at him, and she had laughed and said: 'He went at last'. He heard her. He vomited blood on the floor, and then he rose and walked down the stairs. By the stairs' foot his daughter stood. He turned his face to her and said 'It is your poor father', and she said nothing. He walked up the street, in the very middle of it, and turned up the hill road, and no one followed him but a little boy . . . (AW p.86)

The mayor's death by suicide is almost a kind of substitute for Dusty Brown's. The town's figurehead can no longer sustain his position, and Dusty Brown also leaves, but with his life intact. Dusty Brown's insistence on living brings about an 'end' to the town by exposing to itself its own cruelty. Even the children in that town had had the death-wish; and childhood memories link the seven others in their suicide pact: only Dusty Brown's childhood memory calls him back:

And I then saw myself a boy on a winter day . . . then all came clear into

my breast as action. There on the green slope I went down on my hunkers, on my heels. (AW p.84)

E-town is essentially a hopeless place. The people have learnt to lead an unreal existence, in many ways unworldly but with none of the virtues of hermeticism and many of the sorrows of isolation, symbolised by the appalling isolation of the Mayor and of the little boy who tries to follow, but cannot save, him. Because they will not move on they have brought death into life, like their 'blue tragedy of night in day' and there is no suggestion that suicide is somehow going to bring life into death. Their little Eden may be set for Ever, but man, Everyman, Adam, Dusty Brown, must keep travelling.

Age was creeping in on Yeats, and it creeps in on his characters, Old Dusty Brown being one of the oldest of them, and his companions on the ride all being elderly. Having turned back from a last judgement, he now turns away from the false security of man-made Edens. After the great explorations of the two central novels, there was hardly anywhere left for him to go.

<p style="text-align:center">* * *</p>

And To You Also reveals him at last in his own city. The basket of hope and despair which Hartigan, the flittering ghost of his father, had spoken of, is now his own body in a cold church at a funeral (ATYA p.97). The 'uprights, which are the good thoughts' (Si p.244) and that supported that company of seven at the end of *The Charmed Life* are letting in so much cold that perhaps we can believe that the weaving osiers of the bitter thoughts are fallen away and the memories can be finally jettisoned. But cold it is. The isolation of *Ah Well* has left a mark:

We have no friends, and all are our friends . . . I would like to talk to myself now a sad talking about old friends because we both imagined we had a friend (ATYA pp.97-98).

Even memory comes in for satirical observation as he offers a photograph album and an epidiascope show to pass the time 'with so much more time always coming in on everyone's sticky hands' (ATYA p.104). And suddenly, remembering a man who has stolen the money from his own children's money-box to put it on 'a certainty' and likening him to Adam, blowing his nose with his fingers, Yeats cries out

The knowledge of Good and Evil! without blasphemy, I hoped that
Christ had died that we might forget it. (ATYA p.107)

But he knew it couldn't be done. There had to be some kind of
reckoning between himself and his fellow man that did not lead
to the suicidal cruelty of *Ah Well*. So he gathers in his old friends,
friends of his own making, for a last conversation on neutral
ground. The setting is to be St. Stephen's Green. The oasis in the
heart of Dublin. No more little towns, fabulous journeys or
fortuitously planned encounters, but just one stranger, the park
keeper with his keys, who locks them in as they discourse
through the summer night, finally escaping at dawn over the
railings. The last pages of this novel are almost entirely
reminiscence. They are held together by the subject matter of
paintings and, eventually, death takes over, but they have the
character of something that defies description or analysis without
simply repeating what is there. In this gentle farewell to his
readers, Yeats gives them no more fables, no more significances.

The final colloquy of *And To You Also* is in part anonymous. But
in the manuscript Yeats does, now and again, assign names. In
particular he puts himself in with either his monogram or simply
as 'Me'. While it is not crucial to the ordinary reader to be able to
identify the characters with certainty, it is important for
commentators to do so, or refrain from assigning speeches.
When parts of the conversation were staged at The Peacock in
November 1971 a number of the speeches were wrongly
assigned, and there has also been confusion about the identity of
the narrator who is not the Squire but Jack Yeats himself (Purser
p.167). The characters (with their alternative names) are as
follows: The Artist (Jack Yeats, Me); Bowsie; The Baron (The Man
Without A Shirt); the Old Blade (Old Squire); the Actress (Lady,
Dame); the Good Boy; and the park keeper (the Lurker) who
contributes very little. Excluding the keeper, this leaves six
characters, and the novel refers to seating for five only (ATYA
p.160). Perhaps Yeats forgot to include himself as a candidate for
a seat: on one occasion in the manuscript, he puts what looks very
much like a question mark beside his own name, and the position
is not helped by a misprint on p.187. The line 'I think, man, you
worry yourself needlessly' should read 'I think, ma*m*, you worry
yourself needlessly'.

Does it really matter, then, who says what to whom? I doubt if
it mattered to Yeats. This was his last novel and he knew it. Its

primary purpose was to jettison memories (ATYA p.96) and it
lives up to that intention just as did his first novel. But, above all,
these were people of his own making, speaking for aspects of
himself. They required little differentiation when it was his own
mind only that was being emptied and when he could write
'Sometimes it comes on me that it would be better if . . . I should
not think of any listener' (ATYA p.127).

We, the almost un-called-for audience, are eavesdroppers in
this work. If we have a role in it, it approximates to that of the
park keeper with his keys to the gates of paradise – for a paradise
is a park. It is in our power perhaps to admit and to evict – maybe
even release – the author and his thoughts.

But no: we need not be fearful of our own power. Someone
claims to have copied the key on a piece of doughy bread (ATYA
p.157), and, besides, there is a ladder to get them over the railings
when no one is around to see. Kindly ever to the end, Yeats slips
away from his readers and out of bounds, leaving them with a
blessing and a farewell, strolling in the avenues of a small Dublin
Paradise, in the heart of the first martyr's Green.

Conclusion

You can plan events, but if they go according to your plan, they are
not events.
(Jack Yeats to John Berger, *The New Statesman*, 8.12.56).

Conclusions are foolish things. One begins a work with bold
assertions and it is enough that one does not justify half of them
without being obliged to admit it. They are especially foolish
when it comes to an author such as Jack Yeats. I have asserted
that he was much cleverer than has been supposed, and I hope I
have gone some way to demonstrating that: but since he was also
much cleverer than I am, I am in no position to come to final
judgements on the matter. There is, however, a little consolation
to be had for a Purser like myself, and it is provided by old
J.B.Yeats who maintained that the Pursers were not only 'the
most eminent' of a 'distinguished and intellectual aristocracy' but
that they were 'infallible critics'.[1] He was perhaps nearer the
truth in a letter to my great-grand-aunt Sarah Purser (Plate 7)
when he declared that:

The Pursers have self esteem and pessimism – and I have self esteem and
optimism – your fatuousness is much more interesting and
distinguished than my fatuousness.[2]

With such qualities at stake, who would wish to argue?

But I suppose any author of a book of analysis of another's
work, such as this book is, lays a claim upon that park keeper's
key in *And To You Also*. If so, it has become uncomfortable in my
palm and I, too, am looking for a ladder to make my escape
unnoticed over the railings. Perhaps, as Yeats himself says:

I promised too much and now I feel full of the deaths I longed for when
death was far away. (ATYA p.203)

Nonetheless, my enthusiasm for Jack Yeats remains
undiminished after ten years off and on: but I cannot expect that
to act as a recommendation to others until his novels and plays

196

are back in print, the former in new properly corrected and edited editions. There remains other basic research to be done: hunting out of letters, and the publication of 'LIVES' which would, I believe, be a fine thing to do, whether or no the mysteries of those strange sequences of drawings can be elucidated.

Yeats has also seemed to me a good companion over these years, but a tricky one; and the subtlety and complexity of his imagery frequently leave one having to be content with the sensation of little waves washing the sand away from under one's bare feet. It is a pleasureable sensation: and it is also nice to feel assured that the sad day, when all that is worth knowing about Jack Yeats is known, will never arrive. His was a fascinating and teasing mind which started up many hares; but he was a gentle man and would sooner have raised his hat to them as they disappeared over his horizon, than track them down: and though I have merely stood in the next field watching them race by, I hope I have started a few myself that will survive to enjoy their own freedom.

Manuscript Sources

The artist's papers, which I was kindly allowed to consult and photocopy extensively by his niece, Anne Yeats, contain manuscripts and typescripts of most of his literary works, besides much other relevant material. Anne Yeats also preserved the essentials of his library and his collections of ballads, playbills and newspaper cuttings. Even his folding cardboard boats survive. The bulk of this material is catalogued, and Jack Yeats's own catalogues of his paintings and his playgoing are preserved alongside complete runs of the *Broadsides* and *Broadsheets* which he contributed to and issued over many years. I therefore join the long list of persons who owe a deep sense of gratitude to Anne Yeats for her generosity and scholarly responsibility; and to her and Michael Yeats for permitting me to make use of the material. Without that background this book would be a shadow of itself.

I also owe particular thanks to Hilary Pyle for permitting me to rummage through all her papers for her seminal biography: and to others, listed in the ackowledgements, who have permitted me to make use of manuscript material, including letters and Christmas cards from Jack Yeats.

Other manuscript sources consulted are as follows:–

Trinity College Dublin Library
3777/123-31; 4424-6; 4630-49; 6225; 6238; 7847-51; 8105; and the Bodkin Papers 6913; 6946/1347-1448.

National Library of Ireland
4595; 7935; 10210; 10478; 12160; 13267; 13269; 15113; 15569; 15588;15781-2; 16222; 21132; 22563; 22627; 24268; P7529; P7544-8.

University College Dublin Library
The Curran Papers

National Gallery of Ireland Library
Envelope W13

University of Reading Library
Ms.392

Bodleian Library, Oxford
Ms. Eng.lett.c.255; Ms.Eng.poet.d.194

University of London Library
Masefield/Yeats correspondence

University of Kansas, Kenneth Spencer Research Library
Ms.25.Ja.1-8

University of Victoria, MacPherson Library
Designs for plays

University at Carbondale, Southern Illinois, Morris Library
Coll.55; VFM47; VFM1282

BBC Script Library, Drama Library and Sound Archives
Edited script of *In Sand* for radio production. See also Purser
pp.177-186

Bibliography

PLAYS AND NOVELS BY JACK B. YEATS

Plays for the Miniature Theatre *P. 1 says there are 9 + 7 respectively*

Timothy Coombewest or Esmeralda Grande
London & New York: Secker & Warburg, 1971

James Flaunty or The Terror of the Western Seas
London: Elkin Mathews 1901
London & New York: Secker & Warburg, 1971

Onct More's First Circus
London & New York: Secker & Warburg, 1971

The Treasure of the Garden
London: Elkin Mathews 1903
London & New York: Secker & Warburg, 1971

The Scourge of the Gulph or Fierce Revenge
London: Elkin Mathews 1903
New York: The Viking Press 1929
London & New York: Secker & Warburg, 1971

*The Wonderful Travellers or The Gamesome Princes and
The Pursuing Policeman*
London & New York: Secker & Warburg, 1971

Plays for the Larger Theatre *9 listed*

1 *The Deathly Terrace*
London & New York: Secker & Warburg, 1971

2, 3, 4 *Apparitions (Apparitions, The Old Sea Road, Rattle)*
London: Jonathan Cape 1933
London & New York: Secker & Warburg, 1971

5 *The Silencer*
London & New York: Secker & Warburg, 1971

200

6 *Harlequin's Positions*
London & New York: Secker & Warburg, 1971

7 *La La Noo*
Dublin Cuala Press 1943
London & New York: Secker & Warburg, 1971

8 9 *The Green Wave* and *In Sand*
Dublin: Dolmen Press 1964
London & New York: Secker & Warburg, 1971

Novels

1 *Sligo*
London: Wishart and Company 1930

2 *Sailing Sailing Swiftly*
London: Putnam 1933

3 *The Careless Flower*
London: Pilot Press 1947
Parts of *The Careless Flower* were published in *The Bell* I No.1: *The New Alliance* I No.4 & No.5: II No.1 & No.3 & No.5: III No.3 & No.6: V No.1: *Dublin Magazine* XV No.4: XVII No.1.

4 *The Amaranthers*
London & Toronto: Heinemann, 1936

5 *The Charmed Life* — a novel ?
London: Routledge & Kegan Paul, 1938
London: Routledge & Kegan Paul, 1974

6 *Ah Well*
London: Routledge & Kegan Paul, 1942
London: Routledge & Kegan Paul, 1974
Parts of *Ah Well* were published in *The Bell* I No.4 & No.5.

7 *And To You Also*
London: Routledge & Kegan Paul, 1944
London: Routledge & Kegan Paul, 1974

Books for Children

The Bosun and the Bob-Tail'd Comet
London: Elkin Mathews, 1904

A Little Fleet
London: Elkin Mathews, 1909

Miscellaneous

A Broadsheet
London: Elkin Mathews, 1902-3

A Broadside
Dundrum: Dun Emer Press, 1908
Dundrum: Cuala Press, 1908-15

Life In The West Of Ireland
Dublin & London: Maunsel, 1912

Modern Aspects of Irish Art
Dublin Cumann Leigheacht an Phobail 1922
(See Periodicals – *Ireland and Painting*)

Articles in Periodicals and Newspapers

'A Cycle Drama', *The Success* (Special Edition for Ireland),
7.9.1895

'The Great White Elk', *Boy's Own Paper* Christmas Number, 1895

'On the Stones', *Manchester Guardian* .28.1.1905

'Racing Donkeys' *Manchester Guardian*, 26.8.1905

'Sea Life in Nelson's Time' *(Review)*,
Manchester Guardian, 25.9.1905

'Shove Halfpenny', *Manchester Guardian*, 4.10.1905

'Life in Manchester': The Melodrama Audience',
Manchester Guardian, 9.12.1905

'A Canal Flat', *Manchester Guardian*, 31.3.1906

'The Jumpers', *Manchester Guardian*, 7.4.1906

'An Old Ale House', *Manchester Guardian*, 14.4.1906

'The Concert-House', *Manchester Guardian*, 21.4.1906

'The Glove Contest', *Manchester Guardian*, 5.5.1906
'The Cattle Market', *Manchester Guardian*, 19.5.1906

'The Flat Iron', *Manchester Guardian*, 26.5.1906

'A Letter About J.M.Synge', *Evening Sun* (New York) 20.7.1909
Reprinted in J.M.Synge *Collected Works* London: OUP, 1966

'With Synge In Connemara' *in W.B. Yeats, Synge and the Ireland of his Time* Dundrum: Cuala Press 1911 (almost identical with the above)

'How Jack B.Yeats Produced his Plays for the Miniature Stage by the Master Himself', *The Mask* (Florence) July 1912
Reprinted in *The Collected Plays of Jack B. Yeats*, ed. Skelton, London: Secker & Warburg, 1971

'A Theatre for Everyman', *The Music Review*, Autumn 1912

'My Miniature Theatre', in *The Collected Plays of Jack. B. Yeats*, ed. Skelton, London: Secker & Warburg, 1971

'Ireland and Painting', Parts 1 & 2, *Ar n-Eire: New Ireland*, 18 & 25.2.1922

'A Symposium on a Design from San Gallo', *The Mask* (Florence) Oct 1925

'When I Was In Manchester', *Manchester Guardian*, 2.1.1932

'A Cold Winter and a Hot Summer in Ireland', *The Stork*, IV, 14 March 1933, London: Putnam.

'Beach Made Models', *The London Mercury*, XXXIV, September, 203 1936, pp.425-7.

'Indigo Height', *The New Statesman and The Nation*, XII, 5.12.1936 pp.899-900.

'A Painter's Life', *The Listener*, XX, 1.9.1937 pp.454-5.

'The Too Early Bathers', *The New Alliance*, I, 2, April 1940, pp.3-4.

'A Fast Trotting Mare', *Commentary: The Magazine of the Picture Club*, I, 2, December 1941, pp.5,7,8.

'Irish Authors: Jack B. Yeats', *Eason's Bulletin*, IV, 5, October 1948 p.3.

'The Loveliest Thing I Have Seen', *The Bell*, I, 2, November 1940 pp.40-43.
'The Rock Breakers', *Unidentified and undated newspaper cutting in the artist's papers.*

Poetry: Signed and unsigned

'A 1,000 Miles To Rosses', *A Broadsheet*, April 1902.

'The Travelling Circus', *A Broadside*, June 1908.

'The Adventurer's Oaths' from the cardboard 'Drama of Esmeralda Grande', *A Broadside*, April 1911.

Poetry: Pseudonymous

'Bring wine, and oil, and barley cakes', *A Broadside*, September 1908

'A Pleasant New Comfortable Ballad Upon the Death of Mr. Israel Hands, Executed for Piracy. To the Tune of "I wail in woe." ' *A Broadside*, September 1908.

'Theodore to his Grandson', *A Broadside*, January 1909.

'A Young Man's Fancy', *A Broadside*, June 1910.

'O Irlanda, Irlanda', *A Broadside*, September 1911.

'Die We Must', *A Broadside*, May 1912.

'The Gara River', *A Broadside*, August 1913.

'Dustbins', *The Irish Times*, 8.5.1931.

Jack Yeats also contributed to Punch under the signature W.Bird in 1896 and from 1910-1948, providing captions and drawings.

Criticism

Publications about Jack Yeats, including reviews of paintings significant for his writing, or not listed in Pyle's bibliography to which the reader is referred for full details of other reviews and of Jack Yeats' work as an illustrator.

Jack B. Yeats, His Pictorial and Dramatic Art, by Ernest Marriott, London: Elkin Mathews, 1911.

Jack B. Yeats', by Thomas MacGreevy, Dublin: Victor Waddington Publications, June 1945.

Jack Yeats', by T.G.Rosenthal, in *The Masters* 40, London: Knowledge Publications, 1966.

Jack B. Yeats. Painter of Life in the West of Ireland. Ph.D. dissertation by Martha Bell Caldwell, Indiana 1970. Order 4648-A.

Jack B. Yeats: A Biography', by Hilary Pyle, London: Routledge & Kegan Paul, 1970.

Jack B. Yeats Drawings and Paintings', Centenary Exhibition Catalogue, Dublin: National Gallery of Ireland, 1971.

Jack B. Yeats A Centenary Gathering', edited by Roger McHugh, Dublin: Dolmen Press, 1971.

Jack B. Yeats: Painter and Poet', by Marilyn Gaddis Rose, European University papers Series XVIII, 3. Berne 1972.

The Creative Universe of Jack B. Yeats. Ph.D. by Nora McGuinness, University of California, 1984. Order DA 8507315.

Jack B. Yeats In The National Gallery of Ireland by Hilary Pyle, Dublin: National Gallery of Ireland, 1986.

Articles and Reviews in Periodicals, etcetera.

'Poster Recruits No VII. Jack B. Yeats', *The Poster*, (London), April and August 1900.

'An Artist of Gaelic Ireland', *by A.E. The Freeman's Journal*, 23.10.1901.

'At 9, Merrion Row', *by A.Gregory, The Leader*, 2.11.1901.

'Mr. Jack B.Yeats's Pictures', *by Spectator, The Leader*, 30.8.1902.

'Sketches of Life',', *by Robert Elliott, The Leader*, 5.9.1903.

'Jack B. Yeats',', *by A.E. The Booklover's Magazine*, (Edinburgh), 1908-9.

'Jack B. Yeats Pictorial and Dramatic Artist', by Ernest Marriott, *Manchester Quarterly*, July 1911.
A review of the above in *The Mask* (Florence) V, 1, July 1912.

'Captain Jack B. Yeats: A Pirate of the Old School', by Allen Carric, *The Mask* (Florence) V, 1, July 1912.

'Mr. Jack B. Yeats and the Poets of "A Broadside" ', by Eugene Mason, *Today*, October 1917.

'The Education of Jack B. Yeats', by J.B.Yeats, *The Christian Science Monitor*, 2.11.1920.

'A Talk With Jack B. Yeats', by Trevor Allen, *The Westminster Gazette*, 21.12.1921.

'Mr. Jack B. Yeats', by John Masefield, *The Dublin Magazine*, I, 1, August 1923.

'Pictures of Life In The West of Ireland', by Y.O. (= A.E.) *The Irish Statesman*, 5.4.1924.

'The Pictures of Jack B. Yeats', by Y.O. (= A.E.) *The Irish Statesman*, 17.10.1925.

'A Notable Exhibition', by Y.O. (= A.E.) *The Irish Statesman*, 5.3.1927.

'Paintings by Jack B. Yeats at the Engineers' Hall', by Y.O. (= A.E.) *The Irish Statesman*, 5.10.1929.
 Reviews of *Sligo* in the artist's papers, including
The New Statesman, 21.6.1930.
The Times Literary Supplement, 10.7.1930.

 Reviews of *Apparitions* and *Sailing Sailing Swiftly* in the artist's papers, including
The Sydney Morning Herald, 23.9.33
The Times Literary Supplement, 22.6.1933.
The Listener, 19.7.1933
The Spectator 26.5.1933.
The Observer, 7,5,1933.
The Manchester Guardian, 2.6.1933.

 Reviews of *The Amaranthers*, in the artist's papers, including
The Times Literary Supplement, 4.4.1936.
The Dublin Magazine (by Samuel Beckett) Vol XI No 3 July-September 1936.
The Spectator, 31.7.1936

'On The Boiler', by W.B.Yeats, Dublin: Cuala Press, 1938.p.36.

 Reviews of *The Charmed Life* in the artist's papers, including
The Times Literary Supplement, 5.3.1938.
The Spectator, 11.2.1938.
The Observer, 6.2.1938.

 Reviews and letter on *Harlequin's Positions* in the artist's papers, including
The Leader, 24.6.1939.
Dublin Evening Mail, 6.6.1939.
The Irish Times, 6.6.1939.

'Jack B. Yeats', by Sean O'Faolain, *The Bell (Dublin)*, I, 4, January 1941.

'Jack B. Yeats R.H.A.', by C.P.Curran, *Studies*, XXX, 117, March 1941.

'Jack Yeats', by Kenneth Clark, *Horizon*, V, 25, January 1942.

'Nicholson and Yeats at the National Gallery', by Herbert Read, *The Listener*, 8.1.1942.

'Three Historical Paintings by Jack B. Yeats', by Thomas MacGreevy, *The Capuchin Annual*, 1942.

'Art', by John Piper, *The Spectator*. 9.1.1942, p.35.

Reviews of *Ah Well* in the artist's papers, including
The Times Literary Supplement, 7.11.1942.
Dublin Opinion, December 1942.
The Dublin Magazine, January-March, 1943.
The Bell, February, 1943.
The Irish Times, 4.3.1943.

Reviews of *La La Noo* in the artist's papers, including
The Irish Independent, 4.5.1942.
The Irish Press, 24.3.1943.
The New Alliance, April-May, 1943.
The Times Literary Supplement, 3.4.1943.

Reviews of *And To You Also*, in the artist's papers, including
The Times Literary Supplement, 21.10.1944.
The Listener, 9.11.1944.
The Observer, 19.11.1944.
The Dublin Magazine, January-March, 1945.
The Manchester Guardian, 1.12.1944.

'Jack B.Yeats – His Books', by Eileen MacCarvill, in *The Dublin Magazine*, XX, 3, July-September 1945, pp.47-52.

'Introduction', by Ernie O'Malley to the catalogue of the Jack Yeats exhibition in the National College of Art, Dublin, June-July, 1945.

'Jack B. Yeats', by Edward Sheehy, *The Dublin Magazine*, XX, 3, July-September 1945.

'The Yeats Exhibition', by C.P.Curran, *Capuchin Annual*, 1945-6.
Reviews by James White in *The Standard*, 9.3.45; 15.6.45; 30.10.46; 3.10.47; 10.10.47; 14.11.47; 11.10.51; 8.10.53.

'Visits to Jack Yeats', by John Rothenstein, *The New English Review*, XIII, 1, July 1946.

Reviews of *The Careless Flower*, in the artist's papers, including *The Times Literary Supplement*, 15.11.1947.
Punch, 19.11.1947.
The Irish Press, 4.10 or 12 1947.

Reviews of *In Sand*, in the artist's papers, including
The Irish Independent, 20.4.1949
The Irish Press, 20.4.1949.
The Evening Mail. 20.4.1949.
The Leader, 4.6.1949.
The Christian Science Monitor, 7.5.1949.
The Irish Times, 20.4.1949.
Social and Personal (Dublin), May 1949.

'Jack B. Yeats: An Appreciation', by Daniel Shields, *Irish Monthly*, December, 1949.

'Jack B. Yeats', by J.S.P. introduction for the 1st Retrospective American Exhibition at the Institute of Contemporary Art, Boston, 1952.

'Dublin's Dean', *Time*, 9.6.1952.

'Exposition Jack B. Yeats Peintures', Introductions by Jean Cassou, Paul Fierens, Thomas MacGreevy, Galerie Beaux-Arts, Paris 1954.

'Hommage a Jack B. Yeats', by Samuel Beckett, Pierre Schneider, Jacques Putman, *Les Lettres Nouvelles*, April 1954.

'Drama, Shadow and Substance', *The Listener*, 22.3.1956.

'The Arts and Entertainment', Jack Yeats, by John Berger, *The New Statesman and Nation*, 8.12.1956.

A History of Punch by R.G.G. Price, pp.209-210, London, 1957.

Obituary by G.H.G., *The Irish Times*, 29.3.1957.

Obituary, *The Times*, 29.3.1957.

Obituary, *The Irish Press*, 29.3.1957.

'An Irishman's Diary', *The Irish Times*, 30.3.1957.

'Mr. Jack B. Yeats, A Great Irishman', by E.Musgrave, *The Times*, 5.4?1957.

'Memories of Coole 2: Poets and Sportsmen', by Arnold Harvey, *The Irish Times*, 24.11.1959.

'The Genius of the Irish Theater', Edited Barnet, Berman, & Burto. New York: New American Library, 1960.

'Preface' to *In Sand*, by Jack MacGowran, Dublin: Dolmen Press, 1964.pp.5-7.

' "Unarrangeable Reality:" The Paintings and Writings of Jack B. Yeats', by Robin Skelton in *The World of W.B.Yeats: Essays in Perspective*, Dublin: Dolmen Press, 1965 pp.254-265.

'After The Irish Renaissance by Robert Hogan, London: MacMillan, 1968, pp.43-44.

'Beckett as Literary Journalist and Social Critic', by L.E. Harvey in *Samuel Beckett Poet and Critic*, Princeton, N.J.: Princeton University Press, 1970, pp.414-419.

'Readings of Yeats' Work at Peacock', by Seamus Kelly, *The Irish Times*, 23.11.1971.

'Jack B. Yeats in New York', by Hilton Kramer, *The Irish Times*, 23.11.1971.

'The Lifelong Scholar of Sligo', review in *The Times Literary Supplement*, 31.12.1971.

'Themes and Attitudes in the Later Drama of Jack B. Yeats', by Robin Skelton, in *Yeats Studies*, 2, Irish University Press, Bealtaine 1972, pp.100-120.

'Sub Rosa: The Writing of Jack B.Yeats', by Marilyn Gaddis Rose, *Eire-Ireland*, (St. Paul Minnesota), III, Summer 1968, pp.37-47.

'Solitary Companions in Beckett and Jack B. Yeats', by Marilyn Gaddis Rose, *Eire-Ireland*, (St. Paul Minnesota), IV, Summer 1969, pp.66-80.

'The Kindred Vistas of W.B. and Jack B. Yeats', by Marilyn Gaddis Rose, *Eire-Ireland*, (St. Paul Minnesota), Spring 1970, pp.67-79.

'Romantic Modernist', review by Ulick O'Connor, *The Irish Press*, 16.5.1970.

'The Other Yeats', by Frederick Laws, review in *The Daily Telegraph*, 21.5.1970.

'Jack B. Yeats 1871-1957', by Roger McHugh in *Ireland of the Welcomes*, XX, 2, July-August 1971, pp.16-34.

'The Other Yeat', by Katherine Anderson, in *The Word*, August 1971. pp.10-15.

'Jack B.Yeats: Irish Rebel in Modern Art', by Marilyn Gaddis Rose, in *Eire-Ireland*, (St.Paul Minnesota), VII, 2, pp.95-105.

'Tea With Jack B. Yeats 1940', by Stephen Rynne, *Eire-Ireland*, (St. Paul, Minnesota), VII, 2, 1972, pp.106-109.

'Jack B. Yeats: Some Comments on his Books', by James Mays, *Irish University Review*, II, 1, 1972, pp.34-54.

'The Sterne Ways of Beckett and Jack B. Yeats', by Marilyn Gaddis Rose, *Irish University Review*, II, 2, 1972, pp.164-171.

'Review of Yeats Studies', by T.R. Henn, *The Review of English Studies*, 1972, pp.513-516.

'Brother of the Poet Yeats', review by Herbert A. Kenny in *The Boston Globe*, 17.3.72, p.56.

'Jack Yeats the Novelist', review by Dennis Johnston in *The Irish Times*, 14.9.1974.

'Nudity and Nakedness: Jack B. Yeats and Robert Graves', by Patrick Murphy, *Eire-Ireland*, (St. Paul Minnesota), X, 2, 1975, pp.119-123.

'Jack Yeats: Ringmaster', by Joseph F.Connelly, *Eire-Ireland*, Winter, (St. Paul, Minnesota), X, 2, pp.136-141.

'Men of Destiny – Jack B. and W.B.Yeats: The background and the Symbols', by Hilary Pyle in *Studies, An Irish Quarterly Review*, Summer/Autumn 1977, pp.188-213.

'Beckett/Beckett', by Vivien Mercier New York: Oxford University Press, 1977, pp.24-25.

'Macmillan Dictionary of Irish Literature', ed Hogan, entry by Nora McGuinness on Jack Yeats, pp.696-699.

'The Living Ginger: Jack B.Yeats's "The Charmed Life"', by John Pilling, in *Journal of Beckett Studies*, 1978, pp.55.-65.

'The Other Yeats', by Terence de Vere White in *The Irish Times* Colour Supplements, May 1981, pp.38-41.

'School of Sligo', review by Nigel Andrew in *The Listener*, 12.7.1984.

Biographical Background

Letters, Autobiography and Interview

Passages from the Letters of John Butler Yeats: Selected by Ezra Pound, Dundrum: Cuala Press, 1917.

'A Talk With John Butler Yeats About his Son, William Butler Yeats', by Marguerite Wilkinson, in *The Touchstone*, VI, 1, October 1919.

'Further Letters of John Butler Yeats: Selected by Lennox Robinson, Dundrum: Cuala Press, 1920.

'Early Memories; Some Chapters of Autobiography', by John Butler Yeats, Dundrum: Cuala Press, 1923.

'Tea With Jack B. Yeats 1940', by Stephen Rynne *Eire-Ireland*, (St. Paul, Minnesota), VII, 2.

J.B.Yeats Letters to His Son W.B.Yeats and Others 1869-1922. Edited with a memoir by Joseph Hone and a Preface by Oliver Elton, London: Faber & Faber, 1944.

'Reveries over Childhood and Youth (‚with accompanying plates) by W.B.Yeats, Dundrum: Cuala Press, 1915.

Four Years, by William Butler Yeats, Dundrum: Cuala Press, 1921.

Dramatis Personae, by William Butler Yeats, Dublin: Cuala Press, 1935.

The Letters of W.B.Yeats, ed. Allan Wade, London: Rupert Hart-Davis, 1954.

Autobiographies by W.B.Yeats, London: Macmillan, 1966.

Memoirs by W.B.Yeats edited by Denis Donoghue, New York: Macmillan, 1972.

Works by W.B.Yeats

The Secret Rose, London, Lawrence & Bullen, 1907.

On The Boiler, Dublin: Cuala Press, 1938.

Collected Poems, London: Macmillan, 1950.

The Collected Plays, London: Macmillan, 1953.

A Vision, London: Macmillan, 1961.

Selected Criticism, edited by A.N.Jeffares, London: Macmillan, 1964.

Biographies of Yeats Family

W.B.Yeats 1865-1939 by Joseph Hone, London: Macmillan 1962.

W.B.Yeats; Man and Poet, by A.N. Jeffares,

The Yeats Family and the Pollexfens of Sligo, by William M. Murphy, Dublin: Dolmen Press, 1971.

Prodigal Father, by William M. Murphy, Ithaca and London: Cornell University Press, 1979.

John Butler Yeats and the Irish Renaissance, by James White, Dublin: Dolmen Press, 1972.

W.B. Yeats. A New Biography, by A.Norman Jeffares, London: Hutchinson, 1988.

Articles, and Books with Passages of Biographical Interest
The Journals, Isabella Augusta (Lady) Gregory, Edited by Daniel J.Murphy. Gerrards Cross: Colin Smythe, 1978, 1987.

The Dublin of Only Yesterday, by P.L.Dickinson, London: Methuen 1929.

Men and Memories, by William Rothenstein, London: Faber & Faber, 1931, p.254.

A Fretful Midge, by Terence de Vere White, London: Routledge & Kegan Paul, 1957, pp.111-121.

Today We Will Only Gossip, by Beatrice Lady Glenavy, London: Constable, 1964.pp.30,90,122,131-2,180,182.

Daughters Of Erin, by Elizabeth Coxhead, London: Secker & Warburg, 1965; Gerrards Cross: Colin Smythe, 1979, pp.134-5.

The Strings Are False, by Louis MacNeice, London: Faber & Faber, 1965, pp.213-214.

As I Was Going Down Sackville Street, by Oliver St. John Gogarty, London: Sphere Books 1968.

The Man From New York, John Quinn, by B.L. Reid, New York: Oxford University Press, 1968

The Dun Emer Press, Later The Cuala Press, by Liam Miller, Dublin; Dolmen Press, 1973, Preface by Michael B. Yeats, p.7.

'Jack Yeats', by Anne Yeats in *Yeats Studies* 2. Bealtaine 1972, pp.1-5.

'Synge and Some Companions, with a Note Concerning a Walk Through Connemara with Jack Yeats', by Ann Saddlemyer, in *Yeats Studies* 2. Bealtaine 1972. pp.18-34.

Jack Yeats and His Publisher, by Patricia Hutchins in *Yeats Studies* 2 Bealtaine 1972, pp.121-126.

General

Irishmen All, by G.A.Birmingham, London: T.N.Foulis, 1913. (Illustrated by Jack B. Yeats).

Irish Fairy Tales, edited by W.B.Yeats, Illustrated by Jack B. Yeats, London and Leipsic: T. Fisher and Unwin,.

A Mainsail Haul, by John Masefield, London: Elkin Mathews, 1918.

On Another Man's Wound, by Ernie O'Malley, London: Anvil Books, 1979.

An Experiment With Time, by J.W.Dunne, London: Faber & Faber, 1934.

The Worker, Dublin 12.9.36; 19.9.36; 17.10.36; 31.10.36.

Other works referred to will be found in the Chapter Notes which follow.

A wide variety of ballad publications was consulted, as well as various histories of Ireland and collections of Irish myths and legends.

For a Bibliography of Yeats's illustrations, see Pyle.

Notes

Apart from those abbreviations used throughout this book, the following are used in these notes:

NLI National Library of Ireland
NYPL New York Public Library
TCD Trinity College, Dublin

Introduction

1. Victor Waddington, in answer to a questionnaire from John Purser.
2. Jack Yeats and Synge toured the Congested Districts for *The Manchester Guardian*. The relationship is covered in Pyle, and thoroughly developed by Ann Saddlemyer in 'Synge and some Companions, with a Note Concerning a Walk through Connemara with Jack Yeats', in *Yeats Studies*, 2, Bealtaine, 1972, pp. 18–34.
3. WBY, *Letters*, ed. Allan Wade, London: Rupert Hart-Davis, 1954, p. 764.
4. WBY, *On the Boiler*, Dundrum: Cuala Press, 1938, p. 36.
5. Samuel Beckett, 'An Imaginative Work!', review of *The Amaranthers* in *The Dublin Magazine*, XI, 3 (July-September 1936), pp. 80–81.

Chapter 1: Life and Style

1. To Cyril Clemens, in answer to a questionnaire. TCD Ms 6238/1.
2. Anne Yeats, 'Jack Yeats', in *Yeats Studies*, 2, pp. 2–3.
3. Murphy, p. 566, n. 94.
4. To Lollie, 1883, NLI Microfilm P7545.
5. To Lily, 16 June, possibly 1884, judging from handwriting and the position of the letter among the others.
6. AE, 'Jack B. Yeats', in *The Book-Lover's Magazine* (Edinburgh), 1908–09, pp. 131–38.

7. Joseph Hone, *W. B. Yeats: 1865–1939*, London: Macmillan, 2nd ed. 1962, p. 37. Also JBY to Jack Yeats, 19 August 1916 (papers in possession of Mrs. Bodkin, no. XLIV).

8. Jack Yeats diary for 1889, Monday 28 October, NLI P7547.

9. To Hone, 9 October 1941, Kenneth Spencer Research Library, University of Kansas, Ms 25.

10. Letter from Alfred Pollexfen to Cottie Yeats, 7 November 1915, in the artist's papers; and from Jack Yeats to J. S. Starkey, 3 December 1915, as 1:9.

11. To J. S. Starkey, 17 June 1916, as 1:9.

12. To Quinn, 22 August 1917, from a transcript made by Hilary Pyle, from the NYPL.

13. To Quinn, 12 September 1918, as 1:12.

14. To Quinn, 16 September 1907, as 1:9.

15. Trevor Allen, 'A Talk with Jack Yeats', in *Westminster Gazette*, 21 December 1921.

16. Hilary Pyle, 'Men of Destiny – Jack B. and W. B. Yeats: The Background and the Symbols', in *Studies: An Irish Quarterly Review* (Dublin), Summer-Autumn, 1977, p. 204.

17. P. L. Dickinson, *The Dublin of Only Yesterday*, London: Methuen, 1929, pp. 65–66.

18. Lady Gregory, *The Journals*, 1, ed. Daniel J. Murphy, Gerrards Cross: Colin Smythe, 1978, pp. 486, 489, 470.

19. E.g. *The Worker*, and miscellaneous cuttings in the artist's papers.

20. To Hone, 19 October 1925, as 1:9.

21. To MacGreevy, 29 (23?) October 1932, TCD Ms 8105.

22. To Hone, 11 May 1925, as 1:9.

23. To Hone, 5 April 1926, as 1:9.

24. Jack B. Yeats, *Modern Aspects of Irish Art*, Dublin: Cumann Leighacht an Phobail, 1922, p. 4.

25. To MacGreevy, 30 November 1938, as 1:21.

26. To Curran, 19 December 1943, UCD, Curran papers.

27. Hilary Pyle's papers, not used in her published work.

28. To Cyril Clemens, see 1:1.

29. Quoted by 'Chanticleer' in an unidentified newspaper.

30. William M. Murphy, *The Yeats Family and the Pollexfens of Sligo*, Dublin: Dolmen Press, 1971, pp. 38–40.

31. Ibid. p. 45.

32. To Hone, 5 March 1943, NLI Ms 15782.

33. Dr. H. Purser in conversation with John Purser.

34. Unidentified review in the artist's papers, signed by L.P. Hartley and dated 1936 by Jack Yeats.

35. WBY to Robert Bridges, July 1915.
36. To Sybil Le Brocquy, 22 July 1944, courtesy of Louis Le Brocquy.
37. To J.C. Miles, private collection.
38. Dustjacket of 1933 edition of *Apparitions*.
39. To Ria Mooney, 26 April 1949, from a typescript abstract of this correspondence, source unknown.
40. To Ria Mooney or Eric Gorman, 19 September 1938. As n.39.
41. The artist's papers.
42. To Ria Mooney, 11 November 1948. As n.39.
43. To Sybil Le Brocquy, 25 July 1944. As n.36.
44. To Ria Mooney, 24 April 1949. As n.39.
45. Anne Yeats in conversation with John Purser.
46. To James Starkey, 24 May 1940, TCD Ms. 4635–49.
47. To Sarah Purser, 23 July 1932, NLI Ms. 10201.

Chapter 2: The Theatrical Context

1. From an appeal for funds for the Irish National Theatre, quoted in Micheál O hAodha, *The Abbey – Then and Now*, Dublin: Abbey Theatre, 1969, pp. 9–10.
2. J. M. Synge, Preface to *The Playboy of the Western World*, London: Dent, 1941, p. 107.
3. To 'Aunt' Ethel, 12 September 1951, NLI Ms 21132.
4. Jack B. Yeats, 'The Glove Contest', in *The Manchester Guardian*, 5 May 1906.
5. Interview with MacGreevy, BBC Third Programme, 17 May 1948. See Purser, pp. 177ff.
6. Anne Yeats, 'Jack Yeats', in *Yeats Studies*, 2, p. 4.
7. Robin Skelton, 'Unarrangeable Reality', in *The World of W. B. Yeats: Essays in Perspective*, eds. Robin Skelton and Ann Saddlemyer, Dublin: Dolmen Press, 1965, pp. 263–64.
8. To William McQuitty, 8 March 1948, courtesy of the recipient.
9. Jack B. Yeats, 'Indigo Height', in *The New Statesman and Nation*, 5 December 1936, pp. 899–900.
10. Jack B. Yeats, 'With Synge in Connemara', in WBY, *Synge and the Ireland of his Time*, Dundrum: Cuala Press, 1911, pp. 41–42.
11. As 2:5.
12. To Ria Mooney, or Eric Gorman, 26 April 1949. From a typewritten abstract of this correspondence, source unknown.

Chapter 3: Creating a Theatrical Rhetoric

1. To Quinn, 17 November 1920, as 1:12.
2. To MacGreevy, 23 December 1931, as 1:21.
3. To Sybil Le Brocquy, 22 July 1944, courtesy of Louis Le Brocquy.
4. WBY, *Reveries over Childhood and Youth*, Dundrum: Cuala press, 1915, pp. 56-57.
5. *Eason's Bulletin* (Dublin), IV, 5, October 1948, p.3.
6. To MacGreevy, 30 November 1938, as 1:9.

Chapter 4: The Trilogy

1. Dustjacket of 1933 edition of *Apparitions*.
2. J. B. Yeats, *Early Memories*, Dundrum: Cuala Press, 1923, pp. 82–83.
3. *A Broadside*, Dundrum: Cuala Press, February 1910.
4. Jack Yeats on the execution of Republicans by the Free State government, reported by Lady Gregory in *Journals*, 1, 6 August 1923, p. 470.
5. To Hone, 22 December 1931, as 1:9.
6. To MacGreevy, 30 November 1938, as 1:21.
7. *The Bell* (Dublin), I, 2, November 1940.
8. Hone, *W. B. Yeats: 1865–1939*, p. 247.

Chapter 5: The Context of War (1)

1. To MacGreevy, 8 March 1939, as 1:21.
2. To Ria Mooney or Eric Gorman, 19 September 1938, as 2:12.
3. 'Caoimhghein de Chléir', in *The Leader* (Dublin), 24 June 1939, p. 377.
4. J. B. Yeats, The Royal Academy and Home Rule in Art, pp. 8–9.
5. To Harvey, 18 February 1906; also *The Irish Times*, 23 August 1960.
6. WBY, *On the Boiler*, p. 30.
7. G. B. Shaw, 'Bernard Shaw's Advice to Ireland', in *Forward* (Glasgow), 30 November 1940, p. 4.
8. G. B. Shaw, 'Mr De Valera's Last Word', in *Forward* (Glasgow), 7 December 1940, p. 4.
9. G. B. Shaw, 'Preface' to *John Bull's Other Island*, Constable, 1934.

10. WBY, *On the Boiler*, p. 31.
11. To Hone, 16 June 1939, as 1:9.
12. G. B. Shaw, 'The Luck of Eamonn de Valera', in *Forward* (Glasgow), 1 April 1944, p. 1.
13. WBY, *On the Boiler*, pp. 29, 30, 9, 19.
14. *The Worker*, 31 October 1936, as 1:19.
15. *The Evening Herald* (Dublin), 6 September 1937, as 1:19.

Chapter 6: The Context of War (2)

1. See 2:5.
2. *The Genius of the Irish Theater*, eds. Sylvan Barnet, Morton Berman and William Burto, New York: New American Library, 1960, p. 214.
3. Jack Yeats, reported by Stephen Rynne in 'Tea with Jack B. Yeats, 1940', in *Eire–Ireland*, VII, 2, 1972, p. 109.
4. To Hone, 20 December 1941, as 1:9.
5. To Hone, 2 March 1946, as 1:9.

Chapter 7: The Context of War (3)

1. Jack McGowran, 'Preface' to *In Sand*, Dublin: Dolmen Press, 1964, pp. 5–7.
2. To Bodkin, 22 December 1942, TCD Ms 1404.
3. To Hone, 27 February 1943, as 1:9.
4. To Hone, 22 December 1921, as 1:9.

Chapter 8: Jack Yeats and the Novel

1. To Quinn, 17 November, 1920, as 1:12.
2. See Introduction: 5.
3. Joseph F. Connelly, 'Jack B. Yeats: Ringmaster', in *Eire–Ireland*, X, 2, Winter 1975, pp. 136–41.
4. To MacGreevy, 26 December 1944, as 1:21.
5. Mainie Jellett, 'Modern Art and Its Relation to the Past', in Eileen MacCarvill (ed.), *Mainie Jellett: The Artist's Vision*, Dundalk: Dundalgan Press, 1958, p. 90.
6. Mrs. J. W. R. Purser (née Jellett), in conversation with John Purser.
7. Frank Mitchell, *The Shell Guide to the Irish Landscape*, Dublin: Country House, 1986, p. 200.
8. Jack B. Yeats, *Modern Aspects of Irish Art*, p. 4.

9. To Padraic Colum, 26 June 1918, Berg Collection, NYPL, quoted by Pyle, p. 121.
10. Marilyn Gaddis Rose, 'The Sterne Ways of Beckett and Jack B. Yeats', in *Irish University Review* (Dublin), II, 2, 1972, pp. 164–71, and 'Solitary Companions in Beckett and Jack B. Yeats', in *Eire–Ireland*, IV, Summer 1969, pp. 66–80.
11. To Ria Mooney, 10 May 1939, as 2:12.
12. To Hone, 24 February 1921, and 7 June 1921, as 1:9.
13. Terence de Vere White, *A Fretful Midge*, London: Routledge & Kegan Paul, 1957, p. 121.

Chapter 9: Sligo and Sailing Sailing Swiftly

1. Jack B. Yeats, 'Irish Authors: 36', in *Eason's Bulletin* (Dublin), IV, 5, October 1948, p. 3.
2. Sarah Purser to Jack Yeats, 15 June 1930, as 1:19.
3. WBY to Jack B. Yeats, 18 July 1930, as 1:19.
4. See 8:3.
5. To Hone, 16 November 1921, as 1:9.

Chapter 10: The Careless Flower and The Amaranthers

1. See Introduction: 5.
2. William M. Murphy, *The Yeats Family and the Pollexfens of Sligo*, Dublin: Dolmen Press, 1971, p. 39.
3. Patrick Graham, in conversation with John Purser.
4. To Quinn, 17 November 1920, as 1:12.
5. Jack B. Yeats in WBY, *Synge and the Ireland of His Time*, p. 40.
6. Jack B. Yeats, *Modern Aspects of Irish Art*, p. 6.
7. *Ibid.*, p. 11.
8. To Padraic Colum, 26 June 1918, as 1:12.
9. To Mrs. P. Morgan, 7 April 1943, courtesy of Mrs. Morgan.
10. WBY, *On the Boiler*, p. 36.

Chapter 11: The Charmed Life

1. *Ibid.*
2. To JBY, 5 May 1920, as 1:19.
3. To Hone, 14 December 1925, as 1:9.
4. Terence de Vere White, *A Fretful Midge*, p. 121.
5. To Hone, 2 February 1939, as 1:9.
6. Serge Phillipson to John Purser, in conversation.

7. To Cyril Clemens, 21 June 1938, TCD Ms 6238.
8. See 11:3.

Chapter 12: Ah Well and And To You Also

1. Hilary Pyle's script, as 1:19.

Conclusion

1. JBY, 'Memoirs I'. See also Murphy, pp. 139–40, and note. Murphy quotes further from the same passage in a letter to Olive Purser, 31 October 1966.
2. JBY to Sarah Purser, from 6 Berkely Road, Regent's Park Road, London, Saturday 15 January. NLI Ms 10,201.

Index

Relations of Jack B. Yeats are given in parentheses after the name.